GOING
ALL
CITY

GOING ALL CITY

STRUGGLE AND
SURVIVAL IN
LA'S GRAFFITI
SUBCULTURE

STEFANO BLOCH

THE UNIVERSITY OF CHICAGO PRESS

CHICAGO AND LONDON

The University of Chicago Press, Chicago 60637
The University of Chicago Press, Ltd., London
© 2019 by The University of Chicago
Published 2019
Printed in the United States of America

28 27 26 25 24 23 22 21 20 19 1 2 3 4 5

ISBN-13: 978-0-226-49344-2 (cloth)
ISBN-13: 978-0-226-49358-9 (paper)
ISBN-13: 978-0-226-49361-9 (e-book)
DOI: https://doi.org/10.7208/chicago/9780226493619.001.0001

Figures on pages 13, 18, 27, 35, 37, 46, 56, 61, 66, 70, 79, 113, 131, 137, and
152 by Maria Celis; Figures on pages 85 and 91 by Stefano Bloch;
Figure on page 141 by Chaz Bojórquez (from *One Hundred Tags* ©
Chaz Bojórquez, 1996); Figure on page 147 by Christian Guzmán.

Library of Congress Cataloging-in-Publication Data

Names: Bloch, Stefano, author.
Title: Going all city : struggle and survival in LA's graffiti
 subculture / Stefano Bloch.
Description: Chicago : The University of Chicago Press, 2019. |
 Includes bibliographical references and index.
Identifiers: LCCN 2019023567 | ISBN 9780226493442 (cloth) | ISBN
 9780226493589 (paperback) | ISBN 9780226493619 (ebook)
Subjects: LCSH: Graffiti—Social aspects—California—
 Los Angeles. | Graffiti artists—California—Los Angeles. |
 Subculture—California—Los Angeles.
Classification: LCC GT3913.C22 L67 2019 | DDC 306.109794/94—dc23
LC record available at https://lccn.loc.gov/2019023567

♾ This paper meets the requirements of ANSI/NISO Z39.48-1992
(Permanence of Paper).

CONTENTS

INTRODUCTION

My mother would leave me in her car, parked in front yards, in apartment complex lots, in alleys. I would sit for hours waiting for her to come back. She would tell me to stay out of sight, so I would lie down on the backseats or sit in the footwells or pull down the seats and lie in the trunk. When my brothers and, later, my sister were in the car with me, my mom would scare us by saying that if the police saw us, they would take her to jail, and we would have to live in a foster home with an evil woman who would beat us. My mom never hit us, so she thought threats of violence would scare us. I didn't know enough to fear corporal punishment, but I was afraid of losing her, which was a possibility time and again.

One of those times happened when I was in sixth grade and my brother was about five. We didn't have gas in our apartment, so my mother had boiled water in an electric wok to make pasta. The handle had melted, and when she tried to lift the wok to drain the pasta, the contents spilled onto her pregnant stomach.

"Don't worry, I'll watch your kids," a neighbor said, as the paramedics carted my mother off.

She yelled up from the gurney, "Stay away from my fucking kids you piece of shit! Stefano, stay inside. Keep the door locked."

My little brother and I spent the next two days in the tiny apartment, alone and terrified, watching TV and eating uncooked Top Ramen noodles, too scared to use the wok with the melted handle. On the second day, I walked up to Victory Boulevard to find a super-

market where I could steal some food. I was scared to be defying my mom's orders, but I was hungrier than I was obedient.

Other times my mom would just disappear. I would wake up to an empty apartment, quiet except for the noise from the TV that was always on. It would be past 8:00 a.m., so I knew I wasn't going to school, but I would be starving, as kids tend to be when they wake up. She usually arrived home around noon with a single McDonald's breakfast sandwich. The otherwise repulsive smell of that food mixed with old cigarette odor was comforting because it meant she was home and not in jail, dead, or lost. It also meant I didn't have to go in search of something to eat, although by age eleven I knew how to get around.

When cops came looking for my stepfather at whatever house, hotel, or apartment we were living in at the time, they would tell me that my mom would go to jail if I didn't tell them where he was. I remember one cop yelling in my ten-year-old face, "Tell us if he is in the house or I am taking your fucking mother to jail and you will have to live with a bunch of fucking rapists in juvenile hall!"[1] I couldn't tell them because I didn't know where he was, but regardless, juvenile hall sounded better than the foster homes my mom had told me about.

A few times, my mother was taken to jail after a traffic stop, where she would serve a day or two, or maybe a weekend, for a warrant. Once, when I was five, the police took me with her and put us into a holding cell for a few hours. I spent the time spelling out the names carved in the paint on the wall. Other times, I would come home from school to find one of her friends at the house, smoking and nodding off, there to tell me that my mom needed a break from us because we were driving her crazy. In each case, we later found out she had been ordered into a drug rehab facility. And each time, she would leave early, sometimes breaking a court order, and greet us with hugs, a pack of baseball cards, and promises that she would take us to Disneyland for being good kids. Promises of Disneyland were always hanging in the air.

Every couple of years, I would find her in the bathroom after she

had ODed. I would have to open the door by sticking the ink tube from a pen into the hole in the doorknob to release the push-button lock, drag her into the hallway, and, if we didn't have a phone—which was almost always—run to a neighbor's to call 911.

My mother's habit of leaving me in her car went on for several years. When I was older, I would leave the car, defying her order to lie low, and instead walk the block catching "Cisco" tags.[2] I had lived in enough neighborhoods to read my surroundings quickly. In fact I felt anonymous, almost invisible, in a way that worked to my advantage as a writer. I never felt I stood out. My main concern was how my tag would be seen by someone who might pass through the area. I would always find a bus stop and catch a tag at the base of the bench facing an oncoming bus. From there I would find the nearest freeway, walk up an on-ramp to write on a light pole, guardrail, or sign facing oncoming traffic. I caught these tags during the day, usually with no more than a yellow Mean Streak, and I would be back in the car, no incriminating spray paint on my fingers, before anyone called the police. Then I would keep out of sight, not because my mom had told me to but in case my description had been given to the police: shaved head, white T-shirt, blue Dickies, black Nike Cortez shoes.

The audience I cared most about were the people who knew me or knew of me, but I also wrote for myself. I loved to see my work up in places I had been before and think about how my tag lasted long after I was gone. So I looked for landmarks in addition to the fame spots on the freeway and bus benches. Tags there did not last long but would get immediate views. I would hit every dumpster in the alley, the bases of streetlights, or the side of a drainpipe on the back of a store. Few people would see these "low-pro" tags other than local writers who would wonder what I was doing there. Prolific taggers do not discriminate when deciding where to write, knowing that every tag counts—every tag gets seen by someone at some point. And behind every tag is a story about survival and about striving to be seen, or a momentary reprieve from deprivation and desperation.

GRAFFITI EVERYWHERE

Every city has graffiti. In some cities, graffiti is bold and abundant, written atop bridges, across walls, on newspaper stands and mailboxes. In other cities it is more discreet, relegated to the undersides of bridges, alleyway trashcans, and behind apartment complexes and school gymnasiums. Whether you call it art or see it as indecipherable scribbling, you can't miss it. But however prevalent it is, few people have seen it produced in real time. Most people think they know who is writing it—some kid, some outsider, or perhaps a member of a gang—but sometimes they don't think much at all about how it is created. It seems to just appear overnight.

Political statements, religious psalms, memorials, declarations of love, inane wordplay, and various forms of profanity and imagery have been written on walls in stealth throughout history. But graffiti as individual names systematically and stylistically written on outdoor public and private spaces began in earnest across the US during the late 1960s, when newspapers started reporting that singular monikers were appearing across Philadelphia and, soon after, in New York City. By the late 1970s, cities began to declare war on graffiti, and task forces were created to stop the scourge. Meanwhile "graffiti art" was being brought into galleries and used in advertising. By the early 1980s, graffiti was the visual complement to a burgeoning hip-hop culture. More than ever, race was read into the cryptic wall-writing. Black and Puerto Rican kids were most often its imagined authors.

By the 1990s, even as graffiti became the handiwork of a distinct subculture of self-described "writers" who belonged to a global community, illegal wall-writing became synonymous with gang identity. The term *tagbanger* emerged, conflating taggers with gang members even though these two groups share more enmity than identity. This conflation helped fuel a moral panic. Influenced by the broken windows theory, which connects the appearance of quality-of-life crimes like smashing windows and graffiti writing to the commission of violent crime, cities were funding graffiti-removal efforts by the millions in a stated effort to stop the violence.

While the Los Angeles Police Department founded the militarized Community Resources Against Street Hoodlums (CRASH) task force to combat gangs, the Los Angeles Rapid Transit District (now called the Metropolitan Transit Authority) created the Graffiti Habitual Offender Suppression Team (GHOST). In the first years of the 1990s, CRASH raided the homes of both suspected gang members and graffiti writers in an effort to reduce the nation's highest homicide rate. At the same time, GHOST and related groups, such as the LAPD's Community Tagger Taskforce, raided those same homes to try to control what amounted to a $10 million-per-year graffiti problem in Los Angeles alone.

Since the early 2000s, crime rates, and in particular violent crime rates, have plummeted across the country. In the city of Los Angeles, the number of homicides has dropped from more than 1,200 in 1992, to 656 in 2002, to fewer than 300 in 2012. As a result, the connection outsiders now make between violent crime and graffiti may be more tenuous, especially as street crime and gang membership have become less apparent. But graffiti continues to spread along with efforts to remove it.

Today, the Los Angeles Board of Public Works receives thousands of graffiti reports per month through the Office of Community Beautification's Anti-Graffiti Request System. The City responds by spending about $20,000 per day on graffiti removal. This figure does not include the amount spent by Los Angeles County, the Metropolitan Transit Authority, the California Department of Transportation, the Los Angeles Unified School District, the Department of Recreation and Parks, or the countless private citizens, property and business owners, vigilante buffers, and community groups armed with their own paint rollers, sandblasters, and spray bottles full of chemical solvents. Further untold millions of dollars are spent on graffiti abatement measures and infrastructure as well as on investigating, arresting, prosecuting, and jailing graffiti writers. These same calculations can be made for New York, Chicago, or just about any other city in the US.

We know about the efforts to stop them, but who are these "tag-

gers"? Why, despite knowing that they could be jailed and even killed, do they obsessively cover city spaces with their cryptic writing?

Growing up in LA, I counted some of these taggers among my closest friends. We were growing up and coming of age amid constant violence, poverty, and vulnerability, and my friends and I were scared, traumatized, and independent to the point of self-obsession. We had to create a place for ourselves as a matter of social and existential survival, regardless of the potential costs to our freedom. We could have been called a lot of things: brazen vandals, scared kids, threats to social order, self-obsessed egomaniacs, marginalized youth, outsider artists, trend setters, and thrill seekers. But, to me, we were just regular kids growing up hard in America and making the city our own. Being "writers" gave us something to live for, and "going all city" gave us something to strive for. And for some of my friends, it was something to die for.

GOING ALL CITY

To go *all city* is to mark surfaces with graffiti throughout a given city. To be an *all-city* graffiti writer is to be widely recognized for these efforts. By age sixteen, I had earned all-city status. My name appeared on light poles, electrical boxes, and curbs, spelled out in boldly painted letters along freeway walls, atop buildings, and across billboards from one side of LA to the other. I stockpiled writing supplies, pored over maps, accessed seemingly inaccessible spaces, and hit high-profile spots. And I was not alone. I was one member of an active global graffiti community hell-bent on gaining personal fame through illicit painting.

But this book is not about how to analyze, romanticize, intellectualize, or criminalize graffiti writers or the practice of painting graffiti. Many scholars in the social sciences have already done that. Instead, this book is about my experiences and my identity as a prolific graffiti writer. Rather than telling you how to think about the complexity of other peoples' social lives and their decision-making processes in the context of structural violence, I offer an ethnography—more

specifically an *autoethnography*—of my own day-to-day experiences with poverty, violence, and power. You can read the social commentary about young "vandals" and their motivations for doing graffiti between the lines, extracting an analysis of struggle and survival in the context of navigating the city. But the story I offer illustrates first and foremost the complexity of culture and identity as I witnessed it and lived it for myself. This book is about me, to be sure, but it is also about the countless people who make their way through broken families, violent neighborhoods, and impoverished communities as they strive to make names for themselves in any number of ways. As graffiti writers, we tried to make names for ourselves by going to great lengths to write them across the cities we all share. Perhaps, by the end of this book, for good or for bad, you will begin to understand why.

NAVIGATING THE TEXT

The experience of traumas and vulnerabilities such as the ones discussed in this book are difficult to place within a neat chronology. Past decisions and taken-for-granted experiences accumulate and conspire to affect future outcomes and perspectives in ways that are often unseen and unacknowledged. This book, therefore, follows only a loose chronology, which allows me to rely on different forms of reflection at different times in my attempt to tell a story that is filled with social complexity, changing spatial contexts, and apparent political incongruities. The chapters follow me and my friends from when we were kids walking the block to the time we became all-city graffiti writers traversing the city, with the final chapter describing my path to becoming a college-bound kid navigating a larger but no less complicated world. The chapters do ultimately move forward in time, but it is the geographic progression of my life—from smaller to larger—that guides my story.

In writing this book, I relied on my own memory and reflected critically on my life and circumstances. I visited places where I had experienced trauma, triumph, boredom. Sitting on bus stop benches,

standing on street corners and in front of 24-hour doughnut shops, and walking under freeway underpasses, down alleys, and through apartment complexes and motels where I used to live sometimes brought me to tears, provided me with a sense of exhilaration, or made me laugh. This was part of the process of combining and reconciling memories of personal experiences and impressions with objective facts. The process forced me to re-experience deeply held pain, fear, and inspiration.

A NOTE ON ACCURACY

In the chapters that follow, I'll take you with me, through memories and streets, to discover and navigate the city as life unfolds in ways that are relentlessly real. Many of my stories may appear outlandish to some readers who have not experienced the complexity, incongruity, violence, and madness of being poor and disobedient. Knowing this, I worked hard to ensure the complete accuracy of what I have written here so that your trust in me might allow you to suspend your expectations and prevent you from arriving at quick or simple conclusions.[3] In short, you can rest assured that every detail of this story is true.

1 A NIGHT OUT

THE CREW

I woke up at 1:00 a.m. to the beeping of a cheap alarm clock and the green glow it cast over the Krylon spray-paint cans stacked in a pyramid against the wall. I pressed the off-button and started tapping on the others' shoes to wake them.

All-night bombing missions usually started from my house. Even if my mom woke up as we were leaving, she wouldn't say anything for fear she wouldn't be seen as the cool mom. *Cool* described those parents, almost always single mothers, who didn't care, didn't let on that they cared, were checked out on drugs, or relished the attention they received from wayward teens who usually referred to them as "Mom."

Arest, whose real name was Ignacio, had his feet wrapped in a towel. Before falling asleep, we had made him put his smelly Nike Cortez shoes on the balcony. Arest was our reluctant comic relief. He always seemed to appear from out of nowhere and got around by hitching a ride on the back bumper of the city bus, holding onto the grill with his left hand. He was free-range before that term was applied to kids, and even after years of friendship, none of us had ever met his family.

The Under Ground Kings (TUGK) had become a full crew since recruiting Tolse. After he got in, he brought Lyric and Beto into the crew, and they brought a few friends of their own. Most of us lived in gang neighborhoods and had older brothers in gangs, but we were each looking for something different. With a fully-fledged crew, we could finally function on our own, without the drama of gang affiliation.

This particular night of bombing would be casual. Each of us took

four cans of paint from the pyramid—two in our waistband and one in each pocket of our oversized Starter jacket or hooded sweatshirt. The pyramid shape ensured that no one took more than his fair share, as one missing can would distort the entire formation. We planned to walk from where I lived in Panorama City at the time, up Van Nuys Boulevard, and into Pacoima. A distance of three miles that seemed so far. The route was dangerous because of gangsters and cops, but by the time we made it to the main boulevard a bit after 2:00 a.m., the strip clubs and bars would be closed, and the cops would be busy patrolling for DUIs. By the time we reached the Pacoima Housing Projects around 3:00 a.m., even the most diehard gangsters would be back in their apartments asleep.

There were too many of us to access any one high-profile spot, so we decided to just catch tags on both sides of the street as we walked. Working in pairs, one partner would act as the main lookout, and the other would be the principal writer, who would of course hit up his lookout's name. Inevitably, this caused an unstated battle between Tolse and me. He would be on his side of the street with his sidekick, Arest, and I would be hitting spots on my side of the street with Smoke, a guy who had just gotten into the crew and was happy to be anyone's sidekick.

As we walked, we rarely spoke. The idea of walking down the street wearing headphones and listening to music was strange to us. We couldn't afford such blissful wandering where we lived. We were constantly scanning the streets for certain cars or listening for certain sounds, acutely attuned to our surroundings. It seems like everyone I have seen arrested, beaten, or killed over the years had been "caught slippin'," unaware of danger until it was too late. Posttraumatic stress was good for one thing at least: it kept us on our toes.[1]

Tolse and I were the most prolific of our crew, which had about twelve members at the time. Tolse was notably good looking, even to a bunch of teenage guys who were reluctant to acknowledge such things. He also got teased for not looking Mexican, as did Arest, who was Mexican but got teased for looking Armenian. Years later, all the guys in our crew learned that Tolse was actually Peruvian. We didn't

really know what that meant, but we made fun of him for it. Tolse also got teased for the small black mole at the inside corner of his left eye. We called it his *chocolito*—Spanglish for his "little chocolate." We were best friends, spending every day together from the moment we met in another friend's driveway.

When we met he asked me what I was. I knew he meant what was my race or ethnicity, or maybe more generally where I was born, but I wasn't offended. It was an honest question.

"My mom speaks Spanish, but she's Italian."

"Oh," he said, "so you're not, like, really white, right?"

"Ya," I said, and it never came up again.

I was always "from here," which meant American. But my uncles, the guys standing in front of their low-riders and sporting pompadours in pictures from the 1970s that hung on my maternal grandmother's wall, told me I was a "true Latino," which meant "not white" but "definitely not black." I was not white when it kept me from getting jumped, but I was sometimes just "sort of white." Sometimes I was "Chicano" by way of a wanting and wayward father, but mostly I was "Italian," which allowed me to distinguish myself from other kinds of whiteness, yet still included that historical otherness that comprised my mother's side of the family: part-Jewish, North African by way of Sicily. No one ever made fun of me, because I was too ambiguous for any good jokes or stereotypes. I had green eyes and black hair with olive skin and a muscular build.[2] I was whatever anyone wanted me to be. But first and foremost, I was a graffiti writer.

Aside from when we were ripping on each other, race didn't come up that often. Sure, we were aware of racism as a vague concept, but, on a day-to-day basis, it was our identity as writers that dominated our every conversation and our worldview. If anything, it was *white* people who had a race, whereas the rest of us identified by what we did and how we lived our lives.

When vigilantes chased us, it was because we were writers. When guys from MS13 beat us down or pulled guns on us, it was because we were writers. When people crossed the street to avoid

us, it was because we were writers. When teachers kicked us out of their classrooms or clerks followed us down the aisles of their convenience stores, it was because we were writers. Even when cops threw us on the hoods of their cars to search us after jaywalking or during minor traffic stops, crushing our fingers and breathing their hot breath and insults into our faces, we thought it was because we were writers.

That night, Smoke was lookout. He stood on the curb looking down the street for square headlights, which would signal an oncoming early-90s model Ford Crown Victoria police car. I was hitting every sandstone light pole on the northbound side of the street. On the other side, Tolse was using his lanky frame, acrobatic prowess, and strength to quickly climb atop metal gates and write on awnings, shinny up drain pipes to catch tags fifteen feet above the sidewalk, and pull himself up gated access ladders to hit rooftops and building facades. For every three light poles I hit, he would catch ten tags. He went for saturation, whereas I was forced to gain fame for repetition. I had to have a gimmick to compete with his prolificacy.

His lookout was nowhere near as good as mine—not that Tolse needed one, with his stealth and speed. Arest kept catching his own tags on bus-stop shelters and white walls when he was supposed to be looking out. Smoke, in his oversized Chicago Bulls jacket and Malcolm X glasses and hat, never strayed from his role and never seemed to care if I hit him up at all. At times, it seemed as if he went on these bombing missions simply because he had nothing else to do and nowhere else to go. His brothers were Crips who lived in South Central, he used to tell us, but we never knew anything else about him.

Years later, a few of us from the crew would realize we never even knew where Smoke lived or how we had met him. He just showed up one day. This night of bombing would be the last time any of us saw him again, aside from one possible sighting years later, when Lyric, one of the heads of our crew, thought he saw him playing basketball on a crowded court in the park. Lyric joked that Smoke had returned to the safety of the hood after thinking he saw me get killed.

NAVIGATING THE CITY

Whatever apartment my family lived in at the time became the kickback spot. Guys like Arest would stay for days and sometimes weeks at a time, whereas others typically showed up on school days around 9:00 a.m., just after checking into homeroom and jumping the fence to leave. Female crew members, who were more likely to stay in school and have some sort of domestic commitment during the week, showed up with overnight bags for long weekends.[3] Those who had already dropped or aged out of school usually slept in and showed up later in the day. We didn't have jobs, responsibilities, or rules; our motivations were fame and adventure.

Going all city meant perfecting certain rituals. Before going out painting, we had to stock up on supplies and hone our skills. We stole markers—Mean Streaks, Sakuras, Pilots, Uni-balls, drippers, and Ultrawides. We sat in circles practicing our writing styles in sketchbooks and personalizing our JanSport backpacks. We made fake bus passes and traveled to faraway hardware stores to steal spray paint. We were constantly looking to come up on Thomas Bros. atlases; we'd mark them up and tear out their pages so they'd be more portable as we navigated the city. We would spend our evenings cataloging and stacking our paint, cleaning our tips in

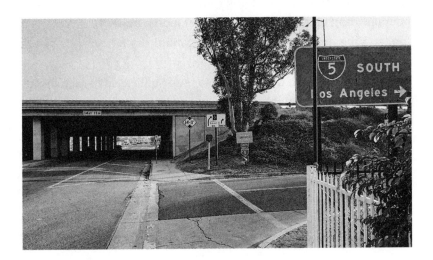

nail-polish remover, and studying old maps to identify new neighborhoods.

We had a system by which we would look for parts of the city that were accessible by bus after 10:00 p.m., identify particular routes, and then trace that route to meet up with another bus line that would take us back home again as the sun came up. Next to the opened atlas would be bus schedules and transit maps for every line in the sixty-mile city of LA. Even with such meticulous planning, we had to walk as many as five miles a night. The chaotic scribbling, as people interpreted it, was practiced, purposefully placed, and planned well in advance.

We had to contend with more than just distance when we went out bombing. We had to know when, for example, club-goers in Hollywood would cause 2:30 a.m. traffic jams, when bread and newspaper delivery trucks would make their way from the industrial districts of South and East LA to the residential districts of the Westside via Cesar Chavez, Atlantic, or Western. We had to navigate surface-street traffic that usually lasted until well after 11:00 p.m. and started up again soon after 4:00 a.m. From not a minute sooner than 3:00 a.m. until not a minute later than 3:59 a.m. was the sweet spot, when the streets in LA were the most desolate. Accessing and hitting big spots with large and sometimes brightly filled-in letters that took time to complete had to be done during that one hour of relative calm. The hours leading up to 3:00 a.m. and after 4:00 a.m. could be reserved for catching quicker tags when there would be shorter lulls in the stream of traffic.

During that hour, there were also fewer police cars and helicopters patrolling the neighborhoods where we wrote. When the gangbangers, drug dealers, prostitutes, and johns went in for the night, the cops would take a break from their constant surveillance and return to the station for shift changes. Homeless people were still in the industrial and commercial areas, but they never posed a problem for us. They usually watched us with a disinterested curiosity from their sleeping bags or from under layers of cardboard as we accessed spaces along freeways and under bridges.

One danger remained, however: concerned citizens and vigilantes, whom we called heroes, who kept the same hours as us. Heroes—almost always middle-aged white guys—drove and walked around the city with an air of threatening confidence and ownership. They sometimes proved to be perverts and predators, but most often they were simply on the lookout for something, anything—and were emboldened by the sight of wrongdoing.

When I was in high school one of my crewmates and best friends, Beto, had a problem with a local writer from another crew called CFK. I can't remember what those letters stood for or what the beef was about, but I do remember walking up to this guy who wrote "Insta" and telling him to leave Beto alone. I wasn't a tough guy, but my notoriety as a writer carried all the weight I needed to be listened to. The next night Insta was dead. One of those vigilantes, William Masters, shot Cesar Rene "Insta" Arce in the back as he finished writing his name on a freeway underpass at around 3:00 in the morning. Masters had been discharged from the military and was carrying an unlicensed handgun in his fanny pack when he killed the teenager and shot Insta's friend in the back as well, but Masters was not charged. Rather, he was celebrated by some members of law enforcement, the media, and the local community as a "do-gooder," "observant neighbor," and "white knight" for combating graffiti and the "Mexican skinheads" who painted it.[4]

Guys like Masters were a greater threat to us than the police or gangsters. There was always the possibility that they would see us accessing a spot, such as the roof of a building or a freeway bridge, and come after us, encouraged by the fact that the law was on their side, regardless of how lawlessly or violently they acted.

Getting on rooftops was already risky, even without vigilantes like Masters. It was not much different from breaking and entering as a burglar, although instead of taking things, we left things behind. On the rooftops, along the freeways, and under bridges, we felt safe, even with all the detritus left behind by drug addicts and drunks. Being on rooftops, like standing on billboards or high up on freeway signs, was the most peaceful part of bombing. These out-of-the-way spaces

gave us refuge and stillness. We were able to let our guards down and, if we were up high enough, we could look out over the city and sit in relative silence against its dull hum.

There were times when Tolse and I would get up on a rooftop and suddenly lose the urge to paint. After walking across tar and gravel roofs, carefully stepping over utility lines running through zinc and copper pipes and around air-conditioning units, vents, and skylights, we would line up our cans along adjacent walls, slink down, and sit. Sweating, out of breath, and often bleeding from scratches and cuts suffered when climbing over barbed wire or through thick brush, we would start to talk.

Tolse was quiet except during these times, when he felt secure. We would talk about places we wanted to live and how great it would be to build a house that no one could tell us to leave. It was during one of these moments that he told me he missed his dad, whom he had barely met, and about how he was scared and ashamed to live in the projects. His eyes filled with tears when he described how he couldn't go home during certain hours because he would get jumped in the complex's courtyard, but if he stayed on the boulevard, the cops would throw him against the wall and rip his shirt. One time he told me his goal was to find a quiet place to read. He knew the names of a few Greek philosophers, the famous ones, and he wanted their books. It was also on a rooftop where I found out that Tolse's mom was from Lima. I didn't reveal his interest in Greek philosophy, but I couldn't wait to tell everyone that Tolse was Peruvian. It was pure comedy, whereas everything else was straight tragedy.

THE FREEWAY

By 3:00 a.m., we were only a block from the Interstate 5 Freeway overpass at Van Nuys Boulevard, the invisible boundary between Panorama City and Pacoima. Panorama City was one of the most crime-ridden and impoverished parts of LA and the site of the largest fires and the only National Guard presence in the San Fernando Valley during the 1992 riot. Still, Pacoima, a mixed industrial and

residential neighborhood on the northern edge of the Valley, was far worse in terms of everyday street violence. It was a deep hood, where gangbangers patrolled with apparent impunity and did their part to make LA's homicide rates one of the highest in the country.

Pacoima's tiny airport, seemingly endless supply of auto-body shops, salvage yards, and clusters of nondescript warehouses made it seem somehow both threatening and empty at night. The fear of crime in the area was as detrimental to our well-being as actual incidents of violence. Anyone out on the streets of Pacoima after dark had to be up to no good, so everybody avoided everybody. The reality about violent crime, though, is that people hurt their own: those they love, those they hate, those they are related to, those they have dinner with, pray with, study with, have sex with, those they do business with, whether legally or illegally, and those they live with. As a result, intraracial violence like "black on black" crime is real. About 89 percent of black victims of homicide are killed by black perpetrators. But what about "white on white" crime? It's real, too, though almost never mentioned in the same breath, if at all. White people kill and get killed by other white people at just about the same rate. This isn't because of some sort of intraracial and race-based hostility within either group. It is because of race-based urban development and histories of segregation.

Histories and current realities of redlining, white flight, block busting, in- and out-migration, ghettoization, racially restrictive covenants, and displacement by gentrification ensure that people live with, and therefore come into violent contact with, other people of the same race. White people live among other white people, buy their drugs off of other white people, love and marry other white people, hurt other white people, dress like other white people, and worship in the same ways as other white people. The same is true for black and brown people. So we were right to fear our own kind, but we were also made to fear our own kind. We looked like gangsters and occupied the same territory as gangsters, and it would be gangsters who would kill some of us.

The area's postwar single-family homes, and even the existence of

its public housing projects and film industry sound stages and storage facilities, were also haunting reminders of the San Fernando Valley's once-thriving suburban economy and almost exclusively white community. By the 1990s, however, white people had already moved to the far west side of the Valley where they would never be affected by our violence, though they were the most vocal of "victims."[5]

We arrived at the freeway underpass, with its large white walls and support columns, which would be our last spot for the night before we entered the projects to sleep on Tolse's bedroom floor. It was the early morning hours of Mother's Day, so if any day could be considered safe in terms of avoiding members of the *Pacas Trece* gang when we left Tolse's unit the next morning, this was it. Even the most hardcore gang members observed holidays celebrating saints and mothers.

Even though Tolse lived in the projects, we all considered him rich. He had lived in the same place, with its cinderblock walls and smooth concrete floors, for the several years that we knew him. His mother had a car, and his older brother, who lived in a small house in

nearby Arleta, even owned an aluminum dinghy with a tiny outboard motor, which he towed behind his pickup truck to the nearby Hansen Dam on the Fourth of July. In our circles, consistency meant wealth.

Tolse, Arest, Smoke, and I were all on the same side of the street as we started to pass under the freeway. We had to shake our cans of paint in our jackets and sweatshirts to make sure the ball rattling inside didn't reverberate through the deadened street and attract anyone's attention, especially because anyone still wandering around at this hour was likely to be amped up on speed and carrying a gun.

Just as we were about to spread out to hit the large walls with tags, a cop car crept up the street and slowly passed us. We each stood motionless, as if it were movement that would draw the cops' attention to the four teenagers holding cans of spray paint and standing in a dimly lit underpass at 3:00 a.m. on Mother's Day in Pacoima.

The car continued on for another fifty yards, then spun around. The driver hit the lights, and the engine made that gut-wrenching sound of acceleration. The four of us ran to the other side of the underpass and up the off-ramp, into the bushes that grow along the freeway.

"Just breathe," I said to Arest. "We'll just wait a second till they're gone and then we'll go to Tolse's. We're fine."

I put my hand on his shoulder as the squad car came speeding up the off-ramp in reverse, with a loud, high-pitched whir replacing the low drone of acceleration. We all took off running across the freeway lanes.

Running across freeways was not new to us. We usually did it to write on the concrete pillars or divider walls separating the two sides of traffic. We also crossed freeways on foot during chases. No gangster or cop in his right mind would continue to pursue us. It always worked.

But that night, just before I reached the center divider, I saw lights streak across my eyes and heard a loud thud as a car sent me flying into the air. I twisted out of control and landed back down on the concrete. When the moment of chaos stopped, I was face down on the freeway. A raised, reflective lane divider was in front of my face,

and everything was silent and still. As I exhaled, the acrid dust on the ground puffed away from my face. I watched both the car that hit me and the police car that had been chasing us drive off. The can of blue Krylon that was still in my waistband had exploded, and the cold, noxious paint was mixing with the warm blood pouring from my head and out of my mouth.

I couldn't move, even when I saw another set of headlights approaching in the distance. At that hour, there were few cars on the freeway, but those that were on the road traveled fast. The driver of the car that hit me likely did not see me before colliding with my body. Who would expect someone to be crossing a freeway on foot at that time, or any time?

I still think about that driver and how scared and panicked they must have been to keep driving, never knowing if the person they hit had lived or died—only a front-end dent, some blood, and an inexplicable spatter of blue paint as evidence anything at all had happened.

My sense of hearing returned. I could hear the swoosh of cars in the southbound lanes of traffic and Smoke yelling, "Cisco's dead, Cisco's dead!" as he ran down the still-empty northbound side of the freeway.

As I lay there thinking I was about to be run over again, proving Smoke right in the end, Tolse and Arest hopped back over the center divider and picked me up under my arms. They pulled me into the emergency lane, flung me over the concrete barrier, and dragged me across the six lanes of traffic on the other side.

Only I had seen the police car drive off after I was hit, so, fearing we were still being chased, they dragged me down the steep embankment and hid me in a dense bed of flowering succulents. We each lay there on our backs, listening for sirens or voices that never came. Feeling immense pressure and terrible nausea but little pain, I asked Arest to remove my shoes. As he pulled off the first shoe, my foot swelled like a cartoon thumb that just had an anvil dropped on it. I was falling in and out of consciousness, and the paint and blood mixture was obscuring my vision, choking me, and making me feel sick. I noticed that, like my foot, my entire body was blowing up beyond recognition. I didn't think I was going to live.

Arest jumped down to the street from the raised embankment to use a public payphone in a strip mall parking lot next to the freeway. Tolse sat with me in his usual silence.

"We're going to be okay," I said. "The police are gone."

He put my head in his lap and started crying.

A car full of gangsters pulled up on the adjacent side street. One guy got out of the backseat, already holding a gun straight out in front of him. In full stride, he jumped up the short retaining wall, put the gun in my face, and asked "Where you from?" Neither he nor Tolse seemed to acknowledge each other.

"I'm from nowhere," I said, as usual. "I just got hit by a car, and the cops are right over there!"

"*Pacas Trece, puto!*" He put the gun in his waistband before jumping back down, and the car sped off. I couldn't see Tolse's face through the paint and blood, but I could feel him still cradling my head.

Arest returned and sat next to me in silence. We didn't tell him what happened. Sometime later—I couldn't tell how long—my older brother pulled up with my mother in the passenger seat. Evidently, Arest hadn't called 911. He paged my brother and entered the payphone's call-back number. My brother then went to my mom's apartment, which didn't have a phone.

My mom was hysterical, yelling from the window of my brother's lowered Volkswagen Bug that it was Mother's Day—why was I doing this to her? My brother was yelling, too. He needed to get out of this neighborhood. It was *Pacas* territory.

My brother had removed the back seat of his car to accommodate a huge homemade speaker box, subwoofer, and amplifier, so we had to call for help to get me to the hospital. An LA County Fire ambulance finally arrived to transport me to the nearest trauma facility: Pacifica Hospital on San Fernando Road.[6]

A FUNNY STORY

The hospital seemed to have more police officers walking up and down the hallways than doctors or nurses. Every so often, an LAPD

officer would stop at the side of my gurney with curiosity and amusement at my battered, bloodied, and paint-covered body. One officer asked me what happened as he lifted the sleeve of my sweatshirt to look at the "gang" writing on my arms. (I occasionally wrote on myself with a pen.)

I told the officer who was looking down at me with a disgusted smirk on his face that I had been hit by a drunk driver on Van Nuys near San Fernando Road.

"Where are you from?" It was the second time I had been asked that question that night. "Nowhere."

He laughed and walked away saying, "You're lucky they just ran over you. You shouldn't have been in their hood, homeboy!"

Aside from the few inquisitive cops, no one ever asked about how I was injured. A nurse finally came to clean me up. She gave me two Tylenol in a paper cup and asked me my age. I was fifteen.

My mother came back to get me with my step-aunt, the only person she knew (besides my brother) who had a car. The hospital discharged me with an ACE bandage, still in its package, for my "sprained foot." I was in excruciating pain, but I managed to scoot into the back seat of the smoke-filled car. On the way home, we stopped at some apartment not far from where I was hit so my mother and aunt could score some methadone from a *veterano* from the *Pacas Trece* gang.

Tolse came over a few hours later. As if nothing had happened the night before, he asked me if I wanted to go rack some more paint, since the pyramid was getting smaller. I couldn't even move. Ignoring trauma was common for us—but wasn't getting hit by a car on the freeway a major event, even for us?

I was right—in a way. By the time Arest and other members of the crew came over that day, I had become the butt of everyone's jokes. I was relentlessly teased for being "slow" and "goofy," for the blue paint that still covered much of my exposed skin, for "falling down" on the freeway only to get "run over like an idiot." Crew members like Lyric and Beto who were not there to see what actually happened were acting out a slapstick version of events as if they had.

Tolse and Arest told the story over and over again, leaving out

how they had actually saved my life. They focused instead on how the cops had driven away and how Smoke ran off into the night yelling, "Cisco dead, Cisco dead," both of them purposefully removing the verb and mocking his deep voice and stereotypically African American cadence.

Meanwhile, my ACE bandage was turning into a tourniquet. Later that day, Tolse borrowed his brother's truck, and we drove to Children's Hospital in Hollywood. My mom sat between us in the cab. I left the emergency room hours later with a cast that extended from my hip to my toes, a stitched and bandaged head, and splints for two broken fingers. So much for the sprained foot.[7]

While I recovered from the breaks, Tolse became one of LA's most prolific bombers, with Arest by his side. He innovated writing styles, hit seemingly impossible-to-reach spots, and very often hit me up with a "Get well Cisco!" TUGK became one of the most well-known crews in the city, thanks to him. He was my best friend, writing partner, and rival, and we would start bombing together again after I healed, but I had a lot of catching up to do.

A few years later, while I was away at college, my mom called me in my dorm room at UC Santa Cruz to tell me Tolse had been shot and killed by a member of *Pacas Trece* at a party in Pacoima. He died less than a half-mile from that spot on the freeway where he had saved my life.[8]

2 THE UNDER GROUND KINGS

THE DIGITAL UNDERGROUND

To start a crew, all you need is a name that will give you some good initials. Then ask a few friends to start writing it. That's it. Unlike in a gang, there is no territory to defend.

My brother started TUGK in 1990, after his writing partner, Pike, came up with the name. The name was inspired by the Digital Underground, a rap group that had a few songs and some music videos out at that point, one of which featured a young Tupac Shakur a year later. Another featured Shock G, the band's founder, wearing a white fur hat, a plaid coat, and a rubber nose, like a pimped-out Groucho Marx. I appreciated that Shock G was willing to assume his ridiculous alter ego as he delivered the song's lyrics in a straightforward monotone. In an era of gangster rap and hardcore riffs, something about comedy was catchy. While everyone was trying to act so hard, Digital Underground went to the extreme and even absurd edges of playfulness.

We used to sit at home and order Digital Underground songs off the Box, a television channel with a call-in number that listeners could dial to select and pay $1.99 to request individual videos—a televised jukebox in the days before YouTube and streaming. Sometimes the request queue would be so long that it would be hours before, finally, our selection would play. We would sit impatiently through Jon Bon Jovi's "Blaze of Glory," Color Me Badd's "I Wanna Sex You Up," and Wilson Phillips's "Hold On" before the bass groove of "The Humpty Dance" would begin, looped behind the opening lyrics. We'd turn the television up full blast, roll open the living room

casement windows, and jump outside to stand on the sidewalk and listen to the song.

As many people as there were who wanted to mess with us, an equal number wanted to hang out with us in front of the apartment building on Laurel Canyon, where I lived at the time. I made friends with Edgar, a guy about my age but quiet, with tough-looking bone structure and a meaty face. He looked like a fighter. He'd gotten jumped into North Hollywood Boyz a couple of years earlier when he was about thirteen. He lived in their hood near a clique that hung out down the street from the old North Hollywood police station on Tiara Street, so his eligibility was a simple matter of address. North Hollywood Boyz had cliques that took their names from many of the streets in the area: Tiara Street Locos, Elmer Street Crazy Boyz, Califa Street Crips, and Delano Street Pee-Wees. Each clique had ten to forty members like Edgar, many of whom got into the gang without having much say in the process.

North Hollywood is a neighborhood located just three miles north of Warner Brothers, Disney Studios, Universal Studios, and CBS Studios, where movies depicting gang life are made but never made well, from an insider's perspective. The violence in gang hoods is insidious, erupting in chaotic bursts that last mere seconds, albeit with enduring and sometimes lethal consequences. Otherwise, gangsters spend most of their time standing around, drinking, talking trash, looking tough, and listening to music.

In movies, "bad" neighborhoods get portrayed as active and full of criminality. In reality, even the deepest gang hood has more moms and little kids walking around than gangsters or drug dealers. The hypervigilance and constant fear they internalize is difficult to detect as an outsider. Consequently, the terms used to identify such neighborhoods—ghettos, inner cities, slums—describe people outsiders expect to find there. The word *ghetto*, for example, is used to evoke negative images of blackness, depravity, or general poverty rather than to critique systematic oppressions, disenfranchisement, and trauma. Yes, violence erupts and people are scared, poor, and vulnerable, but that tells only part of the story about how people live.[1]

NORTH HOLLYWOOD!

Edgar, who wrote "Spread," was as low key as a kid could be. He hardly spoke, barely lifted his head to make eye contact, and had no discernable interests aside from graffiti. He also had some of the most innovative styles I had ever seen. When he wrote, he would connect his letters with extraordinary grace and fluidity. He seemed to float when he wrote on a wall. I wanted to get him into our new crew, but because he was in North Hollywood Boyz, he could not safely cross to our side of Laurel Canyon. So when I eventually got him to come hang out on our wall and listen to the "Humpty Dance," he just left out the fact that he was from the rival hood: his identity as a graffiti writer came first. My brother and the other guys in the building liked him, so he got down with TUGK right away. I had my first bombing partner.

Because my brother belonged to a few different social scenes, TUGK had an odd assortment of members and affiliates when it was first coming up: gangbangers who otherwise didn't get along, guys like Jerry who never actually wrote on walls, and kids like me and Edgar who dedicated ourselves to the craft. Unlike the other crew members, Edgar and I never drank, never smoked, never sought out fights, never had girlfriends, and rarely went to school. Those were just distractions from what was becoming an obsession: to get up and go all city.

The part of the city we inhabited was small, but we knew there was a lot of territory out there to cover. Seemingly half the videos on the Box right around that time were filmed in LA—Suicidal Tendencies' "You Can't Bring Me Down," N.W.A.'s "100 Miles and Runnin'," Red Hot Chili Peppers' "Under the Bridge"—so we had a sense of what to expect out there, however skewed by set dressing and cinematic effects.

In Edgar's apartment building, there was an old man who used to get so drunk that guys from the neighborhood would have to carry him up to his unit and throw him into bed. Edgar would go into his pocket, take his car keys, and show up to my place in a beat-up, brown, late-70s model Datsun sedan. He used the key, but we could start it with a screwdriver if we had to. We would drive around and jump

out of the car to hit spots. Leaving a car running at the curb while two kids jump out to write on a wall was the kind of bombing that movies actually got right, and there was no better way to get caught. It was brazen and ridiculous, and we did it for only a short time before we realized that the exposure was too great. But it was run-ins with gangsters, not cops, that made us realize this.

One night Edgar pulled up to a wall on Victory Boulevard, and I jumped out to hit it. As I was writing out "TUGK" next to our names, someone whistled. I stopped to look and saw about a dozen guys running up to the car from the housing projects across the street. The car was between me and them, so it was Edgar who started getting punched in the face through the driver's-side window. I jumped over the wall and ran along the wash on the other side. I walked the two miles back to my apartment and didn't see Edgar until the next day. He was beat up pretty badly, but he was mostly worried about the

car. He was able to drive it home, but one of the guys had jumped up on the hood and kicked in the windshield. Edgar parked the car back in its spot behind the apartment complex and returned the keys to the guy's kitchen table. He said he saw the old man leaving for work that morning with a hole in his windshield that hadn't been there the night before. Edgar thought it was pretty funny, but I didn't start to laugh until he told me that the guys who had jumped him the night before were from the Victory Projects clique of North Hollywood Boyz. Edgar had been beaten up by members of his own gang.

When Edgar's mom saw his face, she freaked out. Before the end of the semester, he was gone. His parents sent him back to El Salvador, where he was born, because LA was just too dangerous for him. I saw his father a few years later, and he told me Edgar had become a computer programmer in the capital, San Salvador. Being Salvadoran was another secret he had kept from the guys who lived in my building. Jorge and his brothers, who were Mexican, hated Salvadorans more than they hated North Hollywood Boyz. This might explain why Edgar was so quiet: one slip of a *bichos*, *puya*, or *vaya pues* from his mouth would have outed him as Salvy for sure.

GUMBYS

Over the course of the few months that Edgar and I were busy getting TUGK some fame, my brother and his friend Jerry had gotten into a new gang called Gumbys 12 (Gangsters Unnumbered Mafia Brothers Young and Strong, with the number 12 corresponding to the twelfth letter of the alphabet: *L* for liquor). Gumbys were originally from the mid-city area, and they had recruited new members who lived in the San Fernando Valley to form what they called the Villain Side clique. The Valley heads had been in or affiliated with some of the punk gangs going back to the 1980s—Fight for Freedom (FFF), Los Angeles Death Squad (LADS), Criminal Class (CC1), Burbank Punk Organization (BPO), and the Mickey Mouse Club (MMC). Some of these cliques were from the white enclaves of Burbank and the West Valley.

Almost all gangs have names that correspond to a location or refer

to the group's racial or ethnic composition, but some gangs start as party clubs or a loose social affiliation and therefore their names have little intrinsic meaning. Whereas all the original members of Gumbys were black and mostly just drank and partied, the new members and affiliates were mostly white, far more violent, and didn't fit a gangster's typical profile. Three of them were on hit television shows at the time. One of them even released a music video that appeared on the Box, in which he walks through a tunnel and raps in front of a concrete embankment covered in graffiti.

Gumbys eventually made news when five of its newest members were charged in the killing of a police officer's son. The *Los Angeles Times* described Gumbys as "a suburban wanna-be gang" and a "loose affiliation of teen-agers and some young men in their early twenties, [which] probably began in North Hollywood."[2] When my brother and Jerry tried to get out of the gang after the murder, three carloads of Gumbys came to where we lived and brutally beat them in our front yard. Jerry almost died.

Gumbys, like many of these gangs with funny names, gave very serious beatdowns and even committed murders. But unlike majority black or Latino gangs, majority white gangs were rarely classified as such. White gangs were called groups of punks, bad apples, or, as we saw during the homicide case involving members of Gumbys, a "loose affiliation" of "wanna-be" gangsters, even though they engaged in the same mayhem and brutality as some of their nonwhite counterparts.[3]

This is not to say that white kids got a pass from cops on the street. Just as more white kids were joining gangs, more and more white kids were coming into contact with cops, who suddenly became "colorblind" during crackdowns.

THE WHITE KID

On our block there were only a few white kids, each one crazier than the next. One daredevil white kid, "Merge," was always jumping onto parked cars and throwing bottles in the street. He lived with an older couple, who I gathered were his grandparents, in a little house

off the main boulevard, which was otherwise lined with apartment complexes full of black and brown people being constantly surveilled by police patrols.

Merge spray painted his name right on his living room wall. He had kicked holes in his bedroom door, and every window in the house was broken. The only room with furniture was the one in the back, an add-on from about the 1970s, where his grandparents sat and watched a small black-and-white TV all day. They lived on Cup O' Noodles and Kool-Aid and chain-smoked Camel cigarettes. They were morbidly obese and didn't leave the house except for medical treatment. His birth mother was homeless and on crack somewhere. No one, not even Merge, knew where.

Merge, whose real name was Billy, wasn't enrolled in school the whole time I knew him. He lived on scraps of food that he stole or that his friends gave him, and he was always filthy. His was a kind of poverty that most people do not associate with people in cities. It was, however, a kind of poverty that I have always known to exist.

Some people in the places where I lived were bad at being poor. I knew families who made a few hundred dollars per month cleaning houses or recycling cans and bottles, but they always had a pot of food on the table and a clean floor. They may have lived eight people to a one-bedroom, but they took shifts sleeping and cared for the communal kitchen. Others seemed to wallow in their deprivation.

We all got a kick out of Merge. Visiting his house and watching him write on the walls and curse at those two people in the back room was a rite of passage for new kids who moved into the neighborhood. I always wondered how he never came in contact with the police or truant officers, or anyone with any authority.

Merge's luck with the police was not typical for poor, rowdy white kids. When cops would pull up on groups of writers or gangsters, they would always go straight for the one white kid. If a white kid was in the group, he had to be up to no good as far as the police were concerned. Cops would lecture the white kids, saying things like "What are you doing with these knuckleheads?" and "Do your parents know you're out here pretending to be a gangster?"

Some of the worst police brutality I ever saw committed against writers was against white kids. Cops liked to serve them up as an example. They would smash their faces onto the hot, sun-scorched hoods of their cars, press a knee into their backs while they lay on the ground with enough pressure to leave them gasping for air, or crush their interlocked fingers with enough force to turn their knuckles black and blue. When I was the whitest member of a group being stopped, I was the one experiencing all of this. It was as if cops punished people for defying racial expectations.

White privilege, in my community, was most evident in where even the poorest and most criminally active white people got to live, in how they were able to enter a store without scrutiny and suspicion, and even in the sentencing phase when they were charged with crimes. But on the street, I never saw a "white thug" get spared harsh treatment or avoid a beatdown by a moralistic cop whose racism took the form of white paternalism and "tough love." It seems "white trash" is too much of a contradiction in terms for some people. It is also true that most of the all-city writers during the first decade of bombing in LA were white.[4]

Most of our interactions with police were with members of the antigang CRASH unit, most of whom were white men and a few of whom were Latino. Writers knew that a Latino cop would mess with you, slam your face into the ground, and maybe let you go, but a white cop, especially one with a mustache, would calmly crush your fingers and pull your underwear up so high and fast it would cut into your crotch, but then act "professional" while loading you up with a bunch of bogus charges of "resisting arrest" and "lying to an officer." Black cops, and female cops, were pretty rare in our communities at the time. We were being policed, primarily, by white male residents of distant suburbs. They hated us as much for where we lived as for what we did.

Although Merge had incredible writing styles, he never wanted to go writing. If he had, he would have been one of the best around. He spent most of his days throwing a deflated basketball into a netless rim in his driveway, the same driveway where I met Tolse. We moved

away from that neighborhood, and I never saw Merge again. But I was able to stay connected to the guys from TUGK because we were held together by those four stylized initials. Being in a crew, even when physically apart, kept me connected to something stable and sure, and being a writer gave me something to do, something to focus on and obsess over. When life became too bloody and brutal to stay put and endure, I went bombing.

3 GETTING IN

FROGTOWN Y FAMILIA

At a young age, I had learned firsthand how poverty works through eviction, eminent domain, gentrification, drug addiction, gang violence, incarceration, recidivism, police shootings, child abuse, and absenteeism. I was also suffering its emotional toll.

I'm a scholar now. I debate theories in seminar rooms about urban deprivation and dispossession. But I wasn't always able to generalize from personal experience. The constant stress, insecurity, and anxiety of poverty were too much to bear. Deferring to the language of social science has always felt simultaneously alienating and enabling. Theory alienates us from lived reality, but it also provides the framing and vocabulary that allows others to empathize, intellectually if not emotionally.

While I was writing this book, I found that I could empathize with my younger self in precisely this way. Reconstructing my childhood meant reconciling memories with the urban theories that have become the currency of my professional life. In the process, I realized that my identity as a graffiti writer actually began long before I started writing on walls.

Right around my fourth birthday, my father left my mother. He was hooked on heroin and got into a relationship with a woman in New York City. They both worked for the show *Saturday Night Live*: he was the violinist in the band and she was the show's hairdresser. I remember a few of the details from the day he left, such as records being thrown into the street, the sound of breaking glass, and my mom's failed attempt to set his clothes on fire with a lighter in front

of our house. She eventually married my stepfather, who was almost twenty years younger than her. They had known each other years before, when my mom went to beauty school for a short time with his mother. She had even babysat him once, or so they liked to say.

They were wed at a service held in the state prison up in Chino, where he was serving time. My older brother and I were the witnesses. We stopped at Friends Outside, a Quaker-run family-support center outside the prison, so I could get fitted into a loaner suit and then loaded onto an old yellow school bus to ride to the chapel located within the razor-wire fences. My stepfather still had two years left to serve, so in the meantime my mother was doing people's hair in our living room for money and was back with an ex-boyfriend she had told me was my real father.

Estevan Otero was from Frogtown Rifa, a small but notorious gang whose hood was down in Elysian Valley, adjacent to the LA River and not far from Dodger Stadium. Steven, as my mother called him and, as the story goes, after whom I am named ("Stefano" is Italian for "Steven"), wouldn't come to our house because we lived in Clanton 14's hood. So my mom would borrow a neighbor's car to go see him and the woman he lived with, whom she called my grandmother.

The entire Frogtown district has no through streets, just dead-end avenues to the south of the 2 Freeway, each of which starts at Riverside Drive at one end and terminates at the LA River's concrete bank at the other. I was still too young to recognize official street names, so it was FTR (Frogtown Rifa) tags that signaled to me when we were getting close to Steven's bungalow down in the flats. Starting about a block from the turnoff from Riverside, FTR tags would begin accumulating on poles, on cinderblock walls lining the otherwise desolate strip, and across stop signs—the word *CAN'T* and *FTR* written above and below the word *STOP* on the reflective octagon: CAN'T STOP FTR. Some of the tags included an arrow pointing in the direction of their barrio and our nightly destination.

When we got there, my mom had to flash her headlights in a *shave-and-a-haircut-two-bits* rhythm to let the pee-wees blocking the

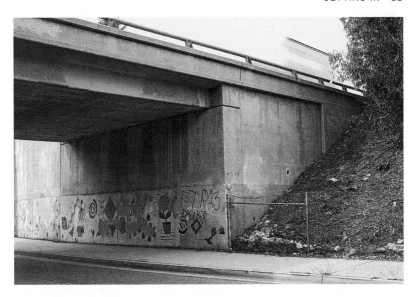

entrance to the neighborhood with dumpsters know we were there to see a local. While a few kids rolled the heavy bins out of the way, others would come up to our windows smoking sherm, ask for some cigarettes, and ask who we were there to see. I was no more than six years old when we started to go down there, but still, the twelve- and thirteen-year-old gangsters would hit me up, asking me, "Where you from!?" My mom was the one who taught me to give the pat answer of "Nowhere," until Steven told me to start saying "Frogtown, *puto!*" After that I was one of them. I was *familia*.

My mom would stand in front of the Otero house and smoke weed while I sat on the hood of the car with some of the *cholas* from the neighborhood. I got my first hickey, a huge purple spot on my neck, before I turned ten from a girl named Kelly who was twice my age. She teased out her bangs, sported thick eyeliner, and wore her pants all the way up to the bottom of her breasts. Kelly ended up living with us and was my mom's first girlfriend, as far as I know. Steven either didn't know or didn't show he cared. When he did start coming to our house in Los Feliz, a few miles away, they all seemed to get along. Kelly sat on one side of my mom and Steven on the other. When my mom couldn't get the car anymore, Steven started coming to our place,

despite the guys from Clanton stationed on the dead-end street that ran below the side of our driveway.

Steven would show up with three to six other guys, and they would fill the house with smoke from their joints. I usually fell asleep on the couch listening to Sister Sledge's *We Are Family* or the Rolling Stone's *Tattoo You* on the turntable, with my head on Kelly's lap and my feet across the legs of my older brother, who was passed out after sneaking a few hits off Kelly's joint when my mom wasn't looking.

It was around that time that I started to wonder why all the spoons in the house ended up in the bathroom, sitting on top of the toilet tank with burn marks on the bottom. Not until I saw my stepfather cooking tar heroin on a spoon a few years later in a hotel bathroom did I understand.

I loved it when my mom smoked weed. I used to call the joints her "smart cigarettes." She would become talkative, cerebral, and funny. She and Kelly would be in hysterics while Steven and the other guys in the room would all be nodding off. Once my mom started regularly using heroin, which eventually intertwined with a lifetime of addiction to prescription opioids and sporadic methadone abuse, I never got eye contact or sustained attention from her again, and she stopped being funny.

When the guys from Clanton went in for the night, usually around 3:00 a.m., Steven would walk down the public staircase and cross out their tags with "Frogtown Rifa" and "FTR" letters. He had that heroin gait and slack posture, but his letters still came out in perfect Old English script. My mother and Kelly would laugh from our rear porch as he wrote on the walls below.

When my stepfather got out of prison, Steven stayed away and my mom was pregnant with her third child: three kids with three different fathers, spread across three decades. She had given birth in the 1960s and 1970s, and would now be giving birth in the 1980s. Later, in the 1990s, she would give birth again, to my sister. She said she conceived my younger brother during one of her conjugal visits. As soon as he was born, everyone knew she was telling the truth

because, unlike me or Steven, my new brother had blond hair and freckles—rare features where we came from.

When my stepfather showed up in his prison-issue white T-shirt, blue off-brand denim pants, and generic white sneakers, he was as fit as any athlete: six-foot-four and pure lean muscle, with a thick mustache and shaggy blond hair. He had cliqued up with the Aryan Brotherhood, a white-supremacist prison gang. Despite that affiliation, he had more of a south-sider Chicano-style inflection to his accent than even Steven did. His arrival meant Kelly also had to leave. Kelly would still come visit periodically, but I never saw Steven again. Some years later, members of a rival gang stabbed Steven and his brother to death in an underground parking-garage elevator in downtown LA. When my mom found out and started to cry, my stepfather grabbed a handful of her hair and told her through gritted teeth to "shut the fuck up."

My stepfather liked to write letters and notes, a practice he developed in prison. He would leave notes around the house telling us to "Stay Away from My Shit," to "Hang the Fucking Towels Back on the Fucking Hook," and "Don't Eat My Fucking Vanilla Ice Cream."

One note on the refrigerator read, "Don't Ever Take Your Shoes Off Again!" I'm not sure, but I think it was his way of telling us not to leave our shoes on the living room floor after we took them off. He would also leave notes dictating odd schedules for us, complete with "meal times" and "shit times," posted on the refrigerator door and bathroom mirror, respectively.

Whenever my stepfather wrote, he would dot each *i* with two little SS lightning bolts, like young girls dot each *i* with a heart or a star. Like his father, who had fought in World War II, he was obsessed with Nazi and other nationalist and white-supremacist memorabilia and regalia. After several of my stepfather's house burglaries, he returned with death's head and eagle pins, Waffen-SS arm bands, daggers bearing swastikas on the grips, and even a complete wool Wehrmacht field uniform taken from one of the upper-middle-class neighborhoods that he targeted.

His father, who hadn't raised him, was a defense attorney and lived next door to the singer Rick Springfield and, much later, down the street from a young Miley Cyrus. He had a large room in which he meticulously curated his war memorabilia, including a large Austro-Hungarian flag he picked up after getting shot down over Kecskemét, Hungary; the iron-cross emblazoned tail section from a World War II German biplane; and one of the microphones that President Roosevelt supposedly spoke into when he declared war on Japan. He also had several Nazi flags.

The few times I visited that huge house I would stare at the iron-cross pins, the professional family photos in which every person was dressed in matching pastel colors, and the shelves of Precious Moments figurines. I didn't understand that his father was a fervent racist, but I did feel that my mother and I were unwelcome foreigners, or "mud people" as my stepfather used to call us, in this white space. In his father's company, there was no trying to pass us off as Caucasian, but my stepfather had also drilled it into us that we were "true white people." This was a daily conversation that he seemed to be having with himself. My stepfather would emphasize our Italian heritage and remind us that the Italians had sided with Hitler. He also made

regular reassuring reference to my green eyes, a trait no one else in my family shared or could account for. Both of the men who have been called my biological father had hazel eyes—one a Chicano gangster, one a Jewish bohemian—but he never brought that up.

My maternal grandmother loved my stepfather's take on our bloodline and phenotype. During World War II, she had become a member of one of the Fascist youth groups under Mussolini, and until the day she died, she described herself in her heavily accented English as "the best prostitute in Roma!" Her mother, my great-grandma "Nonna," with her tight round afro and caramel-colored skin, would walk her up and down a promenade in Rome during the war, waiting to "introduce" her daughter to an American GI. This is how she met my mother's father: an American Sephardic Jew who worked as an Army desk clerk. He got my grandmother pregnant and ended up bringing her, her mother, and his new daughter, my mother, to San Diego a decade or so later. No one in the new family but him spoke a word of English.

They moved into a small house in the Logan Heights neighborhood, where the white kids relentlessly called my mom a "spic." By the time they relocated to LA when my mother was in high school, she was a full-fledged *chola* with high bangs, thick eyeliner, and pierced ears. Her father left the family soon after they came to the US, and it was her Chicana neighbors who watched out for them and whose kids gave my mom her first beatdowns, tubes of red lipstick, and cans of hairspray. It was also in Logan Heights, or what locals called Barrio Logan or "Logan Hypes," that my mother first tried heroin, a habit she wouldn't kick for more than twenty-eight days at a time for the rest of her life.

Her heroin habit, however, started from opioid pain treatment. When she was a little girl, a doctor realized that she had rapidly advancing scoliosis, which caused her severe muscle pain. Eventually the pronounced curve in her spine pulled all the muscles on the left side of her back over to the right. The treatment for it would have put her in a full body cast, but her mother said the other kids would make fun of her, so they did nothing. She started using heroin and doctor-

prescribed opioids later in life when the pain became unbearable, and she kept using it to stay "normal," as she used to say.

My grandmother would sing "Giovinezza di Mussolini! Primavera di bellezza!" with her arm extended in full Fascist salute in front of her bemused Berber mother and dark-skinned, half-Jewish daughter, who spoke fluent Spanish before she ever uttered a word of English. I watched my grandmother sing that same song on her deathbed in Burbank to my half-Guatemalan children and black nephew, who marveled at the paper-thin skin that hung from the underside of her feebly raised arm. They looked at her with as much love and admiration as I had for her. She was their *nonna*. It was the first time I ever felt bad for her. I knew she couldn't love these kids as much as she wanted to because they weren't white. She, like my stepfather, could never love anyone as much as she was capable of.

My stepfather knew about Steven. No details, my mother said, but he knew he came around to "check on us." He was fine with their relationship because FTR and other *trece* gangs had watched his back in prison. On the inside, the racial politics are not what they are on the outside. Whites and south-sider Chicanos have a long-standing alliance in prison. Northern Mexicans, or *Norteños*, and members of the Black Guerilla Family have their own cliques. Members of other races, ethnicities, and nationalities are on their own once they hit the yard, where they are given a pass or extorted.

My stepfather used to explain to me that his racism while in prison was a matter of survival, but on the outside he didn't "give it much thought." He expressed the greatest disdain for cops and "the government"—a general term he applied to everyone from parking enforcement to Congress and sometimes even the electric company when they would turn off our service. But I watched his bigotry guide his decisions about where to eat, whom to buy his drugs from, and whom to live next door to, even if where we were living was a pay-by-the-hour hotel room. He gave approving nods to Latinos, and he jutted his chin out and squared up to black men, "respecting" anyone who returned "fucking eye contact and held his head high like a man."

I also felt loved every time he reminded me that I was "really

white" because even though I knew full well that it was his own twisted and desperate wishful thinking, he wanted it to be true, which meant that he wanted to be able to love me.[1]

The longest stretch he ever spent on the outside during the entire time he and my mother were married—thirty-five years, until the day she died—was six months. His daughter, my little sister, was born while he was locked up. And during those short stints staying with us every three to six years, he managed to turn our already tenuous living situations upside down. He got us evicted by fighting with neighbors. He put us in stolen cars and drove us to faraway motel rooms, where he would shoot up all day—when not out on midday runs to burglarize houses. He once jumped out of a second-story motel window when the police knocked on the door after running license plates in the parking lot. A bone broke straight out of his skin when he landed on the concrete below.

Once, while in a dirty motel room watching a newscaster talk about the capture of the notorious tagger Chaka, my stepfather said to me that graffiti was for lowlifes, like "dogs and fucking Mexicans pissing to mark their territory." I thought back to Steven writing "Frogtown" in bold black letters on Clanton's walls while my mom and Kelly laughed from our back porch. I didn't mention it, and I didn't bother to tell him that Chaka was my idol.

EAST ELMWOOD

During one of my stepfather's short stints in state prison, my mom, my older brother, and I lived in a shotgun-style house on East Elmwood Avenue. The house was eventually condemned by the city, and the property was resold to an apartment developer. When we lived there, it was infested with rats, mold, and a drunk neighbor named Earl. On at least three occasions, we woke up to him in the house: making cereal in our kitchen, sleeping in the laundry room, and lying on the floor in front of the sofa.

Our other next-door neighbor, Ronnie, went to jail for killing his toddler daughter when he punched her in the side of the head as she

stepped in front of the TV while he was watching a football game. My mom took me to her funeral. The little girl, Rhiannon, named after the Fleetwood Mac song, lay in an open casket. The makeup barely covered the bruises on her temple and forehead. My mom told me to touch her face with my fingertips. As we left she was crying and said Ronnie would face justice in jail, where my stepfather or one of his homeboys would catch up with him and kill him. She loved to talk about how men in prison were protective of children.

We lived directly across the street from a small fenced-in concrete slab that had a basketball hoop hanging off the back of an adjacent building. I used to play there every day. My mother was rarely home at that point in my life—she may have been in rehab or jail, I don't really know. My older brother watched me, but I had just turned eleven and was old enough to take care of myself, or so I thought. My brother and I lived off potatoes that we microwaved, and sometimes I would walk to the grocery store and steal boxes of Hamburger Helper and a watermelon. I never stole the ground beef that was supposed to be added to the Helper, because I knew stores watched their meat sections for shoplifters. I would steal the watermelon because I figured no one would suspect a kid of stealing if he walked out of the store with a watermelon on his shoulder.

When we first moved in, a month before my eleventh birthday, NASA's *Challenger* space shuttle exploded in the sky. I had been going to school regularly then, and I was going to be in a school assembly honoring the seven lost astronauts. It was my job to clearly say one of their names. A week or so before the assembly, my mother disappeared again, so I stopped going to school and sat home watching *I Love Lucy* reruns all day. But I showed up on the day of the assembly, ready to say the astronaut's name in front of the whole school. As we all filed into the auditorium, a classmate took my seat at the front of the stage. My teacher walked up and told me to sit with the others in the audience. A few minutes later, I watched as a little girl brightly articulated the name "Ellison Onizuka." I had missed so many rehearsals that I had been replaced. I was crushed. I have never gotten over it, and I never returned to that school again. No one asked me why.

SALVATION

I went back to spending my days between the TV and the basketball hoop across the street. One day I found a box of .22s in the alley that ran along the south side of our house. Earl probably left it there. I took one of the bullets, crossed the street, and started hitting it with an aluminum baseball bat to see if I could get it to go off. A man I had never seen before came out of a service door abutting the enclosed yard and walked up to me. He picked up the bullet and put it in his pocket without saying a word. Then he told me that if I went into the building with him he would give me a caramel from the glass bowl that he kept on his desk. I followed him through a huge unlit room and down a hall into a smaller room, where he gave me the candy and asked me to sit down on his big leather swivel chair. We were the only people in the building.

I went to his office for caramels almost every day after that. Sometimes the main building would be locked, so I had to bang on the doors. He would slowly walk up, all three hundred or so pounds of him, let me in the building, and take me into his office. I started spending all my time with him. If I didn't show up, he would ask me where I'd been the next time I did and playfully threaten to walk across the street and get me. He then started inviting me to show up on Wednesday nights and weekend mornings when his friend Dan would be there. Dan, a little person with a thick Boston accent, wore an orthopedic shoe with a four-inch sole on his right foot to correct for his short leg.

When my mom finally came back home, my older brother, who almost never spoke to me if it didn't involve getting him some Hamburger Helper, told her that these two men in the building across the street were raping me. I had not realized it at first, but the guy giving me the caramels was the pastor of the Calvary Baptist Church, and Dan was his apprentice. My mother told me to stay away from them and that if my stepfather were not in jail he would walk over there and kill them. My brother rounded up a few of his friends the next day to confront the pastor. In the process, he broke one of the

windows on the side of the church with a bottle. It was one of the only times my brother and his friends ever came together to "protect" me from violence.

As I tried to tell them, Pastor Tom and Pastor Dan never raped me. They never did anything but feed me and teach me Bible verses and songs. They brought me into their congregation. Pastor Tom's wife, Mrs. Hilterman, measured my feet so Pastor Tom could buy me shoes that actually fit. Dan gave me food from the supply he kept in a back pantry. Pastor Tom and his congregation were trying to save me.

A few days after my brother broke the window, Pastor Tom lumbered across the street and knocked on our door. He told my mother that the whole family was welcome to come to the church. He didn't even mention the window. She passively thanked him as my brother called him a "child molester" and a "Jesus freak" from inside the house. My mom immediately calmed down. Her opinion of people changed rapidly and dramatically based on little more than a mildly positive or negative interaction. It may also have had to do with how high she was at the time of the interaction, or what bills were due and therefore how stressed out she was, or what she felt she could get from the person. She was as quick to forgive a perceived enemy as she was to turn on people who considered her a friend. The only people she never turned on where her kids. We were her life.

That Sunday morning, I was at church when my brother dragged his speakers onto the front steps of the house and blasted the Clash's *Combat Rock* from our record player to drown out the organ music Mrs. Estees played to accompany our singing of "Onward Christian Soldiers." No one in the small congregation reacted to or even seemed to notice the music from outside that filled the nave.

A few weeks later, Pastor Tom came back to the house to ask my mother if he could take me to church camp somewhere in the Angeles Crest Forest. She said yes, and I left the next Saturday at five in the morning. I was surrounded by kids my own age and counselors who I thought were grown adults but were probably only in their late teens and early twenties. Pastor Tom and Mrs. Hilterman spent most of their time in the main house, making food and writing campsite

sermons for the two hundred or so kids. Every kid at the camp had spending money in a "bank account" (a shoe box with index cards), which they could pull from to spend on things like snacks, slingshots, balsawood airplanes, and swimming goggles. My mom sent me with nothing, so Mrs. Hilterman put money in my account. On the way to the campsite, she asked Pastor Tom to pull into a shopping mall off the 210 Freeway so she could buy me a sleeping bag and flashlight.

Whenever I was away from home, even when I was just at school, all I did was worry about my mom. I felt guilty when I had food, because I knew she wasn't eating. I felt guilty when other people around me were happy, because she was always crying. I resented it when people had basic luxuries, because she had none. But once I was at camp, sleeping in those heavy canvas tents, washing with cold water, and eating lukewarm oatmeal out of tin bowls, I felt that we were roughing it just enough that I didn't have to feel bad for enjoying myself. I didn't know anyone at the camp, but I felt our circumstances—lights out at 8:00 p.m., line up to sing at 8:00 a.m., and gather to pray at noon—put us all on equal footing. I always hated those whom I perceived as the rich kids at school because they didn't seem troubled or stressed out by life. But at camp, although some of the campers may have been "rich kids," they were suffering right along with me, and we were all enjoying, or at least enduring, it together. And because my mom wouldn't have wanted to be there even if given the chance, I was free to enjoy myself and lose myself in the camp's routine and rituals.

We returned to Burbank two weeks later. I had had the best time of my life, and I had even agreed, at the invitation of a camp counselor wearing a Brewers baseball cap, to "accept the Lord as my personal savior" after one of the sermons. We pulled up to the church, and Mrs. Hilterman walked me across the street. The house was empty. I could see all the way back to the kitchen through the mail slot in the front door. The house was full of dirty dishes and garbage, but nothing else.

Pastor Tom got out of his Cadillac and opened the church, but I stayed outside on the front steps and just waited. After about an hour,

Mrs. Hilterman started asking me if I knew anyone else whose house I could go to or whom I could call. Right then my stepfather pulled up in a new Mazda RX-7. The Rolling Stones came blasting out of the T-top sunroof. I hadn't seen him in over a year, but there he was. He told me to get in without acknowledging the Hiltermans. As we drove, he said my mom was at home in our new place. He had gotten out of jail, came up on some fast money, bought a new car, and rented a new place on Grismer Avenue, all in the two weeks I was at camp. As we sped down Glenoaks Boulevard, I told him over the blasting music that I had been "saved." He laughed and asked, "From what?"

When we got home, my mother was passed out on the couch with a cigarette between her fingers. As I put my new sleeping bag on the table, my older brother started making fun of me, depicting in graphic and comical detail a molestation in the woods at the hands of Pastor Tom that had not happened. I stopped going to church, and I never saw Pastor Tom, Mrs. Hilterman, or Pastor Dan again. My relationship with religion proved to be a matter of proximity, though it wasn't the last time my family would have a religious experience.

■ ■ ■

I was in high school, years after my experience at Calvary Baptist Church, when two conservatively dressed people in their mid-

twenties knocked on the door to our tiny apartment in North Hollywood. My little sister, who was about five, opened it, and the couple launched right into a rehearsed narrative about salvation and eternal life. They were Jehovah's Witnesses and, as we learned later, brother and sister. They handed my sister a heavy, gold-colored hardback with *My Book of Bible Stories* written in shiny red script across the front.

From where she was lying on the convertible sofa-bed, and from behind a long-ashed Benson & Hedges Ultra Lights 100s cigarette in her mouth, my mom said, "You can come in and read that to her." The two of them wheeled their leather book boxes full of Watchtower pamphlets into the living room and sat at the small table. My mom said, "You can come whenever you want, but you have to teach her how to read." I kept playing Super Mario Bros. as they opened the book to the first page and starting reading, "All the good things we have come from God . . . ," while my sister studied the picture of erupting volcanoes in a sea of fire on the facing page.

When I got home from school the next week, there they were, reading from the book with my sister as agreed. After a few visits, the brother stopped coming, but Viviana, the sister, kept faithfully showing up with her books and pamphlets. After about a month of lessons, I came home one day to her sitting at the table with my sister, my mom half passed out on the couch as usual, but Viviana was wearing jeans and T-shirt and her hair was down. I had only seen her in a long, dark-colored dress, with her hair pinned up in a French braid. I noticed but didn't stop to say hi on my way to the Nintendo console.

Soon, Viviana was always at our house. She still brought that one book, but more and more it sat unopened on the table with her car keys on top of it while she played with my sister on the floor or chatted with my mom over on the couch. About two months after her first visit, I came home one day to find Viviana with the Nintendo controller in her hands. I stood there watching as she tried in vain to get past the first level of world 2 on Super Mario Bros. My sister's head moved in unison with Viviana's as she tried to jump over the last Koopa Troopa before failing to figure out how to launch herself over the final brick wall and onto the flagpole with the use of a springboard.

From time to time I would join her for a game of doubles, knowing she would die early on, but it would take an ill-timed jump over a fire bar in the castle at the end of world 7 to kill me.

My sister still hadn't found salvation or learned to read when Viviana started sleeping on the couch and not leaving until late at night. She never talked about eternal life anymore either, and she even went so far as to defy the Jehovah Witness creed by wishing me a happy birthday that February. One early morning I came home from a night out bombing and saw Viviana sitting on the roof of our apartment building. I climbed out of our bathroom window to access the roof and found her shaking and crying. She had done some speed to try to counteract the heroin that my mom had given her. I got her down from the roof and told her to go home.

She had come to us looking for a conversion, and a conversion she got.

WOUNDED

We lived in the little house on Grismer Avenue for a pretty long stretch. It was so full of rot it seemed to be sinking into its foundation. My brother joined his first of many gangs while living there. They were a little, short-lived clique called East Side Punx, and they didn't claim a specific hood, so members used to meet up at our house. Members of the local gang whose hood we did live in—Burbank Back Street—would empty our garbage cans on the front yard, throw rocks through our windows, stand outside and yell for my brother to come out at all hours of the night, and, on at least two occasions that we knew of, shoot at our house from the street. One of the bullets stayed lodged in the closet door in my bedroom the entire time we lived there.

One night the local gangsters kicked in the door, ransacked the house, and nearly beat my brother to death. My mother wasn't home and we didn't have a phone, so I ran out the side entrance of the house as soon as the front door came crashing in off its hinges. I went through the neighbor's carport and over her fence to the payphone at

the gas station a short block away, on the corner of Glenoaks Boulevard and Scott Road. A police helicopter lit up the house from above within minutes, and the entire neighborhood was filled with police cars before I hung up the phone.

We never fixed the broken windows or shattered entryway. For the next couple of months, we lived with clear plastic for curtains and plywood for a door. The city offered my mother $5,000 to move soon after that. We had rented the house through an agency and had never met the owner. We paid the rent with cashier's checks made out to cash, sent to a PO box in one of the wealthy beach communities in Orange County. Technically, it was one of the only places we were not evicted from. As the letter from the city said, we were being fully compensated to vacate. Where that house stood is now the City of Burbank's Earthwalk Park. A plastic slide and Bully Free Zone sign sit where my bedroom used to be.

Before all the problems with the local gangsters, the police knew about our family. Right after moving in, I was sitting in the front yard digging a hole with two of my neighborhood friends when police car after police car, maybe ten in total, sped down our street and turned the corner onto the side street that ran alongside our neighbor's house, wheels screeching, engines blaring, and lights flashing, but no sirens. My friends and I heard yelling and a loud crack. We stood up and walked over to see my stepfather leaning against the inside of his car door, grimacing and clenching his teeth. The police officer opened the door of the RX-7 with one hand while holding his gun in the other. My stepfather fell out and to the ground. An officer dragged him away by his arms, revealing what looked like a giant piece of chewing gum stuck just under his armpit. He was shirtless as usual.

He had been shot with his arms raised, and after weeks in the hospital he went off to state prison, where he spent the next six years for residential burglary and resisting arrest. At first he spoke fondly of the prosecutor in his case, Gil Garcetti. He said Garcetti could have tried him for far more time but had felt bad that he got shot "in the fucking armpit." When Garcetti became the district attorney and his office failed to get a prosecution against OJ Simpson, my stepfather

sent me one of his many letters from prison. In it he wrote, "The Juice is still loose I see! Garcetti always was soft on crime. Fuckin' liberal."

As he lay there that day on the asphalt with his arms pulled back and his hands cuffed behind him, my friends and I could still see half of the bullet wound. I started to walk back to my hole in the ground as if nothing were happening. One of my friends asked me if that was my dad. I said no even though we both knew it was. Saying no that day has riddled me with guilt ever since. It was as if the taint of the officer's bullet entering my stepfather had made me ashamed to know him at that moment.

It was the second time I'd seen him get shot. The first time was when he was holding a .22 at his side and accidently pulled the trigger. The bullet entered his ankle and didn't come out the other side. I watched his ankle immediately swell, so much so that the hole seemed to seal itself under the pressure of the engorged flesh around it. He grimaced and clenched his teeth so hard that I heard them grind against each other. He casually walked into the bathroom as if he just needed to take a moment to himself. He never brought it up again except later that day, when he rustled my hair and said, "Use guns to shoot other people, not yourself." Maybe a year or so later, the bullet that had stayed lodged in his ankle migrated to the surface of his skin. I watched as he popped the bulge like a pimple and a small piece of mangled lead fell into the toilet. He just walked away without flushing it down.

Over the years, I watched bullets enter many of my friends. In some cases I arrived on a scene where one of them had just been shot. Most often, the bullet wound had already closed or there was so much destruction that the wound was impossible to see amid the blackened flesh, yellow fat, and wet hair.

4 FACTIONS

BLASTED

Beto walked up the stairs to my apartment across the street from the new North Hollywood police station with his characteristic smile and dopey head bob but holding his right arm slightly akimbo.

"Steffy, I got blasted," he said. He didn't sound panicked so much as amazed and a bit annoyed.

He'd been sitting in the passenger seat of his brother's lowered Cutlass Supreme listening to "One" by Metallica—a detail he added because gunfire punctuates the song—when a car pulled up on his right and the passenger leaned forward, looked across the driver, and asked Beto, "Where you from!?" Beto answered with the standard "Nowhere" just as the bullet entered his upper arm.

"*La Mara, puto!*" yelled the gunman, and the car sped away.

We just stood there looking down at the hole in his arm. There was no blood, and the wound seemed to have been singed closed by the heat from the bullet. Going to the hospital was not an option. We knew from experience that Beto would be tormented by the police, who would want to know who did it, where Beto was from, and what he did to deserve it. Involving the police always resulted in a stressful interrogation that seemingly had nothing to do with the perpetrator and everything to do with the victim. Besides, Beto wouldn't go to the hospital because he was afraid it would attract attention to his undocumented parents. He was also under the influence of his older brother, Hector, who, despite being sensitive and mild mannered, was tougher than anyone in the neighborhood. This bullet wound called

for a trip to Thrifty drugstore for a bottle of hydrogen peroxide and a roll of gauze.

Beto had been shot before. Years earlier, while he was playing on his middle school playground on that same street, a bullet from a .22 handgun hit his head, and he was airlifted to the hospital. When he was discharged months later, the bullet was still in place and he had a pacemaker that pressed so hard from under his skin that its shape could be made out on his chest. Every time a cop slammed him to the ground during one of their daily neighborhood sweeps, we would yell, "He has a pacemaker!" We were convinced that his being slammed to the ground and then having his arms pulled back and his wrists cuffed behind him while being frisked would unplug it. While police officers always ignored our pleas, gangsters usually spared him a beat-down when he lifted his shirt and showed them the square bulge in his chest. But he would have to stand by and watch while his friends got punched in the face and stripped of their shoes.

Beto stayed at my house that day and helped me care for a pet mouse that we had recently renamed the Terminator. The tiny mouse had developed some sort of infection or skin disease that made him scratch away half his face, leaving behind a floating red eye that reminded us of Arnold Schwarzenegger's character in the final scenes of *Terminator 2: Judgment Day*. After pouring some Thrifty-brand peroxide on Beto's arm, we poured some over the Terminator's face and tried to dab a bit of Neosporin on his exposed cheekbone. Beto and I were both more horrified by the mouse's condition than by Beto's, and the mouse would be dead by the time Beto's wound had healed.

Beto also wanted to avoid his mother and father, the only involved parents any of us knew. Beto's mom had a job that none of us understood. As she explained it, she worked in "a place poor people go to get help filling out paperwork and learning about their rights in this country." Beto's mom prepared the family's food every day before leaving for work at 6:00 a.m. Occasionally, we would just be getting back to his apartment, covered in paint after a night of bombing, as she was leaving. She would just greet us with an annoyed but relieved look on her face and direct us to the food already simmering on the stove.

Beto's father was a kind and mostly silent man with the hair of a South American dictator: a high salt-and-pepper coif pulled across the top of his head and kept in place with a small amount of pomade. He watched boxing and *noticias* on various cable channels most of the day. When a Mexican boxer was in the ring for a title fight, Pops, as we all called him, hung a Mexican flag on the wall over the kids' scholastic achievement awards and certificates of perfect attendance. He was never without a plate of food—thick handmade tortillas and a mountain of refried beans; cubed potatoes; and white rice smothered in a green tomatillo salsa they kept in a basalt mortar on the table. We all joked that we had each consumed at least one pestle since it had to be replaced every few months from constant wear.

Pops worked as the apartment manager wherever the family lived. In exchange for discounted rent, he acted as rent collector, groundskeeper, plumber, and general handyman for the building owner. Tolse, Arest, and I never answered to anyone else, but just like his five sons and one daughter, we answered to Pops.

That night, with his upper arm wrapped in gauze that was held in place with Scotch tape because we forgot to buy medical tape, we went out writing. I had a few cans of spray paint, each more than half full. We stayed out of MS13's hood to avoid a second shooting. Given that Beto had a pacemaker, he was never more than a lookout, but I kept it calm that night anyway, just hitting a few walls at the back of parking lots and one easily accessible billboard. I hit Beto up at each spot, stylizing his name as "Betski" when I had the time and space, and even caught a "Terminator" tag that made us both laugh.

Beto's brother Hector was a "long hair"—someone who listened to heavy metal. Aside from that, he dressed like one of the guys from the neighborhood: baggy 501s held up with a canvas belt and metal buckle with an *H* cut into it, and a pair of black-and-white Nike Cortez. He was a soft-spoken guy who stayed in his bedroom most of the time and played his guitar with the amp turned low. He was the oldest of six children, so we looked up to him as an adult, although he was only a few years older than most of us.

At one point he had applied to become a police officer, but he

failed the initial personality test because, as he put it, he was too easygoing for law enforcement. Like many other headbangers in the neighborhood, he got a pass from the gangsters, but some guys still teased that he was a "Satan worshiper." During that time there was a major Satanic Panic taking place, and many of the neighborhood mothers who regularly attended hybrid Catholic-Evangelical churches (with rotating sermons in Spanish, Korean, and Tagalog) conflated heavy metal and the occult. These hybrid-denomination churches liked to scare the hell out their congregations, and even the kids from some of those families wore rosaries while giving beatdowns and crossed themselves before pulling a trigger.

Because of Hector's influence, a bunch of us writer kids listened to heavy metal, especially Metallica. The first CD I ever stole was Metallica's "Unforgiven" single. Hector was uncharacteristically pissed when I brought the CD back to their house: "If you don't buy it, how are they going to know that they have fans in LA?!"

"When they plan a tour," he said, "they go to where the fans are, and they know where the fans are based on the number of CD sales. Damn man, go back and pay for that shit!"

▬ ▬ ▬

Maybe he was worried about Metallica's sales, but he always had a stronger conscience than the rest of us.

In 1992, Metallica did tour through Pasadena, and Hector treated a few of his brothers, Tolse, and me to the show. Hector refused to come inside the stadium until Guns N' Roses, who were accompanying them, were off the stage. They were too soft and "pop" for him. But we were all excited that Mear One, a legendary graffiti writer who became my future writing partner, had just redesigned Guns N' Roses' logo, which the band was now sporting on their kick drum.

We listened to a lot of LA-based bands like Suicidal Tendencies and Slayer despite the growth of gangster rap and groups like N.W.A. and Ice-T, whose lyrics actually spoke to our everyday realities of dealing with the police and navigating the city. The same year Metallica sang about environmental degradation in "Blackened," Ice-T

was saying things like "I'm a star, on the wall's my autograph" in the song "Colors." It made sense that most graffiti writers started identifying with the hip-hop scene, but not Hector. He continued wearing his heavy metal T-shirts and baggy pants, driving his lowrider. And with his brown skin and Chicano lilt, he was equally at home in a gang neighborhood and a headbangers club. Some people called him "white washed," but he was also "too Mexican" to even consider taking his brother to the hospital. Like his parents, Hector was undocumented: the likely reason he had "failed" his police exam.

NAVIGATING GANG TERRITORY

Beto's family, the Gomezes, were poor, often living eight people to a two-bedroom apartment. And there were always at least three members of the TUGK crew in the apartment, too. We didn't go writing from their apartment, but we spent our days there. Sometimes Arest would spend the night, sleeping on the floor with Beto's younger brothers, who were half Arest's age but his same size. The head of the household was Xavier, who wrote "Lyric," and we all respected him. Like Hector he was impossible to categorize with his long hair and baggy jeans, but unlike Hector, Xavier was an active writer and one of the heads of our crew. The only thing that kept him from trying to go all city like me and Tolse was Pops. Having two parents around, no matter how poor, makes all the difference in the world.

When the Gomezes moved into an eight-unit building on the north side of North Hollywood, we were surrounded by warring gangs and cliqued-up hoods. Radford Street Locos on our block had an alliance with Boys from the Hood a few blocks to the west, Vineland Boys and the all-female Runnymede Street Locas to the east, and 18th Street to the north. Sometimes a dozen members of each gang would be kicking it together on Radford Street, which meant Beto, Lyric, Tolse, Arest, and I were locked in the apartment building until they all walked down to the 7-Eleven to buy Slurpees and stand around until the cops sweated them to go back to their street. It was a constant slow-motion game of cat-and-mouse between the

cops and the gangsters. Sometimes the cops would just pull up and, over their loud speakers, say, "It's time to go home fellas. Clear the street or you will be arrested," before driving off.

Before civil gang injunctions were put in place,[1] along with other nuisance laws and the almost complete policing of people from public space, seeing dozens of guys standing in the street, selling weed, and throwing bottles at passing cars usually didn't even warrant a call to police. It was just how things were. But when cops did decide to jump out of their cars and slam us into a wall or pick us up by our pants and drop us to the floor, it was most often unprovoked and away from the deepest parts of gang territory. I think cops liked how gangsters contained themselves in their hoods, whereas we writers moved around the city, and we got punished for it.

The gang injunctions didn't even pretend to target violent crime. People thought that was what they were for, but really, they were used to keep us off the streets and out of sight, and they worked. They also changed everything in our neighborhoods. Whereas groups of guys and sometimes girls used to stand around or walk the block, they now had to kick it behind apartment buildings or other places that couldn't easily be seen or accessed by the police. Our neighborhoods started to look empty. When some of us did try to walk to get some snacks once the gangsters were out of the way, the cops would swoop

on us instead. We became the gangsters in the absence of those gangsters who actually claimed a hood.

The first time I ever had a gun put to my head was when a cop pressed the barrel of his shotgun against the back of my head as I stood playing Street Fighter at the local convenience store on Burbank Boulevard. The cop used his right hand to hold the gun and his left hand to clasp my hands together. He took me outside and gave me a ten-minute lecture on the immorality of gang membership. He kept bringing up the "Crips," the "Bloods," and the "Latin Kings." It is amazing how uninformed the people who police our communities can be about the makeup of those communities. This cop seemed to have gotten his information about gangs from a ten-year-old *20/20* report or some bad movie.

The police crackdowns only got worse over the years, even long after so many gangs had disappeared from their historical hoods. By the 2000s, when being a gangster fell out of fashion and whole gangs had been displaced by gentrification or incarceration, the cops kept coming. Even in the Echo Park district, where the number of homicides dropped from 179 in 1991 to 22 in 2013, the cops kept coming for us, emboldened by an injunction that had never been so unnecessary. By 2017, the number of homicides in the district dropped to zero, but still the cops kept enforcing the injunction against just about every Latino kid who dared to walk the block. Echo Park now has more third-wave coffee shops and gelato shops than it does gangsters, and while the white kids walk freely, Latino kids get frisked. The gangsters are now gone, so hipsters can bar hop and openly smoke weed in peace.[2]

Back when the streets were de facto off-limits due to a crackdown, we hung out in the apartment listening to music and practicing our tags with Sharpies on paper and with Aqua Net hairspray on the bathroom mirror. We innovated and refined many of the styles that we would paint on freeways and streets across the city after Radford Street and their homeboys went in for the night and the cops lost interest in our block.

A few years before I met the Gomezes and got to know the neighborhood, I was hit up while walking past the 7-Eleven near their

apartment on Vanowen Street. What must have been fifteen guys surrounded me and asked me where I was from, some immediately asking for my Izod shirt and black-and-white British Knight sneakers. One guy snatched the monogrammed Dodgers hat off my head. The thought of walking home without a shirt seemed worse to me than getting a beatdown: I was chubby and had back acne, and I did everything in my power never to be seen naked. When they hit me up, I said, "Nowhere," and ignored their demands for my clothes. I knew I was in Radford's hood, but one of the guys called out, "This is North Hollywood Boyz!" My first writing partner, Spread, was a pee-wee from one of NHBZ's cliques. So without thinking I said, "That's cool. I kick it with NH Boyz."

The youngest guy in the group yelled, "This is Boys from the Hood, *puto*," as he landed a flying kick to my face. I started running, but fists and feet struck me from every direction. Forty-ounce beer bottles crashed around me. One hit me in the back. A few of the *cholas* from Runnymede grabbed me by the shirt and scratched my neck and back. The only lasting pain from getting jumped that night was from a pimple on my shoulder that one of the girls tore off with her nail.

I ran into the 7-Eleven, where one of the clerks told me to get out or he would shoot me. I refused to leave and begged him to call the police. One of the *veteranos* from Radford calmly entered the store as his homeboys yelled for me to come back outside. He walked over to where I was standing behind the rotating hotdog display.

"Hey, homes, we tricked you," he said, in a voice that was no less sinister for being measured, almost soothing. "Fuck North Hollywood Boys! Fuck your homies. This is Radford Street. Don't ever come here again, *leva*."

He walked back out and down the street while the rest of the guys threw signs at me through the window.

The clerk finally let me call my mom and 911. It was one of the rare times we had a home phone. I stood in the store waiting while people bought beer, snacks, and cigarettes. They didn't seem to notice me standing there next to the cashier's island with my shirt all stretched out and my face red from being hit and kicked. My mom picked me

up about twenty minutes later. There were no gangsters or cops in sight when she got there.

The *veterano* was right. They had tricked me. When I got home my mom told my older brother I had been jumped by "a bunch of Mexicans." I remember wondering why she didn't identify them as a bunch of guys from Radford Street, which to me was the reason I got jumped.

He started freaking out, pulling at his hair and throwing things around the room like he always did when he was angry. He was so mad he was spitting as he spoke. He told me to get in the car because he was going to drive me back to Radford Street to get the hat they had taken, which was his. We didn't actually go back, of course.

LITTLE ARMENIA

That 24-hour 7-Eleven was one of the centers of activity for Radford. They made almost hourly trips to buy forty-ounce bottles of beer and snacks. They stood in front, mad-dogged customers, hit on girls, and threw signs at passing cars full of other young men. They also opened doors with a display of chivalry for *señoras* and gave respectful nods to men driving work trucks. The girls from Runnymede made sure other young girls didn't even think about parking and going inside.

The guys from TUGK also made trips to 7-Eleven, and like Radford, we traveled in a pack. But getting to the corner store was a mission for us. One of us would go to the apartment building's enclosed parking lot, where we could look across the adjacent parking lots to see if the guys from Radford were hanging out on the next street over. If they were, we would leave from the side gate on Gentry Avenue and make a beeline to the store out on the boulevard. On the way back, we would do the same: look down Vanowen Street to see if anyone was coming from the direction of Radford Street a few blocks away. If the way was clear, we would walk confidently but quickly back to the building's front gate and enter the security code to get inside. Sometimes we would get to the store okay, but by the time we finished a game of Street Fighter or Mike Tyson's Punch-Out in the arcade in the corner,

Vanowen would already be blocked, with ten, twenty, or thirty guys walking down the street, their hands in their pockets, their heads on pivot, and pee-wees aggressively gesturing "what's up" to passing cars.

In this neighborhood, as in every other neighborhood where we spent any time, we had alternative routes of entry and exit. From the 7-Eleven, we could get back to the Gomez apartment by jumping one cinderblock wall abutting the parking lot, going behind the used-car dealership, and running behind apartment building after apartment building, jumping fences and hopping walls, only exposing ourselves to passersby on the main boulevard while crossing over Agnes, Ben, and Gentry Avenues. Taking these routes was also great practice for going out bombing. Skirting danger kept us in fence-jumping shape.

On the corner of Ben and Vanowen, midway between Radford Street and the 7-Eleven at Laurel Canyon, sat one of the only houses on the main street, a typical one-story stucco bungalow converted to a duplex, with a paved front yard that the tenants used for parking. The backyard was also paved and lined with small potted plants. One of the many nights that we had to take this route home with our pockets full of beef jerky and Big League Chew, we entered the yard and found a man pulling a women out of a car by her hair. The sliding chain-link gate was still open, so they had most likely just arrived home after a night out. Without hesitation, one of the new members of our crew, Davis, punched the man at full stride, right in the face. Right then, men and women started coming out of the house, maybe ten in total.

We all poured onto Ben Avenue and spread to the main boulevard. There were six of us, all in our teens, fighting men mostly in their forties—one, in a paisley knitted vest, must have been in his seventies, and a kid wearing an Adidas tracksuit couldn't have been older than ten.

I had just bought a stun gun at the Army-Navy Surplus store on Sunset Boulevard, and I had it in my pocket. Lyric ran over to me and asked for it. I handed it to him, and he ran back into what was now a mass of bodies wrestling in the middle of the street. Traffic was stopped in both directions. The clacking sound of electricity and

blue pulsing light emitted by the stun gun's probes sent everybody running. As the men ran off, I stood next to Beto, who like me had not joined the fight. As Lyric chased the men, Beto and I were attacked from behind by the women of the group. They started hitting, scratching, and kicking us.

The men we referred to collectively as the Armenians ran back inside. I fell to the ground under the weight of a woman in her fifties, who started tearing at my face and overpowering me with blows to the head. Lyric ran over and pressed the dull electrodes onto her neck. But the nine-volt battery inside, which never gave much of a shock even at full charge, had evidently almost died. Still, the remaining clacking sound was enough to make her run inside with the other women. We were the only ones left picking ourselves up off the street.

Walking back to the sidewalk, we saw about a dozen members of Radford on their way to the 7-Eleven. They had watched the whole melee and were laughing, specifically at me. Mexicans and Armenians had a notoriously violent beef throughout the 1990s in LA, and our fight perhaps forged a temporary friendship between us and the gangsters. We got a pass that night.

We walked the block back to the Gomez apartment uneasily, sur-

rounded by the gang members we feared and loathed. They were recounting my beating at the hands of "an old man, a kid, and a bunch of babushka ladies." When we got inside, Pops asked us what had happened. He heard the yelling and could see we were shaken, even if he didn't notice the redness on our faces or our ripped shirts in the dim light of the apartment. Lyric told him we had just fought the Armenians because one of them was hitting his wife. Pops told us to leave them alone because they had had "a hard time with the Communists over there and now the gangsters over here." It was one of the only political statements I ever heard him make.[3]

The day after the fight, Beto and I walked past the Armenians' house and saw one of the men from the night before. He was sitting on the front step and just nodded his head at us. We returned the acknowledgment that the beef was quashed by nodding our heads back. Unlike the gangsters, who seemed to have an institutional memory and held generation-long grudges, the Armenians seemed to settle scores with brute force followed by mutual respect.

VIOLENCE AND PASSIVITY

I have been present at countless brawls and witness to shootings and assaults, but I have never thrown a first punch or pulled a trigger. I feel responsible for participating in violent interactions nevertheless. Sometimes it was my very presence that gave my friends and crewmates the reason and confidence to confront someone. Given my notoriety as a writer and my ambiguous ethnic identity, my friends and crewmates often felt a need to protect me or at least defend my name. Once, while walking through the Panorama Mall, which was more of a covered strip of off-brand shops and fast-food places than a mall, a guy picked me out of a crowd of eight writers.

"You have a problem with Mexicans, *ese*?!" he yelled from over the heads of my crewmates, almost all of whom were Latino.

Without hesitation, a few of my friends started punching him, and one stabbed the guy with a screwdriver. Having them stick up for me that way made me feel helpless, loved, and respected at the same

time. I also felt bad, though, for the guy who might have accepted a simple "No" from me, had I gotten the chance to respond before the violence erupted. But the people where I come from, where many people come from, couldn't or refused to control their first instinct, which was often to lash out against anyone who challenged us or dissed us on any level. Harsh looks were met with thrown fists, and I have seen bullets fly in response to mad-dogging. Where I come from, a "microagression" can get you killed.

Being identified as a bomber and being recognized for passivity got me off the hook in many situations. Many times, I was told that my "homies are going to get capped," or "you're cool, but we have beef with your homeboys." I appreciated this distinction, even though I worried about the welfare of my friends and family. I had to actively stay above the fray to avoid being punished for the actions, expressions, and identities of others in my family, in my crew, and even those who lived in my neighborhood. But this didn't work with police. They didn't seem able to read me as different from the gangbangers and drug dealers I lived with and I was related to.

Cops would jump from their vehicles, grab me by the neck, throw me against the hood of their car, and ask me where I was from. After searching me and finding nothing, they always wanted to know where I "threw the dope" or "tossed the gun." Not producing contraband was grounds for more torment than "just being honest." When they realized I was not banging or dealing, they would berate me for being in a neighborhood where I "didn't belong." Once they determined that I was not "one of the bad guys," they treated me as a criminal for the possibility that I would become a victim. Unlike the guys from Radford Street, cops could never be appeased. They found ways to torment people who lived in the neighborhood but then didn't respond to calls when we actually needed them around.[4]

The police's inability to distinguish between those who commit acts of violence from those who refrain from hurting others resulted in wholesale crackdowns on young people in my community. Antigang policing became de facto anti–youth-of-color policing. Law enforcement's adherence to the broken windows theory of policing

was used to justify their indiscriminate targeting of young people. If small, quality-of-life crimes give rise to the commission of larger, more violent crimes, then a tagger or a loiterer is definitionally indistinguishable from a drive-by shooter, or so the logic goes. While the courts may treat us differently during sentencing, we are treated the same while in the grasp of an angry cop who has been taught to conflate our appearance, our actions, and our sheer existence with criminality.

The Gomezes taught their sons that no one was going to see them as any different from the gangsters who lived in their neighborhood. This was as much because of their skin color as it was their poverty and home address. So their only hope was to get out of the neighborhood and move someplace where they would be seen as outsiders. They knew they couldn't combat structural racism and everyday bigotry by moving away, but they could reduce their kids' chances of getting shot by a local gangster or a cop whose bias was based on geography. This is what had motivated Pops to come to the US. He knew there was some semblance of safety in being different.

5 WHERE WE STAYED

MAKING A PLACE FOR MEN

My family usually moved to a different motel, apartment, or rental house every four to six months, depending on how long it would take to be evicted, but we had managed to stay in the apartment on Laurel Canyon Boulevard where we started TUGK for the better part of a year. In LA, narrower streets are where wealthy people live, and as streets get wider, neighborhoods get poorer. Laurel Canyon starts in an actual canyon above the Sunset Strip, where it has one tight lane in each direction and is lined with million-dollar homes. Down in the Valley it becomes a straight, wide, multilane thoroughfare crowded with apartment complexes like mine, advertising "First Month Free Rent," "No Credit Check," and "Move in Now." It was easy to get an apartment in one of these places. The complexes with dozens, sometimes hundreds of units with popcorn-textured ceilings, wall-to-wall beige carpeting, electric-range ovens, and paper-thin walls overlooking expansive concrete courtyards, tiny fenced-off pools, and high-security parking lots were usually run by rental agencies eager to fill vacancies. The smaller complexes, those with around a dozen units, were also easy to move into, since they were usually run by resident-managers who were less likely to do a credit check if you had cash in hand and promised to pay the rent on time and not destroy the place.[1]

The duplexes, triplexes, and fourplexes on streets like Laurel Canyon were older and usually had more character—arched doorways, thick adobe-style walls covered in stucco, Spanish-style tile roofs, and heavy wooden doors with wrought-iron door knockers—like the apartment building in *Three's Company*. But just as in the television

show, these places usually housed only white people—elderly white people in particular.

In the large complexes, women were the ones who rented the apartments. Women leased the cars, and women cashed the paychecks and state checks to buy the food. Utilities were in women's names, and women enrolled kids in school, picked them up from juvie, and did the laundry. And women took in the men who turned apartment buildings and sometimes whole streets and neighborhoods upside down. When these men first arrived, they would lie low and act like visitors so they wouldn't get their girlfriends (or moms, or sisters) evicted. But soon enough, they'd be kickin' it in front of the building with the rest of us.

The men who came through these apartment complexes were always coming from some desperate situation: from other cities and states where they had warrants or had done jail time, or from living

with girlfriends who couldn't take it anymore, mothers who finally had enough of caring for their adult sons or had died, or sometimes sisters whose new boyfriends, husbands, or grown sons wouldn't tolerate another man in the house. Women's apartments acted as de facto halfway houses between jail and the street.

For men in these circumstances, living with other men is too risky for legal reasons. Other men in their circles often have a pending case or are also on probation or parole. But men also keep other men in check. When guys get together, one of them is likely to tell the others to "keep it cool" because he doesn't want to "get busted for some stupid shit." Most people imagine that men incite other men to commit crimes. In fact, a man is most likely to get caught up and taken in during a domestic dispute: fighting with girlfriends, siblings, or mothers, with the drama spilling out into the street and becoming a public affair.[2] Even theft or battery can be tied to relationships with women. Often, theft is about getting money to fulfill a promise to help with rent, and battery is about fighting other men over claims to a particular woman, her apartment, her car, or her financial support. A common refrain in the neighborhoods I lived in was "Bitches cause problems," but in truth, women economically and emotionally sustain the men, who then get caught up in drama and blame the women who support them.

Women and children also pay the costs associated with male imprisonment at every stage: when a man is arrested, potential financial support is lost; when he is inside, he may demand that money be put on his books; when he is released, he may cause the woman in his life to be evicted or force her to break ties with the support systems she may have developed and maintained in his absence.[3]

STRAYS

When my older brother's friend Jerry came to live with us on Laurel Canyon, he immediately started calling my mother "Mom" and made the typical promises to "stay for just a little while," help pay the rent, and keep the kitchen clean. Men like Jerry could never help with the

laundry, because they couldn't risk being seen coming and going from the laundry room. Apartment managers keep track of who swims in the pool, who parks in the parking lot, and who uses the washers and dryers.

Many "strays," as my mother called them, lived with us over the years, but it never ended well for anyone involved. The only man I remember who ever had a regular job and actually fulfilled his promise to help with the rent was Neto. One day after work, Neto walked into our tiny apartment without knocking, and Tesho, another guy who had been sleeping on our couch for a few weeks, punched him in the face. He hit Neto so hard that it took several minutes to revive him. Neto missed a few days of work because of the gash on his cheek and several loose teeth. Tesho told my mom he was just trying to get Neto to "Show some respect for the fuckin' pad." My mother loved taking care of wounded, sick, and needy men, but she was also secretly impressed with such brute force enacted on her behalf. As soon as Neto healed, she made him move out and let Tesho stay. Neto lost his job because he had nowhere to live, and Tesho moved out a few weeks later when he met a woman who had a car, an apartment up the street, and a baby daughter who stayed with her grandmother most of the time. Tesho lived off the food stamps intended for that little girl.

When Jerry showed up to stay with us, the younger guys in the building and I had already claimed the front of the building as our territory. We would stand in front from morning until late at night, looking hard, mad-dogging people in cars, and sometimes throwing rocks at passing buses. We weren't gangsters, so we didn't throw signs or represent anything larger than ourselves, but like gangsters we acted as neighborhood sentinels.

Cody and Jorge were my two best friends in the building. We all liked an older girl of seventeen named Ximena who lived right above me. Her mom never let her out of the apartment except to go to school. She walked all the way to North Hollywood High, and Jorge told us he walked her there a few times, which I think was true, though it never amounted to anything. But Cody told outlandish

stories about midnight rendezvous with her in the laundry room. His stories were part *novela* and part *Archie* comics.

When we met, Cody and Jorge weren't taggers or gangsters, just teenagers in the neighborhood. But people are intent on applying labels, so if you were not a gangster you were a church kid, a school boy, a party girl, or something. No one is nothing, and no one can afford to be seen as neutral. Within about a year they were both in gangs and usually drunk or high.

Cody lived in a one-bedroom at the back of the building with his mother, who worked all day on weekdays and spent all weekend watching and sending money to televangelists. Jorge, whom we called "Grandpa" because he had graying hair at age fifteen, lived across from him in another one-bedroom overlooking the rear parking lot. He lived with his mother, a seamstress who spoke only Spanish, and his two older brothers who came to "stay" with them when they were released from prison.

To "stay" somewhere as opposed to "live" somewhere or with someone is common vernacular. It means that the living situation is temporary or entered into only out of necessity. Permanence and commitment are all too often hard to come by in disenfranchised, hyperpoliced, impoverished, and otherwise broken communities. So like my own older brother and Jerry, Jorge's older brothers didn't actually "live" with their mother, they just "stayed" with her. Also like my own brother and Jerry, Jorge's brothers were gangsters.

Many of the people where I came from were not labeled gangsters because they were misunderstood—they sometimes embraced the gangster label as a means of being understood. Without the gangster persona, without the respect and fear it evoked in others, they were just another "lame" in the neighborhood who lived with their mothers and were either ignored or taken advantage of. To suggest that "gangsters" are labeled as such by outsiders is to deny those who identify themselves as gangsters the agency and identity they work so hard to craft. For this reason I define certain people as "gangsters" and "taggers" without qualification.

This is who we were—writers, gangsters—and we worked hard

at cultivating the distinction. However, when the label is used by law enforcement and school officials, the distinction becomes more problematic. "Gangster" becomes a label applied to young Latinos and Latinas or black kids who have tattoos or wear certain clothing. This can land them in a gang database, which acts like a gang initiation in the eyes of the state. And like actually being in a gang, it is difficult to get out.[4]

When all the strays and stragglers became semipermanent residents of the building, they took over the front of the complex, transforming it from a largely innocent kickback spot to a full-fledged "neighborhood."[5] The older brothers, Jerry included, represented two different gangs that had one mutual rival, North Hollywood Boyz, whose larger hood we happened to live in. Almost every day, at least one car full of NH Boyz would drive by throwing gang signs, and my brother, Jerry, and Jorge's brothers would throw signs back—Kaos 13, Gumbys, and Vineland Boyz, respectively. Once in a while, one of the NH Boyz would fire a shot or two, and Jerry or one of Jorge's brothers would throw a rock or a bottle or, if they happened to have a gun on them at the time, would fire back.

Since we lived in the front unit of the complex, a few stray bullets landed in my living room over the course of several months. My mom used to tell Jerry to please stand on the other side of the building if he was going to throw signs. The guys from NH Boyz knew Cody, Jorge, and I were "just writers" and left us alone most of the time, but the volley of rocks, bullets, and bottles became so commonplace that Cody, Jorge, and I would sit behind the low wall that wrapped the front of the building to avoid getting hit or mistaken by others for one of the gangsters who lived in what had become a well-known neighborhood target. When we were finally evicted, though, it was not because of what happened in front of the building. It was the result of a situation with Trigger, a guy who moved in with his mother and younger brother around the corner from us after he got out of jail.

TRIGGER

Trigger was my brother's age and from Lennox 13, a gang from a place by the same name that butts up against the runways at LAX. He had cliqued up with members of a San Diego–based gang, Logan Heights, while they were all serving time together. One of the guys from Logan Heights lived with his mother in a little house a few blocks away. Like Trigger's mother, she had relocated there for the sake of her younger kids after the oldest went off to jail. People moved to new neighborhoods to escape violence, but the violence often proved far more mobile than they realized. Eventually, three members of Logan Heights moved into that little house, likely with unfulfilled promises to help pay the rent and do the dishes. Within a year, the whole neighborhood was full of guys who had just gotten out of jail, where they had forged alliances with some and decided to hate others.

Logan Heights and Lennox fell into conflict with Vineland Boyz while locked up, and as a result, Trigger and the guys from San Diego had an immediate beef with Jorge's brothers, even though they had never met. They came to our building as soon as they heard who lived there. This beef also put them on good terms with the NH Boyz, now that they had a mutual enemy. The first confrontation was with Jerry.

As he sat eating a bag of chips on the front wall, the guys from Logan ran up and beat him down, leaving him unable to open one eye, walk, or even speak coherently for more than a week after they stomped his head into the sidewalk. Seeing people get punched in the face and kicked on the body is never as terrible as watching someone's head get stomped into the pavement and hearing their teeth scrape the concrete.

About two weeks after Jerry's brutal beatdown and his slow convalescence in our apartment—which meant he was for once keeping a low profile and out of the manager's sight—Trigger starting walking the block with his little brother. I watched from our living room window as he wrote LNX13—shorthand for Lennox 13—with spray paint across the low wall out front. I wouldn't have known he was out there, since we never opened the heavy, tobacco-stained curtains to look outside, but for several minutes before catching his tag, he stood out there yelling, "Come out, *putos*! This is Lennox *trece*!" and then, in the menacing sing-song Southern accent of Robert De Niro's character in the recently released *Cape Fear*, which everybody was emulating at the time, "Come out, come out, wherever you are!"

Trigger's brother and I, who were both about thirteen years old, made eye contact: a shared look of guilt, embarrassment, and fear on our faces. Neither one of us projected hostility. Instead, we offered each other a helpless and subtle shrug of shame.

Two days later, after the LNX13 was crossed out by one of Jorge's brothers and replaced with a V13, Trigger came back and stood in front of the apartment again, yelling for the "Krackers, Vanilla Beans, and Gumballs"—derogatory plays on Kaos, Vineland Boyz, and Gumbys—to come out. I don't know if it was Trigger's boldness or the fact that he didn't play by the same rules as members of the other local cliques, but no one—not my brother or Jerry, nor either of Jorge's brothers—went outside. Jerry and my brother sat there in our living room telling my mom that they didn't want to "disrespect the apartment by going out there." After a few minutes of yelling, the windows came crashing in, and the heavy curtains blew inward. I knew it was not bullets, since they usually just punctured a window,

moved straight through the curtains, and disappeared into a wall or the ceiling.

Trigger was pulling pieces off the terracotta-colored stone that topped the cinderblock wall and throwing them into each of our windows. The apartment manager had the windows replaced the next day and didn't say a word about it. We all joked that he was so cool about it because his brother-in-law owned the glass company that did the work. Jorge's brothers stood there watching the work being done, telling the manager it was "just some crazy *mayate*" who had done it, referring derogatorily to the fact that Trigger was half black, a detail that didn't seem to matter to the Israeli landlord.

It was Trigger's third visit that actually got us evicted. The previous night, I had been out writing. I walked all the way up Laurel Canyon, past Ventura Boulevard and almost all the way to Sunset Boulevard, before turning back as the sun started to come up. Up on the hill, Laurel Canyon's every twist and turn is marked with a large reflective yellow street sign with a black arrow indicating the direction of the curve ahead. I caught a tag in white spray paint on every black arrow along the three-mile route, and even a few tags with black paint on the yellow parts of the signs. I went alone on this mission because Cody wasn't allowed out at night and Jorge didn't like to walk farther than the corner store.

When I first started writing, I would just pick a street and walk it for hours, writing on everything I could. I saw the city from the perspective of a kid who walked everywhere or took buses, so bus stops, newspaper stands, and low-hanging street signs were on my mental map. Not until I had the perspective of a teenager and later an adult in a moving car did I become more selective, aiming for spots that would get more attention and be seen from different angles and at faster speeds. But those first nights of bombing, when the city seemed so small, so accessible, and so linear, gave me the greatest sense of accomplishment.

Those local missions also had the most immediate payoff, since I was writing for an audience that consisted of Cody, Jorge, Jerry, and Jorge's brothers. But I was most proud of my work when my older

brother saw it. I started writing because of him. The younger brothers of some well-known writers had come to our apartment after school one day and were so impressed to meet my brother, whose work they had seen. He was a gangster, but he was also a small-time graffiti writer. He had some of the best writing styles, mixing Old English *placas* with motifs copied from the cover of Suicidal Tendencies albums—Venice Beach gangster letters blended with hardcore skater fonts.

Gangbangers and graffiti writers are members of distinct groups, but some people, such as my brother, proudly identified as both. When one of my friends asked my brother if I wrote, as if I weren't standing right there with them as my brother signed their sketchbooks, he replied with a laugh. That laugh, which I took to be more dismissive than cruel, was the moment I decided to write my name on walls. You can't impress another gangster in any sort of measurable way without resorting to violence, but as a graffiti writer you could catch more tags, hit more spots, go farther, and get more fame. You could go all city.

By the time I got back to our apartment after hitting Laurel Canyon, it was just before 8:00 in the morning. School buses were stuck in traffic, and I wanted to get inside before I got picked up for truancy. But I stopped at the convenience store and bought a warm apple pie in a cardboard sheath. I was in front of my building when I saw Trigger running toward me from the other side of the street, holding a sawed-off shotgun.

I dropped the rest of my pie and ran up the driveway to the back of the building, with Trigger only about thirty feet behind me. I turned the corner at the back of the building and ran up the flight of stairs to Cody's unit, three stairs per stride. I opened the door, flew inside, and slammed the door shut just as Trigger caught up to me. Cody's mom had not left for work yet and was standing in front of her TV watching *The 700 Club* at full volume. Trigger gave the door two whacks with the end of the gun barrel and left. Cody's mom ducked into the kitchen and told me not to leave until he was gone. Cody was still asleep; like Jorge and me, Cody almost never went to school.

When Trigger banged on the door, the sound traveled halfway

across the complex and got the manager's attention. When the manager walked up later that evening to ask Cody's mother—the only trustworthy person in the building in most people's eyes—what had happened, he saw the two circular dents in the door. Cody's mom told him that someone was chasing me and had done that. The manager walked down, banged on our door with an open palm, and handed my mom an eviction notice for causing damage to the property.

I saw Trigger's brother a few years after we moved out of the neighborhood. He said Trigger was back in jail. He also told me he had started writing and was in a local crew, and even back then, when we made eye contact, he had known who I was and had seen my tags around the area. He said his brother also knew who I was and was sorry for chasing me that morning. He knew I didn't gangbang, but he had been up all night on speed. He'd been waiting across the street in the bushes for my brother, Jerry, or one of Jorge's brothers to come out so he could kill them but mistakenly went after me instead.

CAMPING OUT

When Logan Heights formed an alliance with North Hollywood Boyz and started to take over the neighborhood, Jerry decided to become a writer and asked to join TUGK. Before he could catch his first tag, though, he was stabbed several times in the head by members of Logan Heights. He barely survived. This attack actually kept him in a gang, because he needed the distinction, if not the actual backup, to help him retaliate. He still lived with us after the eviction, in the place my mom rented a few miles farther north in Sun Valley. Once again, my mother took care of him as he recovered. He got out of bed only once in more than a month, when his girlfriend picked him up and drove him over to the Logan Heights house near our old apartment. He shot one bullet through the front window. It was all the ammunition he had at the time.

When my stepfather got out of prison for a brief time, he kicked Jerry and my brother out of the house. He told my brother he had to grow up and be a man, which meant moving out, and he called Jerry

a "fucking freeloader and a rat." The worst thing you could be in my stepfather's eyes was a rat, someone who told on people or turned them in to the authorities. In prison, rats and child abusers were everyone's targets, regardless of race or affiliation. He said he knew Jerry was a rat because he looked like one. Everyone else thought Jerry looked like a frog, which earned him the gang name "Sapo" (Spanish for *toad*).

Soon after they left, my stepfather returned to prison after his parole officer found drugs in his urine. He never lasted more than a few months on the outside. But whenever he did get out of jail, he would order my mother to cancel her welfare check because he would "take care of things" and didn't need the government supporting his family. And as usual, within a few months of his violating the terms of his parole, we became homeless.

My younger siblings went to stay with their grandmother, my stepfather's mother, who lived in a fourplex in Van Nuys. When the sheriff's deputies came at 6:00 a.m. to put locks on our door, they warned my mother that she would be arrested for trespassing if she re-entered the house. They gave us thirty minutes to collect our things and told us to make arrangements with the landlord to get the rest of our stuff later. We never came back. I lost everything I couldn't carry away that morning. I was used to it; we would get evicted three times a year, sometimes more. My mother did call the landlord at some point, but he just ignored her and had the house emptied. I had met Tolse while living in that house, so I just held onto our friendship.

We drove over to the apartment one of Jerry's girlfriends had rented for him and my brother, and we asked to spend the night because my mom and I had nowhere else to go. Jerry told us they would get evicted if the manager found out we were staying there. We had to leave.

Before we left, however, I went into Jerry's bathroom and carved my name into my arm. I used the corner of a razor blade to scratch, not slice, each letter of my tag name into my skin; the blood slowly filled in the grooves of each letter—C-I-S-C-O—before I wiped it away

with toilet paper. I can still see those letters if I hold my arm up to the sunlight.[6]

That night, we slept in my mom's pickup truck. I went out after my mom fell asleep and hit about two dozen spots near where we had parked. I only had a marker, but it was a broad-tipped Sakura full of permanent black ink that Merge had given me as a "going away present," so I wrote my name in bold letters—stylized versions of the still-bloody letters on my forearm that were sticking to the inside of my sweatshirt sleeve. I hit a few newspaper stands, the sides of public telephones, and a smooth white wall where the tag showed up nicely and could be seen from passing cars. I was now a bona fide writer because I was getting up in more than one neighborhood and on more than one street. People would start to notice and ask who I was. I was going to become too important for me to harm myself.

Once the felt-tip on my marker was frayed and I couldn't write anymore, I climbed into the back of the truck, through the hatch on the camper shell. My mom didn't get mad when I woke her up while climbing in, and she seemed the most content I had seen her in a long time. I fell asleep wondering if Cody or Jorge, who still lived on Laurel Canyon as far as I knew, would ever see these new tags and think about me.

6 LEFT BEHIND

THE BALI HI

When my family was homeless or on the run, we usually stayed at themed motels that didn't ask for identification: the Polynesian-inspired Bali Hi or Mexican Pueblo–themed El Cortez in Van Nuys, the Tiki-themed Safari Inn in Burbank, or the Spanish Mission–style El Patio Inn in Studio City. We would pull up under the covered carport, and my mom would walk through the lobby door and into the tiny reception area, which typically smelled of mildew, cigarettes, and food and was filled with the sound of daytime television or the local nightly news.

The "exotic" themes stopped at the signs outside. The rectangular rooms were all about the same: small bathrooms with blackened grout in the shower and rust stains beneath the faucets; stained, short-pile, wall-to-wall carpeting; a peeling laminate dresser with a TV on top; a small, wood-veneer table in the corner with one or two filthy upholstered swivel chairs; an end table; a cigarette-burned clock radio; and one or two full-size beds with polyester bedspreads. Nicer rooms also had a hutch and a vinyl-covered ice bucket.[1]

These motels were well known for prostitution and movie filming. At both the Safari Inn and the El Patio Inn, we had to keep our curtains shut during the filming of two movies, each of which coincidently involved Patricia Arquette: Quentin Tarantino's *True Romance* was filmed at the Safari Inn during one of our stays, and David Lynch's *Lost Highway* was filmed at El Patio Inn a few years later. But when the film crews left, the motels would go back to being havens for prostitutes, drug dealers, unwitting German tourists, single men,

and old ladies who sat around all day and smoked. Sometimes there were other families like ours, but my mom never let us talk to them. "If they're staying here," she would say, "they must be trash."

We stayed at the Bali Hi off and on for years. In the early years, my stepfather would take us there when he was out of jail and in violation of parole. My mother and I, and sometimes my little brother, would wait for him to get back from a job. He would tear into the room with one or two suitcases filled with jewelry, collectable coins and stamps, new and antique guns, and baseball cards. He always went for stuff that the local fence would buy without question. My brother and I loved to sit on the bed and roll mountains of loose nickels, dimes, and quarters into paper rolls before taking them to the bank, where we'd exchange them for cash. Just about every house he burglarized had a stash of money in a piggy bank or five-gallon water bottle. They were heavy to lug away, but even a half-filled Sparkletts bottle had hundreds of dollars inside.

My stepfather always burglarized houses during the day. He used to say that he never wanted to scare a sleeping kid or get shot by a homeowner. He also had a way with dogs. If he entered a house when everyone was at work, he could calm any dog and keep it from barking or attacking.

He returned from one job with a huge haul. He walked into the room, sweating profusely and gritting his teeth, and asked me to come help him get the "groceries" from the car. He and my mother constantly spoke in code, even when no one was listening. Still in my boxer shorts and tank-top undershirt, I walked to the rear parking lot, past the ice and soda vending machines, to the car. He grabbed a bulky sweatshirt that was full of stuff and awkward to carry and told me to get the two large leather satchels from the backseat. We walked down the path that went in front of all the poolside units, each of which had a humming air conditioner sticking too far out into the path. Just as he was about to cross the threshold into our room a gun slipped out of the bundle in his arms, hit the ground, and discharged one bullet up into his leg.

He went into the room and fell against the foot of the bed, putting his foot right on top of my balled-up Dickies pants, white T-shirts, and tube socks waiting in a pile to be washed. I watched as the blood started to pour from his wound onto my only clothes in the world. I put the bags on the floor and just stood there not knowing what to do. He was making the worst growling and grunting sounds I have ever heard. This gunshot seemed to affect him even more than when the police shot him in the armpit several years before, when we lived in Burbank.

My mother came out of the bathroom, where she spent the majority of her time, and started screaming.

"I should be at home cooking dinner for my family! These kids should be in Little League! They shouldn't have to see this! You motherfucker! Look what you have done to our lives!" It was one of the only times I heard her talk to him this way, acknowledge our situation, or reveal that she was conscious of our predicament.

He responded by telling her through gritted teeth to wrap a pillowcase around his leg just above his knee to stop the bleeding and to bring some towels soaked in hot water.

I tied the makeshift tourniquet as she ran into the bathroom. She returned, telling us to keep it down or the manager would call the police. The bleeding stopped more quickly than I expected, and

my stepfather scooted up onto the bed. My mom cut a small plastic trashcan in half and placed it under his leg to elevate it. She must have also given him a shot of heroin, because a minute later he was nodding off.

I lay next to him on the bed and kept swapping out bloodied towels for clean ones, which I soaked with hot water and laid over his leg. The wound, which looked like a small black hole, had swelled shut, but the taut, shiny skin around it looked like it was going to split open under the pressure. His leg turned purple and black, and although it stayed that way for weeks, he was back on his feet within two days. I hid the gun, an old .38 revolver that he took from somebody's nightstand, behind the filter in the air conditioner.

After he fell asleep, I gathered all my clothes and put them in the tub to soak. The blood had hardened, and all I could save were the pants and socks. The shirts were too stained. The socks never got white again, but no one would be able to see that. I did the laundry as I always did in those days—by taking a shower fully dressed in the clothes I wanted to wear. I would use a bar of soap to wash everything and, after rinsing, I'd take everything off and place each item on a towel laid on the floor, roll the towel up with the clothes inside, and step on it to get the excess water out. I would then hang the clothes over the back of a chair, and by morning they would be dry. Everything would be stiff from the soap I used, but it would be clean.

When I returned to school after my stepfather shot himself, I was wearing my white tank top—what we all called a "slingshot" and people later started calling a "wife beater." While walking to one of my classes, the assistant principal came up to me and told me I looked like a gangbanger and that wearing a shirt like that to school was not allowed.

"One of these days," he said, "if you keep dressing that way, you'll get shot."

We stayed at Bali Hi for about another week. Although he could walk, my stepfather couldn't go out on any jobs with a hurt leg. Burglarizing houses was physical and, given the neighborhoods he worked in, often involved scrambling up a hillside and climbing over

a wall or backyard fence. My mom, as always, took the haul to a fence in Burbank. The guy worked out of an old bungalow that he said was a film production office during Hollywood's Golden Age. He was extremely tall, with a glass eye and a blond toupee. He would use a small torch right in front of us to melt down the gold jewelry we brought him. He would do some sort of chemical separation of the molten liquid, weigh it on a beautiful old balance-beam scale, hit some buttons on his large desktop calculator, and then hand us cash. He also bought the stamp collections, some of the more valuable coins, occasionally one or two of the better baseball cards, and some of the antique guns, but never the newer ones—my mom sold those to her drug connections. She got $125 for the .38.

GETTING AWAY

My mom was going to give my stepfather the money from the fence so he could pay the rent on the room and buy some "stuff," but before she could do it, he got arrested on a warrant while limping back from the McDonald's up the street. He called the room collect from county jail late that night to tell her so. We hadn't eaten all day, but she was just scared enough of him to not spend one dime of his money that night. In the morning, though, she and I got into the car and drove to the McDonald's for breakfast. On the way back, she pulled into the motel's drive-through portico and left me in the car so she could run the rent inside.

Less than a minute later, she came running out with the manager chasing her.

"You motherfucking loser pieces of shit! I called the cops, you piece of shit!" He was carrying a stick cocked over his head as if he were going to smash her head.

She jumped in the car and we drove away.

"He was going to kill me because of you," she said through her tears. He had told her that the cleaning lady found all the damage I had done to the room—that I had trashed the place, cut up the chair cushions, scratched the table, and "tagged up the TV."

I became stoic when I witnessed violence, but now the feeling of responsibility made me want to throw up, and I started shaking. I felt dizzy. We kept driving, frantically, as if my mother thought we were being chased, and I was thinking about how everything we had left in the world was still in that room.

I had in fact scratched my name into the top of the TV set and the table—the same style of letters I carved into my arm a few years later—but the chairs had slashes in them when we moved in. Like most graffiti writers, I compulsively caught tags—on napkins, on steamed up mirrors after a shower, even in the air with my fingers—practicing my styles and emulating others' styles. I was committing to muscle memory a certain curve of the S in my name and the flare of my O, preparing what I would reproduce on walls at night. Everything I owned had my tag name etched into its surface. The addiction to writing never goes away. Everything is writing. Every surface is for writing on. That TV, those walls, my arm. It all belonged to me, because I had nothing.

My mom continued sobbing, barely able to catch her breath, until we made it to her connection. So much had happened in such a short time, but all she could talk about was the man at the motel and my "destructive streak." When she came back to the car about an hour later, she was back to normal: slightly sedate, slightly smiling. I asked her to please drive back to the motel, because I had left my rabbit and my baseball cards behind.

We traveled with an animal most of the time, and while staying at the Bali Hi I kept a rabbit in a travel-sized pet carrier in the bathtub. I was scared to encounter the manager, so I had my mother pull up on the adjacent side street. I walked into the motel through the back parking lot, past the ice and soda vending machines, and down the walkway to the room. The cleaning lady's cart was parked outside a room a few doors down from the one we'd stayed in. Our door was wide open, and the room had been cleaned. But right there in the bathtub where we left him was my rabbit. All our other stuff—some clothes, a suitcase from one of my stepfather's "jobs," and my card collection in a wooden box—was in a pile on one of the cut-up chairs.

No one even noticed as I walked back out with the caged rabbit and our stuff.

THE RABBIT

A couple weeks later, we found an apartment to rent. It was a one-bedroom upstairs unit with a small balcony overlooking a dirt and gravel embankment of the Tujunga Wash, a tributary of the LA River. It was midsummer, and keeping the rabbit from overheating meant trips to the park, where we would let it hop around in the shade.

The apartment was just three hundred feet from the end of Judith Baca's Great Wall of LA mural, supposedly the longest in the world. I used to walk along the wash and look down at depictions of California history, from the dinosaurs and Spanish conquest through the Civil Rights and Chicano/a movements to depictions of the post–World War II baby boom and white flight, that helped give rise to the San Fernando Valley where I stood. I had written on murals before and would again in later years while out bombing, but this mural was sacred to me. It was also out of reach, painted down on the high vertical banks of the wash.

I didn't understand the historical content of the mural. But this was, counterintuitively, a turning point for me. I could not understand the anguished faces in the panels depicting what I later understood to be Chinese laborers, Japanese internment, and mass Mexican-American deportation. I couldn't understand it yet, but I was moved, captivated by the masks worn by gay men sitting at a bar in Silver Lake, the Native American man's long braid being cut off with oversized white sheers in the Mojave Desert, the sinister face of Joseph McCarthy holding his typewritten blacklist. Rosie the Riveter and her wrench being sucked into a television set by Susie Homemaker wielding an Electrolux vacuum cleaner. A pair of black jackboots standing over a stripped-naked zoot-suiter. The ghostly face of a woman clenching rubble as skeletal figures lay on wooden shelves behind her, while others walked the barbed-wired perimeter of a Polish death camp.

It was an almost daily routine for me. I used to stop and look down every time I walked by on my way to the nearest pay phone, on the campus of the community college I would attend years later, to call family members for help. My grandmother would just cry when I told her we were hungry; she'd have panic attacks that I could almost feel through the phone's plastic receiver. Repeating over and over again, "mio Dio, mio Dio": "my God, my God" in Italian.

One of my aunts, whose kids were all semi-successful child actors at the time, would berate me for calling, yelling that my "fucking drug addict mother needs to get it together and stop relying on other people to feed her kids." I was the kid she was talking about. Once she did bring a bucket of KFC to our house, but when my mom opened the door, my aunt threw it in her face. When she left, my little brother and I picked up the fried chicken from the floor and ate it. My mom joked that she was glad she hadn't brought drinks.

Years later, two of my aunt's three actor sons, my cousins, became drug addicts. One of them died of a heroin overdose in a Maricopa County jail, where he was serving time for holding up a pharmacy. He was found dead, wearing his prison-issue pink socks and underwear. My aunt started smoking crack later in life. I ran into her when I was

in my twenties, and she asked to borrow forty dollars. I gave it to her without saying a word.

Sometimes I even called my stepfather's family from that phone, to ask if they would bring us groceries. I didn't know them aside from the few visits to their house I had made over the years. They would accept the collect call and then ask me to call back later because they were busy. My stepfather's stepmother had a coldness to her voice that scared me. I don't know why my mother made me call them. They never helped us. They never responded. We didn't even know them. I hated asking people for anything.

Another aunt, Margaret, who was born in Mexico, lived in Silver Lake. She took me in sometimes when I was small and my mother had disappeared. She was kind to me, and she was the only member of the family who never disparaged my mother or asked me to account for her actions. I already knew my mother didn't feed us. I knew she would sleep all day and disappear by dawn. I knew that the one meal I would eat for days was a McDonald's Egg McMuffin. I knew I had to revive her on the bathroom floor every time she overdosed. I saw the cockroaches infest our apartment. I knew we never owned a bed. I knew I didn't go to school for months at a time. I was aware, on some level, of my fear, anger, sadness, and shame. But I couldn't understand why adults were always reminding me of these facts and yelling at me for them.

When I was at Aunt Margaret's house, everything seemed so quiet. She kept the TV off except when she wanted to watch *Dallas* or *A Current Affair*. The rest of the day she would spend cleaning, making sandwiches, and sitting and reading, followed by a trip to the grocery store and then home to prepare dinner, which we would eat while sitting at a table. I would be bored out of my mind when I would first get to her house, but then the down time, the routine, the errands, and the food started to feel good. It was also the first time I had ever seen someone other than a hotel maid make a bed in real life. It was nice to feel the smooth sheets and the weight of the comforter, nice to have a pillow that wasn't a balled-up sweatshirt or sofa cushion that smelled like cigarettes. Having a bedtime though, which for me

meant lying in a dark room for what seemed like hours before falling asleep, was torture. At home, I slept wherever I fell asleep, and I fell asleep wherever I happened to be lying while watching TV. I loved being with Margaret, but I would never call her on my trips to the payphone. If I had, she would have come and gotten me, and leaving my mom and little brother behind made me feel guilty.

When I was done making my phone calls, I would walk back along the mural. It made me feel better. I wasn't being told how to think or feel about myself or about history in some didactic way. I was also not being shamed or made to account for my situation by people who seemed put out by our poverty. My personal history and experiences were dwarfed by the struggles of the people in the mural. That was all I knew. The mural gave me the opportunity to question my ignorance and ask naive questions about what was apparently important enough to paint on a wall. I was confronted with a form of expression that showed me how to think but didn't force me to think any one particular thing. Markings on walls always provided that for me: they showed me that someone else was telling a story that I didn't need to fully understand to appreciate.

We had lived in the apartment for only four days when my aunt Margaret invited us over for a Fourth of July barbeque. Even though I hadn't called them, she and my uncle had heard from my grandmother that my stepfather had returned to prison. Before we left for my aunt's place, my mother put my rabbit on the porch in his cage because his thick, nitrogen-rich urine smelled up the apartment, which had almost no ventilation and no bathroom window. When we got home late that night, the rabbit was dead. The downstairs neighbors had had a barbeque of their own, and the smoke had billowed up and suffocated it. Or maybe the fireworks had scared it to death. I can't be sure.

The dead rabbit stayed on the balcony for over a week, until it smelled so bad I threw it down next to the dry wash below. The cage landed on its side, and for the next week I watched the dead rabbit become bloated, then wriggle with maggots, and finally deflate and dehydrate in the hot sun. I checked on it every day to see what stage of decomposition it was going through. About a month later, when all

that was left was a tuft of fur stuck to the bottom of the cage, I saw a guy who lived in an encampment in the nearby bushes use a hanger to scrape the contents out onto the ground and walk away with the empty cage. I continued to check the balcony from time to time out of habit. I loved that rabbit so much, but I was used to watching things I cared about disintegrate.

7 PLAYERS

SOMEBODY TO LOVE

We'd been living in a small house for about four months when the owner started showing up in the evenings. My mother and stepfather had not paid the rent, so the owner would pull his car into the dirt yard, honk his horn, yell, and flash his lights in through the front windows. More terrifying than the owner screaming for his rent was my mother fighting to restrain my stepfather, who wanted to go outside and kill the guy for scaring "his fucking kids."

Soon after, my stepfather was back in prison, so the owner resorted to formally evicting us instead of intimidating us from his car. We were only weeks away from the marshals putting us and our stuff on the street.

Before we managed to move, my paternal grandfather tracked us down to this house. He pulled up in his sun-bleached Nova when I was outside on my bike. I had strapped a battery-powered radio to the handlebars, and I would ride around the neighborhood listening to oldies on K-EARTH 101.1 FM. My grandfather, whom I didn't know very well but recognized right away, got out of the car with an emaciated man who had short hair and a long mustache. I did not recognize him at all. He was my father. I had always pictured my father with long curly black hair, loose linen shirts, and tight bellbottom pants hanging over the brown leather clogs that he wore for the short time that I lived with him when I was small.

They walked up to the front door without acknowledging me, knocked, and exchanged a few words with my mother. On their way back to the car, my father tussled my hair and asked me how I was

doing. My grandfather, who was a kind man, quizzed me about some world event and asked to feel my biceps and pretended to be amazed at my strength. Then they got in the car and drove away.

My mother said they had shown up "for no fucking reason" and "as usual" didn't give her "a fucking dime." My most vivid memory of that day is of my grandfather's threadbare corduroy pants and the way my father grimaced in pain when he stepped up on the curb.

I got a letter in the mail about a month later. I opened the slim envelope, addressed to me, which the mailperson handed me along with a pile of junk mail. Inside was a single sheet of paper. At the top it said "CERTIFICATE OF DEATH" in all capital letters, with "State of California" typed below it. The letters of my father's name were typed into each of the cells below. All the other cells were filled with information I didn't recognize, including a San Diego address I didn't know. A section in the middle had several lines under the heading "Death Was Caused By." Only one of those lines had anything written on it: "Acquired Immune Deficiency Syndrome." He had died of AIDS.

"This is nothing," my mother said when she came outside and took the letter from me. She started crying uncontrollably as she went back in the house, leaving me standing there with the empty envelope from the San Diego County Recorder's Office still in my hand.

Later that day my mother murmured, out of nowhere and to no one in particular, "I knew he looked skinny," followed by some reference to his having cancer. She had told me that Steven Otero was my father, but that that guy in prison was my "dad." Later she told me that Steven had adopted me, before telling me my imprisoned stepfather had. I had used my stepfather's name, Sykes, my entire life because it was "official." The man whose death certificate I had just read had been a vague figure holding a violin in my distant memory, but it was his last name—Bloch—that I would use years later when I enrolled in college.

Six years after my father died, I enrolled myself in high school, and I joined the football team. I walked onto the team a few weeks after training started during my junior year. I was still limping from having been hit on the freeway when my friend Freddie, who had been

a graffiti writer in junior high school but now wanted to become a cop, asked me if I thought I could make it through one day of football practice. He told me all I needed was a pair of running shorts, a pair of cleats, and a towel. He also told me I wouldn't make it past the first hour of conditioning.

I had never watched a football game in my life, and I didn't care about actually playing, let alone winning, but I figured training would help me get the leg I broke on the freeway back to its normal size and function. The team was full of a bunch of ex-writers and gangsters and more than a few future cops and soon-to-be prison inmates, but being on the team kept them all out of trouble and off the streets for at least a few hours after school and on game nights.

By September I was on the field playing when our team won its first game in more than a season. Our lineman coach, Coach Cranston, was the reason I got any playing time at all my first year on the team. He used to tell me, "You are one of the worst football players

I have ever seen, but I'd rather have you out there giving 110 percent than have one of these other knuckleheads who are far superior to you giving 50 percent. So listen for your name because if we are up by more than a touchdown, you are going to get some playing time." As the game ended, Queen's "We Are the Champions" started to play. My teammates and I ran across the field holding our helmets in the air.

I don't know if it was the emotion of winning the game or if it was because it was okay to cry since everyone on the field and in the bleachers was doing the same, but I sobbed so hard that my stomach hurt. A few months earlier, I had watched a tribute concert on MTV for Freddie Mercury, who died of AIDS soon after my father did. My mother cried during the concert when George Michael performed "Somebody to Love" in front of 90,000 people at Wembley Stadium in London. It was as if, for the first time, she was acknowledging the disease. Before that concert, she would say that AIDS was only for groups of people that started with an H: "Haitians, hemophiliacs, heroin users, and homosexuals." I was terrified and felt guilty for not knowing which of these groups my father belonged to, and even more terrified because my mom did belong to at least two of them. Years later, when she died of liver failure as a result of Hepatitis C, she was using heroin and had a girlfriend. But she considered never having gotten AIDS to be almost a bragging right.

After beating the Narbonne High School Gauchos that night by more than a touchdown, I went back to my girlfriend's house. I didn't have any interest in a relationship, but she had won me over one day on campus by asking, in a whisper, if I was "really Cisco." By the time the season started she was more impressed with my position on the team and became our biggest fan. She attended every game and joined the team support staff, making posters that said "Beat Sylmar!" or "D-Fence" and even tying ribbons onto milk bones for fans to wear around their necks as they cheered on the North Hollywood High School Huskies and our canine mascot.

I had other "fans" as well. I was voted "Best Hair" that year even though I had a shaved head. During the season I would let my hair grow out all week and then shave my number into the back of my

head. In the yearbook photo I am standing with a classmate who won best hair for the girls, and we are both wearing #71 jerseys: my varsity game jersey and my practice jersey. Another classmate asked to borrow my jersey because he was going to be in a music video that weekend. After practice that Friday I gave it to him, still soaking wet with sweat. When Dr. Dre and the D.O.C. from N.W.A. pull up in a convertible Chevy Impala in the video for "Nothin' but a 'G' Thang" with Snoop Dog, there he is wearing my blue and white #71 jersey in the front row of the crowd. When my girlfriend told me she saw the video, I acted unimpressed. I was religiously listening to Pantera, whose *Vulgar Display of Power* album had come out earlier that year, so I pretended that Dr. Dre didn't matter.

My girlfriend and her mom lived in a tiny two-bedroom apartment in MS13's neighborhood. Whenever we went there, we would pull into the covered parking lot and go quickly inside to avoid being seen by any of the guys hanging out in the front of the building. My girlfriend's unit was empty and spotless, even sterile. Her mother, Laura, was constantly cleaning every surface with disinfectant wipes, moving on to frantically flossing her teeth, then combing out her huge afro with a giant brush, which made a swooshing noise that echoed off the tile floors and bare walls. She talked nonstop about court TV, drama with the neighbors, and "that *pinche maricón*" Fidel Castro. She may also have at some point identified as my girlfriend's father, but I wasn't sure and I never asked. In addition to having large breasts, huge hair, and a booming voice, she shaved her face and sometimes spoke of her daughter's "*otro padre*," who stayed behind in Cuba when she and her daughter fled to the US in the summer of 1980. She was also the reason I was with her daughter.

Laura treated me like a son and a best friend. She watched out for me and tried to give me motherly advice, but like a friend, she encouraged my graffiti career. She also bought all of my spray paint so I didn't have to steal it like a "*pinche* Mexican," as she put it. She said her father, who had also fled Cuba as part of the Mariel boatlift, financially supported her, and that she would never accept welfare like one of those "lazy *niches*." She moved between different dialects

of Spanish-language racial epithets. Despite the talk, on the first and fifteenth of every month, she would pull into the check-cashing place on Sherman Way, leave me in the car to listen to oldies on the radio, and come back after cashing her state check and collecting her booklet of food stamps. We never acknowledged the state aid she collected, which she said was "only for losers."

We would go grocery shopping and fill the spotless refrigerator with the only things she let in the house: tubs of vanilla yogurt, packaged lunch meat, and Wonder bread. We would get individual packets of mustard and mayonnaise from a Chinese-run sandwich place next to the Food for Less where we shopped, and she would organize every tub of yogurt (or "Jo-gurt," as she pronounced it with her Cuban lilt) with the labels facing the same direction. We only bought small sizes of each product, since she would never allow half-eaten food to remain in the house.

She would pay her rent and the utility bills with cash, then buy gas, bags of chips, and fat-free muffins from the gas station. With the rest, she'd buy cans of spray paint for me from Builders Emporium. I would walk in with her and select the brand and colors—four six-packs of Krylon ultra-flat black, four six-packs of Krylon sparkling silver or Rust-Oleum aluminum, and one six-pack of Krylon flat white. I would load up the cart and then walk back to the car as she paid. At this point in my graffiti career I went from catching tags and doing simple outline throw-ups—or quick "bubble letters"—to painting larger letters that I filled in with silver and outlined in black. I used the white to paint highlights, which I never put in the right places. I had never taken an art class, so I had no idea how to properly shade or draw back shadows, but I improvised.

THE TEAM

Whenever we won a game, no one on the team could sleep. All the guys would go out for one-dollar noodles across the street from our school, sit there until the restaurant closed around 11:00 p.m., then walk over to the 24-hour Yum Yum Donuts and hang out in the

parking lot until about 1:00 in the morning. After the homecoming game the previous year, our school's homecoming king was beaten and stabbed in that same parking lot. The fight was a spillover from campus race riots, which were a spillover from the city's larger riots the year before.[1]

The team was made up of a bunch of guys who had only their impressive size, speed, and strength in common. They would all hang out in the middle of the school's quad and talk during lunch. It was one of the most diverse crowds at the school: a Salvadoran quarterback, a Tongan center, a Mexican lineman, a black running back, Armenian receivers, and a defense that looked like a meeting of the junior UN, complete with an outside linebacker from Syria, an inside linebacker from Colombia and a strong safety who was Jewish but told everyone he was half black. Racial jokes were never-ending among this group, but these guys would have died for each other, as would any member of their all-white conservative coaching staff. Years later I ran into our backup offensive lineman working the graveyard shift at a gas station on Laurel Canyon. He said one of our other teammates walked up one night holding a gun to rob the place, but when he recognized him from the team, he said sorry and walked away.

One day at practice, Coach Cranston, a 290-pound grizzled white man like the type I associated with old movie actors and cops, gathered all the linemen together to address the constant name-calling on the field and in the locker room.

"I don't care what fucking names you sons-a-bitches have for each other," he said, "and I agree that some of them are pretty damn clever, but if I ever hear the word *nigger* on this field you will limp off of it and never come back! I have busted far too many of my knuckles on white-racist-sons-a-bitches' faces and have gotten too many stitches in return to let a bunch of zero-and-ten football players use that word!" It was the first time in my life I heard a white man speak out so blatantly about race, let alone against racism.

The only other group on campus as diverse as the football players were the graffiti writers. Even after I joined the team and made friends with the other players, I still hung out over by the soda ma-

chines under the close watch of campus security and "undercover" cops. My writer friends admired the fact that I was on the team, which they expressed through constant ridicule and cliché homophobic jokes about tight ends and wide receivers.

Today, as part of my research, I go out on police ride-alongs with guys who remind me of my old football teammates. Police forces, especially in places like LA, are far more diverse than they were when I was bombing in the 1990s. The white cop with his thick mustache and penchant for squeezing kids' fingers, and worse, is still around, to be sure, but guys like the ones I played football with are there now too. So are their girlfriends.

I sit right next to these people who wear guns and badges to work. Most of the cops I have met are also not much different from my friends who joined gangs. They surveil, they act vigilant, and they maintain control over space. They act violently, they abuse their power, but they also care deeply in some inarticulable way. They ignorantly and unquestioningly uphold vague codes of conduct, and they look to each other for a level of support they think others can't provide. They use the same slang and they make the same jokes. They watch the same sports and hope to someday drive the same makes of car. People generalize about cops just as much as they generalize about gangsters, but none of them are actual heroes or villains. At least not all the time. They are the same people, often from the same neighborhoods, some of whom went to the academy whereas others went to jail. The main difference between wearing handcuffs on your utility belt or on your wrists is mostly a matter of chance, and barely a matter of choice.

GETTING A RIDE

After our first win against Narbonne, I was back at Laura's house watching her watch infomercials and floss her teeth. She asked me if I wanted to take the car to go writing. In those days, getting rides to go bombing was a sort of sacrilege. It wasn't until a few years later, when middle-class and wealthy kids started bombing, that having

your own car and using it to go out became acceptable. Besides, I had never driven a car by myself, so I asked her to come with me, drop me off at a few spots, and wait for me. We got into the car and I directed her to my old neighborhood over the hill in Los Feliz. I told her I wanted to hit a spot on the 101 Freeway where it crosses under Vermont Avenue, where writing partners Poize and Panic, Gin and Duce, and Chico and Bruin had letters, Roc from BLA and POone had these cool little throw-ups, and K187 from KTL and Rage from TCF had hard-to-read tags that were captivating. I also wanted to pass by the house I had lived in for a short time with my father when I was a baby. I didn't tell her this part. I also didn't tell her it was because of him that I had cried so hard on the field earlier that night.

I held a can of spray paint in my lap and had two more cases sitting in the footwell of the backseat as we drove the eleven miles over the Cahuenga Pass to my spot. As we passed through the intersection near my old house, I told her to slow down because I had an idea. I wanted to hit the bottom of every electrical box in the city, starting with the one on the corner where Vermont Avenue, Hollywood Boulevard, and Prospect Avenue all came together in a large intersection just east of the Hollywood Walk of Fame. E-boxes, as writers refer to them, are five-foot-high by three-foot-wide by two-foot-deep utility boxes that hold all the electronic equipment to regulate traffic signals. They sit on concrete bases about twenty feet from the corner.

I asked her to pull up to the box with enough room for me to open my door without hitting the high curb. I opened the door and leaned out to write my name across the concrete base in black letters that flared downward. I soon realized that I could hit boxes all night virtually undetected and that these bases were landmarks. Buffing crews restored the boxes to their original shade of institutional gray, but the base was a different material and had to be sandblasted, which was far more difficult to do. That night, I hit every box on Hollywood going east to where the boulevard merges with Sunset, and then down Sunset to Silver Lake, south under the 101 Freeway to Temple Street, and on to Downtown where Temple terminates at the LA River.

I had attended school all day (really, I just occupied a classroom

with dozens of other students while our teachers tried in vain to teach or gave up and just asked, in defeated voices, that we please keep it down); I had played most of the fourth quarter of a football game; and I was now leaning in and out of a car until just after 4:00 a.m., when traffic became too dense to continue. I knew this repetition would get me the fame I was after and force people to associate my name with this one spot. Fifty tags on the same piece of infrastructure was worth a hundred tags scattered around on walls, bus-stop benches, and telephone poles. In just one night I became the king of something.

Laura didn't say more than a few words as we listened to K-EARTH for more than four hours straight. After 1:00 a.m., the station would stop playing commercials, pit two songs against each other, and ask listeners to call in to vote for which song should continue to defend its title as the best song of the night. "Suspicious Minds" by Elvis overtook "Unchained Melody" by the Righteous Brothers at about 2:00 a.m. I hummed along to both songs, but I still had "We Are the Champions" and "Somebody to Love" stuck in my head. I was too filled with adrenaline, excitement, and fear to cry again that night. By the tenth or eleventh tag, I forgot all about my father, and Freddie Mercury for that matter.

The route we took went through popular neighborhoods for writers, passing the Sanborn Yard on Sunset, cruising strips and drug markets on Hollywood, and busy bus lines through Downtown. I hit the oncoming traffic side of the e-box bases for bus riders, the street sides for people in cars, and the sidewalk side for people on foot. By the next weekend, word had spread through the writing community that I was on a bombing mission. Everyone knew where to look to see me up, and even if I had not yet hit a particular e-box, people started to associate the infrastructure with my name.

END OF THE SEASON

Our team played an away game at Verdugo Hills High School that next Friday, and the team bus didn't get back to the school, where

Laura was waiting to pick me up, until after 11:00 p.m., so my night of bombing was cut short. During the game I touched a live ball for the first time. I was on kick return and the ball landed right in my arms. I had at least five yards of room to run with it, but Coach Cranston drilled it into us all week at practice that if we got the ball we were to fall on it, or as he put it, "Let the guys with smart hands move the ball downfield. You gorillas are just there to throw your weight around and open holes to make the good-looking players look even better, and hopefully get laid."

That night I still managed to hit about a dozen electrical boxes on Ventura Boulevard between Lankershim and Coldwater before going back to the apartment to have some yogurt and fall asleep on the couch, where I always slept. I had some broken fingernails from getting them smashed between face masks and helmets during the game, and some abrasions on my knuckles from scraping them against the sidewalk when finishing the bottom of my letters. I also had residue on my forehead from the tape I wrapped my head with to prevent my helmet from flying off. Coach Cranston would always write "Hi Mom" or "Battery" on the white medical tape with a Sharpie before we left the locker room. I listened to "Battery" by Metallica before every game.

Football season was a productive time for me as a writer. I felt validated by the fact that I was doing well in school, since team members weren't allowed to play on Friday if they didn't maintain near perfect attendance and pass their classes, which for me was as easy as showing up. I also had Laura buying my paint and keeping it safe for me under her daughter's bed. But as soon as the season ended— late in the year, since we made it to the first round of the playoffs—I stopped attending classes. I also stopped going out bombing with Laura. I worried that another writer was going to spot me leaning out of her car. If word got out about how I was getting around, writers would talk crap. Going all city by car wasn't the same as going all city on foot or by skateboard. I was also getting bored. Between September and December, I had not seen my crewmates. Laura told me those *"pinche* Mexicans" would get me into trouble. They also stayed away

because they suspected I was getting rides and free paint, which annoyed them. I enjoyed going all city, and I enjoyed even more being known as the e-box king, but bombing with Laura was becoming far too routine. By January 17 I was back on the streets and on foot. I know the precise date because I had just gotten back to her place for the last time after a full night of bombing from Downtown to Cudahy when the apartment windows began to shake violently. For a split-second I thought the local guys from MS13 had seen me go inside and were trying to break in. It was the 6.7 magnitude Northridge earthquake. When it struck at 4:31 a.m., I was wide awake and eating a lemon yogurt with black paint still all over my fingers.

Laura was so mad at me for going out writing without her after that, she forbade her daughter to see me. My girlfriend showed up at my mother's apartment one day to drop off the pager that I had given her for Christmas. As she and her mother left, my now ex-girlfriend came up to me and said, "My mom won't let me see you anymore because this *bruja* she goes to told her you're gonna get AIDS like your father." Laura was the only person I had ever told how my father had died.

All my spots near Laura's apartment were crudely crossed out over the next few weeks. The person never left a name, just an unsteady slash through my tags. Writers hold their cans at a particular distance from the surface they are writing on, and they know how to control for the can's pressure and the flow of paint from the tip they are using. Our muscle memory does not betray us in this regard, even if we are in a hurry, if we mess up, or if we are simply not that good at writing or have no style. But we can always read can control, or a semblance of can control, in each other's tags. There was no doubt in my mind that Laura was using the paint I left under her daughter's bed to cross me out. So I focused on hitting huge freeway spots that nobody could ever touch, but everybody would see.

8 SMALL WORLD

THRIFTY HEISTS

Being writers did not make us immune to or keep us insulated from opportunities to do bad. Poor and broken communities offer young people countless pipelines into gangs, the drug trade, theft rings, and inevitably prison—just as communities of privilege provide ample pipelines to college. By 1995, a year after my last football season ended, each of the TUGK members was in a second crew, and each of these crews had a different ethos.[1] While members of KRS (Kings Rulin' Society), the crew I had gotten into a couple of years earlier, were focused on drawing and drinking (neither of which have ever interested me at all), members of STP (Setting the Pace), which became Tolse's main crew, were caught up in fighting and racking.

The racking scheme decimated the LA graffiti scene of the mid-1990s even more than gangbanging had. Someone had gotten their hands on the keys to the glass case at the local Thrifty drugstore, where they kept the higher-end cologne. Bottles of cologne that were popular at the time—CK One, Drakkar Noir, Grey Flannel, Polo—could be stolen and then sold for a few dollars per bottle at one of those wholesale-style shops that sell everything from mops to radios. In fact, the store owners and fences that lined downtown LA's Toy District specifically asked for razors and batteries too, which were also kept in locked cases behind glass. This market set off a stealing spree. The same dedication writers displayed in mapping the city looking for spots to hit or traveling to art supply and hardware stores to steal markers and paint was now being used to find drugstores with locked cases that they had the keys to.

Someone would steal the keys from one store and use them to open cases at every store in the region, since the locks were all the same. At first, writers would use the same tactic they used to rack paint: they would wear a large jacket and fill their pockets. But the operations grew in scale, so they started bringing duffle bags and backpacks, filling them as they emptied the display cases and grabbed watches too. Greed inspired boldness. When female writers joined the racking crews, they would ask to see jewelry in a nearby case while their male counterparts would clean up. Jewelry was harder to sell, and unless it was pure gold, which it never was at a Thrifty, it would bring in far less than a box of Gillettes, a pack of AA batteries, and a few bottles of spray cologne. Soon even deodorant was added to the list, meaning the stealing crews, which grew to a couple dozen writers that I knew of, had to make a stop in the personal care aisle after filling up on the harder-to-get merchandise.

Racking crews started getting fame for their efforts. STP members were known to travel all the way to Phoenix and San Francisco, a six-hour drive in each direction from LA, to load up from stores that had not yet been hit and whose loss-prevention staff were not yet on high alert. Members of other crews, such as ICR (Insane Criminal Rule), drove as far away as Salt Lake City and even hit up the greater Vegas area on their way home. It was the equivalent of going all city in the racking world. But unlike going all city, prolific racking came with an actual monetary payoff. I would remind my friends that no one ever retired from rackin' or slangin' and that eventually they'd get busted and go to jail. But getting locked up also provides clout. When you get put away, you obtain immediate folk-hero status, made visible with "Free so-and-so" tags written around the city.[2]

Inside, there is a thriving market for drugs, cigarettes, soap, and razors, just like on the outside. And like on the outside, getting involved in the racket is largely a social affair, putting people in touch with others who act as clients, providers, and pimps. The illicit trade runs parallel to the racial divisions and gang alliances in which individuals may act as prey, predators, and protectors. In fact, I saw friends who went into the prison system as rackers and taggers but

came out as full-fledged drug dealers affiliated with hardcore gangs, to whom they now owed a debt. Prison is not a place for rehabilitation; it is a training ground.

I hated my friends more for letting prison drama pull them in than for getting sucked into prison in the first place. I always found myself angrier at the people I loved than at the system that took them away from me. I could see my friends making bad decisions, but systems of oppression are insidious and, like the violence of my community, invisible until they erupt in a burst that has immediately life-altering consequences.

Tolse entered prison on one of his short stints as a writer-turned-racker and exited as a member of San Fer, with a large homemade tattoo to show for it. Even before he lost his life, I had lost my friend to the relative safety of gang membership in prison, which the lack of protection offered by the state made a necessity. While Tolse's crews and his gang are as much to blame for his death as the guy who pulled the trigger, so too is the entire penal system that uses inter-inmate hostilities to its advantage. The racial divides and violence, including sexual violence, that we rebuke on the outside are uncontested on the inside, and they are tolerated, if not outright perpetuated, by guards and other prison staff. Black, white, and Latino inmates enforce a racial segregation only seen in the most racist of outside communities during the most overtly racist of eras. These racial groups act as feeders to the gangs that protect them: the Black Guerilla Family, Nuestra Familia, Aryan Brotherhood, and *Sureños* that form the Mexican Mafia.

By some pretty reliable reports, rackers were pulling in tens of thousands of dollars every few months. Tolse bought an Astro van after only a few months in the game. Those of us who were too dedicated to bombing to get enticed had our own money schemes, which were lower reward but also lower risk. When we needed some cash, we would glue the corners of a razor blade onto our index fingers, walk into a Tower Records, and pretend to be flipping through the stacks. The back of each CD had a magnetized antitheft device glued to the cellophane wrapper. We would run our finger with the razor

around the sensor and let it fall off into the rack. When our stack of CDs was about six deep, we would pick them up and shove them down our pants, each pant leg held tight at the bottom with a few rubber bands. After filling our pants with one or two dozen CDs, we would head to one of the independent shops and sell them for two to four dollars each, depending on the popularity of the album.

None of the shop owners asked any questions about where we happened to get our hands on a bunch of new CDs with circular cuts on the back, but each store made particular requests for the top sellers: one store wanted a dozen KD Lang and Mariah Carey CDs; another one wanted Natalie Merchant's *Tigerlily* and Alanis Morissette's *Jagged Little Pill*—as many as we had to sell. Some stores, like the little "New and Used" CD shop on Ventura Boulevard in the Valley, requested Rancid, No Doubt, Cypress Hill, and Ol' Dirty Bastard CDs. The owner of one "Buy-Sell-Trade" shop who asked for Naughty by Nature's *Poverty's Paradise* once said, "I know you guys are fucking taggers, so you better not do that shit around here!" He would then hand us the money for the stolen CDs and walk out to the sidewalk to make sure we left without vandalizing anything.

White Zombie, Red Hot Chili Peppers, and Faith No More's new albums were a little harder to unload and only earned us two dollars each, but Smashing Pumpkins' double album, *Mellon Collie and the Infinite Sadness*, was the best score, since it was both easy to find and fetched up to three dollars more than the others. Making ninety dollars per day was easy if you didn't factor in the stress and time spent on the bus. The CD racket didn't get in the way of our writing careers either. In fact, we would hit up the Aaron Brothers or Michael's out in the suburbs on our way to a faraway Tower Records, catch tags in far-flung neighborhoods, and end the day at an In-N-Out Burger with a box of markers, a new sketchbook, and some spending money.

The cologne gig, however, took over some of my friends' lives. Tolse was on the road and outside of LA all the time. His goal was to make it into Canada for some big scores, but getting back over the border scared him. The Mexican border was another story. Tolse and his partners made connections in Tijuana, and getting the stolen

items south across the border was easy. They were still writers of course, so seeing STP and ICR tags in places like Des Moines and Dallas as well as Tijuana and Mexicali became common. It was also the year that the first graffiti website was launched, so writers with computers and internet connections could track their spree by going online and seeing where their tags were being photographed and uploaded by locals.[3]

They had cultivated an organized crime ring. Writers became territorial over particular Thrifties and even over whole regions of stores. Soon the heists became more brazen and started to look more like full-blown robberies than racking runs. People often cite drugs as the commodity that inspires criminals to expand their geographic reach and protectionist practices. In this case, it was toiletries.

BIRTHDAY

I stopped racking CDs by year's end, as stores hired more security for the holiday season. By then I had switched to car parts—windshield wipers and water pumps that I stole from small stores like Chief Auto Parts and returned for store credit at larger places like Target, where I would do my Christmas shopping for my little brother and sister. But right before my birthday in February, Tupac's *All Eyez on Me* and the Fugees' *The Score* had dropped, and record shops were offering top dollar: five dollars per CD. I "came out of retirement," as we joked on our way to the Blockbuster Music in Glendale. It was my birthday, and I had spent the previous night bombing, so I was tired, still paranoid after a night out, and feeling sentimental about turning nineteen: my last year as a teenager. I decided to stay outside as my crewmate went inside for the new releases and possibly a few KD Langs on the way out to cover gas money.

I was in the parking lot when two police cars pulled up simultaneously from opposite directions. I put my arms up. One officer put me in handcuffs as the others ran inside the store with their guns drawn. My friend was put into one car while I was put in the other, then we were driven to the station a few blocks away. Processing was quick,

as it was only about 9:30 in the morning. I was put into a two-person cell on a five-cell block that opened into a small, caged common area. My friend must have gone to another area because I didn't see him. My cellmate didn't say anything to me when I walked in with my bedroll. I just climbed on the top bunk, scared and tired. I fell asleep and woke up as a guard was placing food on the floor. The first thing I said to my cellmate was "Wanna trade your orange for my bologna sandwich?" He grabbed my sandwich as he nodded in agreement.

The light that hung right above my bed made a faint and constant buzzing sound. As soon as I noticed the buzzing, interrupted only by my bunkmate's unusually loud farts, I couldn't go back to sleep. What must have been four or five hours later, the cell door opened again, and a guard placed trays of food on the ground. And again I asked my cellmate for a trade: his apple for my Salisbury steak. He nodded, slid my tray over to his, scooted the wet meat onto his tray, and put his apple on mine before sliding it back over. That night, for what was presumably dinner, I ate two mealy Red Delicious apples, a serving of mashed potatoes, a side of cooked carrots, and a Styrofoam cup full of juice.

There was no "lights out" in this place—the lights were never turned off—but before "bedtime," we were let into the common area, populated by an old Armenian man in a wrinkled suit, a Latino guy in what looked like the previous night's club gear, a middle-aged white guy obviously detoxing from something strong, and two Mexican day laborers who felt compelled to tell me in Spanish that they didn't do anything. The guy from my cell was also Mexican, but a *Sureño*. He was more the former-high-school-baseball-player-turned-car-club-member than the gangbanger kind of *Sureño*, but either way, he probably didn't speak much Spanish, and he seemed annoyed by the guys pleading their legal case to me.

We all just paced around, mostly in silence. A few minutes later, a guard walked by and yelled into the cage as if he were already in the middle of an argument. "If you don't take a shower now you will have to in the morning! None of you are getting out of having to shower! Period!" I thought it was an odd exhortation, since no one

seemed to be passing up an opportunity to shower. Cops used to do this too: make odd pronouncements and demands unprovoked and out of context. Once, while a cop was searching me on the street, he stopped and got in my face to say, "I'm not taking off your fucking socks. You're doing that shit yourself," but then went back to patting me down and the subject of my socks never came up again.

The next morning, I woke up to food being placed on the floor again. Again, I asked for a trade: this time my cellmate's mostly green orange for my slab of processed Canadian bacon and cup of milk. "Why do you always want to trade me?" he asked. I told him I was a vegetarian.

"What the fuck is that?" he asked me.

"I don't eat meat."

"Why the milk too then? There's no fucking meat in milk."

"Well, I'm actually a vegan . . . I don't eat any animal products," I said. He asked me if I ate chicken, and I said no. He reached down and grabbed my bacon, but he didn't give me his orange. When the bologna sandwich arrived for lunch, he did the same, taking my food either out of anger that I didn't eat meat or simply because he knew I wasn't going to eat it anyway and he didn't need to offer a trade. I had shown my cards and lost. Thankfully, I was called into the detective's interview room before dinner.

When the detective questioned me about the commercial burglary charge I was facing, which sounded worse than I realized, he never brought up the fact that I had a razor blade in my pocket with missing corners that matched the pieces of blade glued to my friend's finger. In fact, the detective didn't seem interested in the case at all; he just made light fun of the fact that I had spent my birthday in jail. He even asked me if I knew what time of the day I was born. He got a kick out of the fact that I was born at the precise time I was being booked, and in the Scientology building in East Hollywood to boot. But I told him I wasn't a Scientologist. The big blue building on Sunset Boulevard reopened as L. Ron Hubbard's flagship church just months after my birth.

He then asked me to tell him that my friend had planned the bur-

glary. I lied and told him I didn't know the guy. He then asked me why I threatened the store manager and, pretending to read carefully from his pocket-size notebook, read, "I will kill you, you fucking fat bitch, if you call the police." I didn't know what he was talking about, but it sounded like one of those things police say during every interrogation to throw you off guard and get you to admit to what they know you've done. I told him I never even entered the store, which was true.

A few hours later I was walking down Colorado Boulevard with my shoelaces in my hand during an early Friday rush hour. They also gave me back my Mean Streak in a clear Ziploc bag with my wallet. It always surprised me how a marker was high-grade contraband to some cops, but others didn't even seem to care.

THE HAPPIEST PLACE ON EARTH

It wasn't the first time I had spent my birthday in a jail cell. A year earlier the TUGK guys took me to Disneyland. Beto's dad, Pops, drove us in his van forty-five miles east from our neighborhood in North Hollywood to Anaheim in Orange County. We spent some time walking down Disneyland's Main Street, USA, and then headed for It's a Small World at the far northeast side of the park. While on the ride, one of us, probably Arest, jumped off the boat and onto a platform to dance with some of the singing animatronic characters, which led to a day of mischief in the park. We each got our own car in Autopia, a line of seven of us in total, and then abandoned them in the middle of the course. On the Motor Boat Cruise, we all jumped off our individual boats and onto one very crowded boat and then returned to the dock to the amusement of hundreds of park guests waiting in line. At one point, an angry dad chased us when Tolse spit from the high-flying gondola ride, which, for good reason, was removed from operation a few years later.

But it was when we started to write on park infrastructure, using the paint markers we never left home without, that we attracted attention from the park's security. Vandalism would not be ignored the way childish mischief might. While waiting in line for Thunder

Mountain, Tolse started to write out a roll call on the guardrail of everyone in the crew who was there: Lyric, Bet, Other, Mage, Sinner, Play, Arest, Squek, and me, Cisco.

Two men in suits and wearing earpieces walked up to us in line and asked us to follow them. Once we were away from the line of park-goers, three of us were placed in handcuffs and led "backstage" to the Disneyland jail. An odd combination of fear and excitement overtook us as we watched Disney characters remove their oversize costume heads while we walked to the holding cell behind the cast members' dressing rooms.

The cell looked like any other I had been in before. It was a typical concrete room with walls painted light gray, with actual bars and a heavy bolted door. There was a security camera in the corner, which we knew was in use because when Beto took a picture of me sitting on the concrete bench, an officer came from around the corner and took his disposable camera.

Beto, Play, and I sat with one other park "guest" on the narrow bench. This other prisoner-guest had stolen one of those foot-long pencils with a tassel at the end from a gift shop. She was crying and kept yelling through the door that her Church of Latter-day Saints youth group, which had chartered a bus from Utah, was going to leave her behind. One by one, we were interviewed by a uniformed officer from the Anaheim Police Department on suspicion of vandalism. The only thing that gave away the fact that we were still inside the amusement park was the officer's badge, which included a tiny Mickey Mouse in a Keystone Cop–style uniform, extending his arm and brandishing his own even tinier police badge.

We were all released on our own recognizance and ordered to return for an arraignment at the Anaheim Court House. Perhaps it was the Mickey Mouse badges, or the fact that we had been arrested at Disneyland—more likely it was how we always dealt with police summonses—but we disregarded the tickets, keeping them as souvenirs in our wallets with the other jaywalking tickets and orders to appear. In our community, it was rare to willingly step into a courtroom.

A year later, I received a 6:00 a.m. call from Play's mother, who

told me the Anaheim Police had just torn through the apartment with an arrest warrant for her son. He was led away in handcuffs, real ones. Unlike Beto and me, who had both been arrested before, the Disneyland arrest was Play's first encounter with the police in which he was fingerprinted and photographed. He ended up serving several days in the Orange County Jail for failure to appear and one charge of misdemeanor vandalism, to which he pled "no contest." The conviction that resulted from Play's arrest at Disneyland started a life of almost constant probation, delinquent fines, and sporadic incarceration. In fact, I never knew Play to be free of warrants for his arrest after that, and he never returned to Disneyland.[4]

- - -

We had started TUGK as a bunch of kids who wanted to escape our broken home lives and the chaos of our street, perhaps ironically, by going out and writing our names on stuff and getting fame in the process. But the other ills associated with living in communities such as ours eventually robbed us of that naive prospect. Some of us were aging away from tagging and moving into lives of higher-level crime and sophisticated survival tactics. Our geographies were getting bigger as new undertakings pulled us off the block and into far-flung places to rack, distant hoods in which to kick it, and faraway jail cells to do time. Going all city was starting to mean different things for each of us as our worldviews grew along with our desires and egos. I, however, remained a tagger. Perhaps my naivete and romantic notion of notoriety saved me in the long run.

I'm not sure what became of my warrant from Anaheim, or if one was even issued, but I have been back to the "Happiest Place on Earth" many times since. While standing in line there, I think about how the entrance to It's a Small World sits just three hundred feet from the on-ramp to the Interstate 5 Freeway outside.

9 KIDS RULIN' SOCIETY

KIDS TO KINGS

I was under no illusions. KRS asked me to join their crew because, at least in part, they wanted Tolse. I had followed the writing career of Oak Dee from KRS for years. He had become my favorite Valley writer, so KRS was, by extension, my favorite crew. He used a thin tip to hit light poles, placing his *O* on the pole perfectly, not obscuring the letter by going too far to either side. He also hit landmarks on parking curbs, and he occasionally caught more sprawling "Oak Dee KRS" tags on the walls of freeway underpasses. One of the things that made him stand out was his two-part name, which he modeled after the first writers and break dancers, who traditionally added the first letter of their surnames to the end of their nicknames. His last name was Delgado.

Graffiti writers, like street skaters and members of other rowdy, creative, and transgressive subcultures, have underground heroes and follow the careers of those who, like ourselves, are otherwise unknown. Unlike pop stars and professional athletes, our folk heroes are other people's folk devils. Oak Dee was one of mine.[1]

Writers on the West Coast, like Oak Dee, and predominantly Latino crews, like KRS, were influenced by hip hop, but instead of black and Puerto Rican influences from the early 1980s in New York, it was "Hispanic hip hop" acts like Lighter Shade of Brown and Kid Frost from Southern California. When I got into KRS, Lighter Shade of Brown had just released their albums *Brown and Proud* and *Hip Hop Locos* at the same time that Kid Frost, whose video for "La Raza" featured graffiti writers in the act of painting, released *Hispanic Causing Panic*.

By the 1990s, graffiti crews, like these hip-hop acts, also adopted names that reflected their ethnic composition, including crews like Hispanic Pride Raza (HPR) and Mexicans Causing Panic (MCP), both of which were aligned with KRS. Crews like White Mother Fuckers (WMF) and The Black Underground (TBU) also formed but couldn't maintain active memberships.[2]

I met Oak Dee's cousin Knot, a fellow writer and KRS crew member, during summer school. Summer school was intended to be a place where all the kids who had messed up at their respective campuses in the district would come and try to pass a truncated and remedial version of biology, math, or English in the hope of graduating. Instead, it was a free-for-all for kids who had nowhere else to go for the summer months. The kids from every school who were failing their regular classes crammed together with whatever teacher was willing to sit in a sweltering classroom for four hours a day. In summer school, you got to meet people from across town—new relationships were formed, new beefs were started by members of different gangs, and, in the case of me and KRS, new alliances were created.

Most of the KRS members had attended San Fernando High School. San Fernando is a predominantly Latino, working-class city on the north side of the Valley. As an incorporated city, it has its own police department. Cities within the county of LA that have their own police forces or sheriff's departments—San Fernando, Burbank, Glendale, Torrance, Inglewood, Signal Hill, Pico Rivera, and many other municipalities across the greater LA region—also have the most brutal cops. Cops in LA can be brutal, but these smaller forces were often made up of officers who couldn't even toe the LAPD's mutable version of the thin blue line.

The City of San Fernando and the greater San Fernando Valley are namesakes of the Mission San Fernando Rey de España, founded in 1797. The mission also lends its name to the San Fer or SF gang, one of the region's oldest and most racially integrated gangs, representing San Fernando's transition from majority white to majority Mexican-American during the post–World War II decades. It is still common to see SF tattoos on the chests and necks of both Mexican

Mafia and Aryan Brotherhood members. Violence had gotten so bad in San Fernando by the 1990s that if you weren't from San Fernando, you usually didn't go to San Fernando. But since many of the KRS guys had brothers in San Fer or were affiliates themselves, I came in as an invited and therefore protected guest. The local cops had cultivated a rapport with San Fer over the years, with some members of the police force even sporting SF tattoos of their own.

When Knot found out I was one of his classmates, he came up to me and told me his cousin, Oak Dee, wanted to meet me. I got the feeling one must get when being asked to the prom, or maybe even when experiencing a first kiss. My knees got weak, my stomach dropped, and I felt lightheaded. That weekend, I took the bus up to Rally's Hamburgers, where KRS held most of its meetings going back to the mid-1980s. Several of my graffiti idols were there: Tagger, Chance, Chrome, Amuze, and of course Oak Dee. Although they were a localized SF crew, they sometimes made their way into parts of the Valley where I had lived. In Amuze's case, he was a bus writer whose tags were carried into every community. The only truly all-city member of KRS was Chalk, but she had gotten out of the crew a few months earlier.

Unlike the writers I knew personally and went to school with from Hollywood and North Hollywood, the members of KRS possessed a certain mystique for me. This aspect of fame, which comes from being elusive, meant a great deal to me, and it's why I always kept a low profile outside of my crew and my circle of close friends. I wanted my fame to be connected to what I did on the walls, not to how I presented myself socially. I didn't see the point in going to parties and meeting people, then bombing for an audience who already knew who I was and what I looked like. Besides affording me some of the mystique of the unknown, this social distance also kept me from making enemies over the years. The people most likely to hurt or kill you are the ones you have loved, have considered friends, or have done business with, whether legal or illegal. So I kept my distance from the scene at large, and this, perhaps counterintuitively, fed into my notoriety and helped me avoid the scene's infighting, drama, and beef.

At a KRS meeting, the members got together and voted me in. My name had preceded me, and Knot vouched for me personally. They knew I could get up and they knew they liked my work. The first and only thing they asked me after I was officially in the crew was "Where's your homeboy Tolse?"

After the freeway incident, when I was laid up for a few months with a bulbous plaster cast from my toes to the top of my hip, Tolse had become a diehard member of STP, even tattooing the crew's name on his legs, arms, chest, and back, just as Beto had tattooed TUGK across his stomach, just eight inches below the bottom of his pacemaker. I didn't see him often, but I kept KRS's hope and their interest in me alive by saying I would talk to Tolse about the crew when I saw him. At the next meeting, two other members of the nearly defunct TUGK crew—Lyric and Beto—got into KRS. KRS seemed to settle for three members of our fledgling crew and never again mentioned the possibility of bringing Tolse in.

KRS had given rise to STP in 1987, when a few members of KRS wanted to start another clique. From that day forward, there had been mutual low-level hostility between the crews. STP was more well-known and widespread, but KRS was a more tightknit group

of close friends. Because I was recruited from afar, I always felt like an outsider. But being able to represent and hit up the KRS initials meant a lot to me, not because it represented actual crewmates but because of what it represented in terms of the crew's lore, which was mostly thanks to Oak Dee.

A few months after I got in, I proposed that we battle STP. At the time of the proposition, most of the members of KRS were dormant as writers. KRS had become a de facto drinking, partying, and graffiti "art" crew consisting of a bunch of guys, some of whom were now entering their thirties, who had recently changed the crew's name from Kids Ruling Society to Kings Ruling Society to reflect the fact that they were getting older. It was a hard sell to get a bunch of overweight, out-of-work fathers, some of whom were also parolees or on probation, to agree to go bombing in the interest of winning a battle initiated by a teenager who had never even lived in San Fernando. But they agreed to a meeting with STP in a neutral location: the McDonald's on Nordoff and Van Nuys, right down the street from where I was living at the time.

BATTLE

Four of us from KRS came to the McDonald's to meet up with what we thought would be a few of the STP heads to set the boundaries and rules for the friendly battle. We had been waiting there for an hour or so when about twenty members of STP, packed into four cars, rode up, got out of their cars, and surrounded us where we were sitting. STP was quickly becoming a lightweight gang, and these types of displays and flexing became common for them.

Their crew head, Bruno, an all-city bomber and, judging by his appearance and mannerisms, a part-time gangbanger, did all the talking. We agreed that the battle would take place over the course of ten days, inclusive of two weekends, and cover most of the east San Fernando Valley, from Sepulveda Boulevard on the west to Vineland Boulevard on the east and from Devonshire Street and the 5 Freeway on the north to Ventura Boulevard on the south—an

area of forty-four square miles. An impartial crew would determine the winner based on whichever crew did the most damage during those ten days. There would be no prize or penalty; we would battle only for notoriety and bragging rights. I was battling because STP had stolen my friend.

At the end of the short meeting, as STP got back into their cars, I made eye contact with Tolse. He awkwardly walked up and said, "What's up?" Then he joked that we should go out bombing together to start the battle that following Friday. I took him seriously and agreed, even though it defeated the purpose of the battle, since we were the most active bombers in our respective crews.

Over the next several days, we stole paint all day to prepare for bombing all night. During the battle, there was no concern for spot selection or finding landmarks, and barely a concern for safety or style: the object was to be seen by the judges, fast. I had to convince the members of KRS who had retired from bombing—or had never been bombers to begin with—to go out all night in groups of two or three and write on walls with spray paint. To make things sound easier, I told them that all they had to write was "KRS," since the battle wasn't about individual names.

I joined a few of the members who were going out with Chrome in his two-door 1986 Chevy Regal. I was used to moving stealthily through the city, a backpack full of preshaken cans, ducking and dodging, hiding and climbing, hitting multiple spots per minute for hours at a time. But here I was in a car full of guys at 3:00 a.m., driving slowly down the street looking for easy-to-hit walls. We drove for about fifteen minutes before coming to a stop right in front of a large white wall, at which point the bespectacled and frequently drunk Klock, who considered himself an artist and a DJ but had never done much illegal graffiti, got out, pushed the seat forward, and let some *veterano* in the backseat, who may not even have had an actual graffiti name, out of the car. The *veterano* stood on the sidewalk, vigorously shook his spray paint, and slowly wrote a huge, wobbly *KRS* on the wall. Then he stood back to admire his work for a moment. When he got back in the car, he was breathing

deeply. Klock jumped in after him and Chrome drove away, hooting and hollering in triumph. Fifteen minutes later, we'd find our next spot and do the whole thing again. It was excruciatingly slow and unproductive. I just sat in the backseat in frustration over what inefficient vandals these guys were.

On another night of the battle, we sped down the street in a souped-up Nissan with an outrageously loud modified exhaust. Everyone in the car, including the driver, would jump out in full, flagrant view of passing traffic and practically knock each other over to scrawl KRS tags across walls at different angles. Then they'd jump back in the car and speed off, bumping music and making a scene. I realized these guys just didn't have the ability to bomb, let alone write. They lacked the cunning, the energy, the stealth, and the sheer skill. Their version of bombing made a mockery of the craft. I would have found it funny if I weren't so serious about beating STP.

Writing well with aerosol paint takes practice, and if any of the many necessary elements is not in perfect sync, the tag comes out wacked or you get caught in the act. You have to determine the perfect distance between yourself and the wall, often approaching its surface at a full sprint while looking out for oncoming traffic. You have to judge the pressure of the can you are holding, which is determined by the amount of paint you have left as well as the thickness of the tip you are using. You have to estimate the dimensions of your surface as well as its texture to account for possible snags in the stucco or grooves in the facade that will force you to adjust the distance between the tip of the can and the wall, mid-letter. You have to use your whole body to make your letters proportionate and stylistically coherent, your pointer finger maintaining the perfect pressure to avoid an inconsistent flow of paint, the arm opposite your writing hand extending out as counterbalance, your legs spread slightly more narrowly than shoulder width for stability, your knees bent just enough to allow you to move vertically through each letter, and your weight over the balls of your feet to allow you to move smoothly along the wall horizontally, all while relying on your hearing and peripheral vision as you watch out for

possible approaching gangsters, cops, or heroes who want to stop you, jail you, or kill you.

I encouraged my crewmates to continue bombing and spent much of the battle on my own, on foot and in silence. By the end of the first weekend, I was exhausted. I would sleep for an hour here and there during the day, but otherwise I had to spend the day amassing more supplies, planning routes, and executing those plans for hours every night. I would get off a bus somewhere in the battle zone and see STP tags everywhere. I had to match every one of those tags to make our presence known. I wrote indiscriminately on stores, the sides of banks, and even on the North Hollywood police station. These were spots I would never hit unless I was in a battle. My tags had to last just long enough to be seen by one of the judges, and being indiscriminate was necessary to win.

The battle brought Tolse and me back together. The fame he had gained as a writer, which started back when we were small-time bombers and TUGK members, earned him more friends, and I resented them for coming into his life. I was jealous and spiteful, but I was also protective. I couldn't stand to see anyone else in my life being lost to recklessness. STP thrived on drama and damaged the graffiti scene with their machismo. I watched as our mutual innocence disappeared from Tolse's face, which hardened as he started to play the role of tough guy. I knew Efren, whereas the members of his new crew knew only Tolse. I needed his friendship, whereas they just wanted his fame. We had stopped being writing partners and best friends, but less because we went in different directions than because he went in one direction and I refused to follow.

But once the battle started I could be with Tolse and at the same time prove that I was a better bomber than his new crewmates. More than midway through the battle period, we finally met up at my apartment. We waited until about midnight to leave. We moved down opposite sides of the same street, running to hit the next spot, and the next spot, and so on. We watched each other's progress as well as each other's back. It was the most fun I had had while out bombing in a long time, and it was nice to be out with Tolse again. I didn't care

about KRS or STP. I wanted TUGK back together again and out on the streets, and a battle was the only way to make it happen. Graffiti was the only thing in my life I had control over, and I was desperately trying to keep my crew together.

The apartment where I was living became home base for the KRS crew. Members who had watchful parents or disapproving spouses would stash their paint there. Crew members male and female would sleep on the floor while others made stacks of quesadillas in the kitchen. Our gas had been turned off weeks before, so I was happy that we had an electric range. Tolse also came by during the battle. The guys would joke and say, "Hide the maps! Hide the paint! The enemy is here!" as he walked in the door. But Tolse would just laugh. For such a competitive person, he rarely showed it when he was away from the wall—he'd just smile wryly.

We went out together again on the last night of the battle. The members of the impartial UTI (Under the Influence) and USC (Un-Stoppable Criminals) crews would judge the battle at another McDonald's, on Ventura Boulevard. When Tolse and I arrived, there were already more than fifty writers in the outside seating area, spilling over into the parking lot and onto the sidewalk—about fifteen members of KRS, twenty-five members of STP, and about ten UTI and USC judges, plus a few girlfriends, wives, friends, and stragglers who had gotten word that the meeting would take place.

One of the older and more composed members of UTI whom we called Smurf reassured the store manager that we would be respectful and even order some food if he promised not to call the police, which he agreed to. The meeting was brief anyway. Tolse and I walked into the center of the seating area together, which tempered any animosity that had grown between the crews in the last two weeks. Our respective crew heads and the judges gathered together in a semicircle as well. Chance, one of the heads of KRS, called the meeting to order. Every one of the judges called the battle a tie. Tolse left in a car with Bruno and other STP members, and I left by bus with some members of KRS. The battle had served its purpose, even if for just a short time.

GETTING BIG

The KRS crew gained a lot of fame from that battle. Though the judges, one of whom was Bruno's cousin, declared the battle a tie, opinion within the larger graffiti community favored KRS. For several years, KRS had been an SF crew (aside from Oak's forays into North Hollywood); now, it was mentioned in the same breath as several of the era's all-city crews. Our meetings at Rally's grew so large that we had to relocate to the football field at San Fernando High School. What had been a dozen-member crew when I got in was now forty members deep, and more important, most of us were actually doing graffiti.

While having more members was effective in getting the crew up, we weren't selective enough when it came to personality types. Part-time writers who were also full-time gangbangers were getting in and starting beef for the crew. In one case, a new member who was also from the Columbus Street gang caught a series of KRS tags on Van Nuys Boulevard, then used the same can and distinctive nozzle to cross out Blythe Street Locos, making it look like KRS was in cahoots with Columbus Street. Other new members risked everyone else's freedom when they jacked people while we were out mobbing, punched people in the face for mad-dogging us while we were on bombing missions, or brought drugs and weapons into our scene.

As STP had, KRS was getting too big for its own good. Part of this was the result of the battle, but some of it had to do with the increasing popularity of graffiti overall during that era. What had been a small and tightknit community of bombers until the early 1990s had become a far more diverse and diffuse community of writers who saw themselves as being in direct conflict with rival graffiti crews, gangs, police, vigilantes, and a morally panicked and outraged general public. Since the 1992 LA Riot, interracial tensions had risen, street violence had increased, political tribalism had intensified. And doing graffiti—an illicit street-based practice dependent on social apperception—became that much more fraught and, frankly, terrifying.

GUNS

I, too, got caught up in the violence of the era, and every incident involved a gun that almost literally fell into my hands. The first time, I was standing with Smoke and Beto in front of an apartment building in the Panorama City neighborhood, where my mom had just rented a unit with "No security deposit—No credit needed—First month free." A lowered Cutlass Supreme on rims, full of guys, whipped around the corner, and out of the rear window flew something the size and color of a football. About ten seconds later, a long line of police cars came rolling Code 3. When the street was clear, we walked to the patch of ivy along the sidewalk to see what had come out of the window and found a paper bag with a gun and a handful of loose bullets inside. It was an old .38 Smith & Wesson revolver that looked like the one my stepfather had shot himself with a few years earlier, only this one was in rough shape, with a bunch of deep scratches and dings and part of the grip broken off. The serial number that had been stamped on the frame inside the cylinder had been rubbed away.

Smoke put the bullets in his pocket and I put the gun in my waistband. We decided to go bowling at the place down the street where members of Blythe Street hung out and played video games in the small attached arcade. We thought having a gun on us was funny. We talked about how great it would be to stick the gun in the face of any Blythe Street pee-wees who decided to act hard with us. That never happened, and we spent the rest of the night playing Street Fighter, handing the gun back and forth to each other. We all wanted a turn feeling invincible. The General Motors assembly plant on Van Nuys Boulevard at Blythe Street in the heart of Los Angeles' San Fernando Valley had just closed down, and evictions along Blythe skyrocketed. The LAPD came in and put concrete barricades at the east end of the block to help slow the growing drug trade. Drivers looking to score had to enter and exit the hood at Van Nuys, across from the now gated and abandoned one-hundred-acre site. The year after the plant closure, the City Attorney issued a civil gang injunction against hundreds of defendants, making Blythe legally off-limits to all the young

guys who laid claim to the street. This pushed them north, out of the new "safe zone," and up Van Nuys Boulevard to our neighborhood. We were ready, gun in hand and our hearts in our throats.

When I got home that night, I put the gun in a kitchen drawer. I was going out writing for a few hours before the sun came up, and going out with anything illegal on you other than paint was not done in our circles, especially if you were a writer with serious all-city aspirations. You had to stay clean if you wanted to get up. The next day, I went to check on the gun and it was gone. My mom said she sold it for forty dollars and used the money to pay the electric bill. Our power was turned off anyway because she actually used the money to buy a pit bull puppy from one of the displaced members of Blythe. The guy had moved in a few weeks before and was selling the dogs from his first-floor balcony at the back of our building. The puppy was stolen off our balcony a week later, most likely by the guy who sold it.

We were left in the dark and had to run a one-hundred-foot extension cord to an outlet in the laundry room in order to watch TV, but I was relieved to be rid of the gun because it made my hands smell metallic—a smell I still associate with fear, arrogance, and recklessness.

The second time a gun landed in my hands was when a beef started between me and yet another crew that Tolse had gotten into: ICR. ICR, which had entered the theft ring with STP, was made up of older writers who also dabbled in higher-level and far more organized forms of crime. Something about their business acumen made them seem much more sinister and sophisticated than the people I had known up to then. They were a criminal syndicate whose members were also writers and artists.

One of my best friends, the sister of an STP crew member, had a boyfriend in ICR. One of this guy's friends from ICR called me one night and asked if I was hooking up with his crewmate's girlfriend. I told him I wasn't, and he ended the phone call with an approving "*Orale pues.*" Still, I was scared. Although I was friends with Tolse, he was a new recruit and held no sway over the other members' actions. As with STP, they were interested in Tolse's fame but not in what he had to say. I was also scared because ICR members were known for

brutality, exacerbated by impulsiveness. These convoluted and complex social networks provided so much opportunity for violence to spill over even if you tried hard to avoid it.

I had seen bullets fly, windows crash, and bones break, but the violence had never been aimed at me. But on this night, I sat on my living room floor sick with fear. At the time, we lived across the street from the new North Hollywood police station,[3] but some of the most violent neighborhoods in the city are the ones that have police stations in them. Cops pull in and out of gated parking lots at full speed and rarely waste time paying attention to what is happening in their own backyards.

I called a cousin for backup. Although his mother was the one who had spitefully thrown chicken in my mom's face when I was younger, he was the one member of the family who was never put out by our poverty, and he showed up about half an hour later. I thought he was just coming to pick me up and take me to his house, but instead he walked in holding a black plastic case that looked like it contained a drill. He tossed it to me and I opened it. Inside was a semiautomatic Luger pistol with an additional cartridge of hollow-point 9 mm bullets. We engaged in a few minutes of armchair legal discussion about the Second Amendment and my right to self-defense. We even halfheartedly joked about how the two of us constituted a "well regulated Militia." Before he left, he showed me how to load it, cock it, hold it, aim it, and if necessary shoot it.

Years earlier, I had been friends with a member of ICR. We would work out together sometimes, he would come by and play Nintendo with my little brother, and we caught a few tags together under a freeway overpass near my apartment. But when football season started up, I had less time for hanging out. I had practice, class, game nights, and then bombing trips with Laura. Midway through the season, when I was starting to become well known for my e-box bombing, he came by my mom's apartment and asked me to come outside with him. I handed Viviana the Jehovah's Witness my game controller and followed him out the door.

Even when he was friendly, he was intimidating—six-foot-four,

lanky, and muscular, with penetrating, bulging eyes and a short, military-style haircut. He was as racist as my stepfather, which was a by-product, he claimed, of spending so much time in prison. Also like my stepfather, he spoke with a Chicano lilt and dressed like a *cholo*. He was Aryan Brotherhood when locked up and a member of the mostly Chicano North Hollywood Boyz when on the outside and not catching tags with his graffiti-writing friends like me. His complexity and inconsistency was the norm. Still is.

When we got to the back of the apartment building to talk, he pushed me up against the wall and put a knife to my throat.

"Do you have a problem with me?"

Before I could catch my breath to answer, he continued, "I thought we were friends, but I see you getting up all over the place, but you never have time to kick it with me. Let me know right now that we are not homeboys so I can cut your fucking throat right here and right now."

"No, we are cool," I said, barely audibly, as if I were talking to a baby having a tantrum. "I am just busy with football. My coach won't let me be late to practice. And I have a ride to go bombing, but she won't let anyone else come. We are cool. You're my friend," I squeaked, my voice falsetto and cracking with fear.

I realized his pupils were huge and his mouth looked dry—he was hopped up on speed. All I could do was talk him down long enough to get away from the blade pressing into my skin. He put the knife away and hugged me, then walked back inside the apartment with me and challenged my brother and Viviana to a game of Super Mario Bros. as if nothing had happened.

I sat on the couch watching them play, trying not to shake and not daring to run. They rescued the princess from the dragon and beat the game that day. It took them twelve hours of nonstop playing and was thanks in part to the extra lives they got from repeatedly jumping on the Koopa Troopa on the steep steps at the end of world 3, level 1. I think that is also when and where Viviana scored her speed ball, since no one else in my life other than this guy from ICR ever used meth. Meth, we all thought, was just for white boys.

The night of the phone call, I stayed awake with the gun in my hands and waited for ICR to show up. That familiar metallic smell was back, and the oil from the beautifully cared-for gun was on my hands. At 2:00 a.m., two of my crewmates from KRS, Grams and Fury, showed up to help me out. They were two of the newest and craziest members of the crew. Fury was, like many of us in the graffiti community, a low-level criminal who grew up in a tough community surrounded by drug-addicted, gang-affiliated family members and with nonexistent fathers. He was raised mostly by his grandmother, which wasn't uncommon where we came from. Fury was the one with whom I would later get arrested for stealing CDs on my birthday.

Like many of us, though, Fury shied away from hardcore crime. But Grams grew up in a gated community in the West Valley, had "renounced" his father's wealth, as he put it, and decided to start living as a tagger, a dope dealer, and by all accounts a sexual predator who would sell drugs to girls then rape them while they were incapacitated. Most of his victims attended a private Catholic high school in the Sherman Oaks district of the Valley. Many of the newer members of the crew led crazy, violent, and predatory lifestyles, but Grams was in a class by himself, so I tried to avoid him.

When Fury brought him over, he had a sawed-off shotgun with a taped grip tucked into his waistband. We walked into the bedroom that no one used because it was still full of boxes of dirty clothes from when we moved in. My little sister was asleep on the living room floor in front of the TV that was never off, but we still spoke in whispers about the situation with ICR. Grams was holding the shotgun and mimicking an imaginary shoot-out when it went off. He shot a hole straight through the cheap apartment door, sending buckshot and splintered wood flying into the living room. The quick pop of the gun didn't even rattle my sister, but she was covered in splintered wood. Grams ran out the door, possibly thinking he had hit her with some of the shotgun shell pellets, and Fury threw the gun on the top shelf of the overfilled closet, as if no one would find it there, had it indeed just become a murder weapon. The lack of clear thinking and communication during events like this always amazed me.

Grams and Fury didn't come back, and that was the only trigger pulled that night. No one from ICR came to my house, so I gave the Luger back to my cousin the next day. My decision to hold the gun that night made me the least safe and most out of control I have ever been. I had carried a gun before, but this time I had convinced myself that I would actually use it. Premeditated self-defense as a justification for holding a gun is reckless and unrealistic.

The next day I was mad at myself for getting sucked up into the situation. I realized that problems over other people's gangs, girlfriends, and guns were distracting me from the one thing that had insulated me from the same sort of pervasive violence that had always surrounded me. I went bombing that night alone and unarmed, writing only my name. I was done with KRS. Grams's membership in the crew was the last straw. I decided to focus once again on the pursuit of all-city status. KRS had become another STP, and it was partially my fault.

Recently I was listening to a news story that involved a teenager who was arrested for carrying a gun. At first I thought the fact that he had a gun on him put him in a special category of criminal: someone who was begging for trouble and far from an innocent victim of a stop-and-frisk. Who would make such a reckless decision to carry a gun?

Then I thought about my former self and realized that I hadn't made a reckless decision to carry a gun; instead, equally recklessly but with less intent, I had made no decision at all once the gun landed in my hands. The same might have been true for the kid on the news. When you live in an environment where guns fly out of car windows and show up on door steps, settling simple beefs safely demands knowing how to abstain from violence, even when that violence is so routinely a ready option.

10 FREEDOM

A DIFFERENT VIEW

Only when I was homeless did I fully experience the city.

As a writer, I spent much of my time trying to move around undetected, but homeless people often don't have the luxury of not being seen. My brand of homelessness was and is common. Unlike those who sleep on the sidewalk and push their possessions around in shopping carts, most homeless people couch surf, maintain jobs, go to school, and look like everyone else. These people often move in and out of homelessness throughout their lives, and they do everything they can to avoid the sidewalks and shelters, where they feel even less safe and more vulnerable.[1]

Most of my homeless experiences were with my mom. We always lost our place to live when my stepfather would be sent back to jail, but he would leave us with something to drive, usually a small pickup truck with a camper shell over the bed, which he would buy, lease, or steal when he was out. That truck would become our home until we found an apartment to move into or until it was impounded or repossessed. Twice he bought a sports car when he was robbing banks. He parked them around the corner from wherever we lived and wouldn't let my mom touch them. She told him it was inconsiderate when he bought a two-seater Mazda RX-7, because my little brother and I had to sit in the storage compartments in the back.[2]

Living in a truck on the streets of LA involved a lot of driving and even more parking. When we wanted to go to sleep for the night, we would cruise around until we found a quiet side street where we could pull over and hopefully not be seen climbing into the back, under

the camper shell. But in the hours leading up to that time, we would find a place to sit and watch the world go by through the windshield. When you stay in one place like that for a long time, you get a sense of how people inhabit a city.

One night, as we sat parked near the air pump and pay phone at the edge of a brightly lit gas station, I watched a group of five guys walk from under the Alvarado Street underpass at the Hollywood Freeway, a strip of sidewalk that in recent years has become a densely populated homeless encampment now that Downtown has been gentrified. Without warning, four of the guys started to punch the fifth. He started to run. When he fell, they started to kick him and stomp on his head and chest. After more than a minute, they stopped and walked away. The guy who had just been beaten lay there with his arms spread out as if he had been crucified, one leg hanging off the curb and into the gutter.

My mother and I watched in silence. After a few minutes, an ambulance pulled up and stopped in front of the man, then drove off. Occupants of the few cars that passed didn't seem to notice the guy. Soon his four attackers came back. One of the guys knelt down and touched the man's neck, presumably feeling for a pulse. They didn't notice us sitting across the street in the little pickup truck, watching them. Each guy took a limb of the lifeless man's body, and together they carried him to a dumpster a few yards away, tossed him in, and left. As soon as the guys turned the corner at Temple Street, my mother started the truck, and we drove away. We went to sleep that night parked on a side street back over the hill in Burbank.

A few years later, when I was out writing and had just hit a spot on the freeway, I walked over to that same dumpster and almost instinctively looked inside. Before walking away, I caught a tag across the front of it. A chill ran through my body, and I got so scared I almost couldn't move. I went straight home to where I was living at the time. I couldn't fall asleep all night, wondering what it was like when his body was discovered in that bin—or maybe it was found later, in the trash truck, or when it got to the dump.

After that night, we tried to sleep inside as much as possible. We

frequented Denny's restaurants all over the city, but even Denny's got too rowdy after midnight. I think I saw more fistfights and more men beating on women inside Denny's than I saw on the streets. My mom refused to go downtown when we had nowhere else to go because that was where "homeless people" went. We did, however, start going to a 24-hour diner called the Original Pantry, located near Skid Row. The place was owned by the mayor of Los Angeles at the time. He also owned some of the most famous high-end restaurants in the millionaire communities of Malibu and Pacific Palisades. This is how my mom rationalized it: if a rich person owned it, it must not be so bad. We would sit there all night, sipping cheap coffee, eating overcooked scrambled eggs, and trying not to look desperate or tired.

SPECIAL CASES

My mother did not have the organizational skills or even the stability necessary to navigate state bureaucracy. She often failed to collect her welfare check because of her own negligence. She would fail to send in a signed form, forget to check in with her caseworker, or simply neglect to submit a change of address when we relocated. Each of these tasks relies on a kind of literacy and wherewithal that she did not possess. I watched this same inability to navigate welfare systems among many of my friends, their families, and my neighbors. We would blame "the system" for not helping us, but the system was an abstraction, a convoluted entity that could no more be blamed for withholding aid than it could be reasonably relied upon, and the people attempting to navigate it were often destitute, sick, angry, and lost.

Although my mom spent the welfare money on drugs, and would pay a cable TV bill before paying a gas bill, state aid also kept us alive as children. On the first of each month, my mom would start waiting for the mail carrier to deliver her check and food stamps, and by the third, when they still hadn't arrived and a "pay or quit" notice had been slipped under our door, she would go down to the welfare office in tears. There we would sit for hours in an always crowded waiting

room that looked, smelled, and even sounded like the waiting rooms we sat in when we visited my stepfather in jail—from the crying babies and yelling mothers to the armed guards and muffled public address system through which hostile caseworkers barked out their clients' names. State bureaucracy and despair revealed themselves in these spaces like nowhere else.

During the mid-1990s, the state was in the process of switching from the Aid for Families with Dependent Children (AFDC) system to a program called Temporary Assistance for Needy Families (TANF). In anticipation of this, my mother had to show proof of citizenship to remain on welfare. According to her, her caseworker, who "barely spoke a fucking word of English," told her she had to show a passport or birth certificate in order to sign up for the TANF program's mandatory job training and to be issued a check. My mother had come from Italy after World War II, and she arrived here, she said, "on an army plane with no fucking papers." I never got any more details than that. My grandmother remembers it as a navy ship. My grandfather had just won a Commander's Medal from King Umberto II of Italy, which is why he was able to bring his family to the US, or so they told me.

Because of either my mother's inability to produce proof of citizenship or her inability to interpret the new requirements, she was kicked off welfare. But there was a backstop that kept my little sister, my brother, and me fed. My mother could reapply every month for emergency aid. This meant she had to arrive at the welfare office without an appointment and get in line at 7:30 a.m., sign the sheet on the clipboard when the doors opened at 8:30 a.m., then wait for a caseworker to see her and determine if her need was great enough to warrant a distribution of funds.

After about six hours of waiting in the stifling, cacophonous room, an interview with a caseworker in a small cubicle would follow. The caseworker, whose English I always found to be very clear, would ask a series of questions from a printed sheet of paper and check boxes as my mother spoke. Because my mother had children, the aid was always granted. My mother would then have to go back to the waiting room for an additional two hours or so and wait for

her name to be called again. By 5:00 p.m., the clerk who sat behind a small barred window in the back of the room would slide her cash dispersal through the slot along with several color-coded booklets of food coupons in denominations of one dollar (brown), five dollars (purple), and ten dollars (green).

We would then deliver most of the food stamps to my step-grandmother's house, where my brother and sister would stay when we were homeless. The entire way there, my mother would be yelling about "foreigners" who took advantage of the system and got more money than her. Her anger would be directed at different groups at different times and usually corresponded to whatever ethnic group she had recently had contact with, or whatever ethnic group my step-father had told her from prison was "invading our country." Filipinos and Armenians became Russians and "Arabs" at some point. Mexicans and African Americans were often spared direct blame and her verbal wrath because it was with our Mexican and black neighbors that my mother conspired against landlords, found out about support through Legal Aid and Renter's Rights, and got rides to a church food pantry when our food stamps ran out or she had sold the last of them, two-to-one, for cash.

Soon after the 1994 Northridge earthquake—when our apartment looked like it had been turned upside down and our dog, Baby, ran

out the door during the shaking and never came back—our Mexican neighbor came through the backdoor telling my mother in hushed, rapid-fire Spanish that the guy from FEMA was on his way up the front stairs. *"¡Alguien del gobierno está aquí y dijo que van a pagar por cualquier electrodoméstico que se quebró en el temblor, y cualquier comida que se echó a perder!"* ("Someone from the government is here, and he said he will pay you for any appliance that broke in the earthquake and for any food that went bad, too!")

When my mom opened the front door, she was ready. She told the FEMA adjuster that our refrigerator and stove both fell over and didn't work anymore, and that the freezer was full of rotting steaks because the power had been off. Not long after—it may have been a matter of days—we received a $1,000 check from FEMA for the cost of the appliances and $200 to cover the food. The man holding the clipboard had never even stepped inside the apartment.

We didn't even know if the stove actually worked to begin with, since we had not turned on the gas since we moved into the apartment the previous year, but we really did have steaks in the refrigerator that went bad while our electricity was down. Everyone I knew on welfare had those steaks. In front of every check-cashing place on the first and fifteenth of the month, when state benefits were doled out, there would be a car with its trunk open and a sign advertising "Choice Beef 4 Less." The length of the line to cash checks was matched by the length of the line to buy the shrink-wrapped and discounted "filet mignon" kept in ice chests.

Ten months after the earthquake and long after we had spent the FEMA money, my mother cheered when Proposition 187—or what was being called the "Save Our State" ballot initiative—passed. Prop. 187 sought to deny undocumented immigrants access to social services such as welfare, emergency hospital care, and public schooling. I never knew my mother to connect the politics that she supported with the negative effects those politics had on us and the people who had our backs.

During our long, agonizing welfare office visits, I would walk the block around the prison-like Department of Public Social Services

building catching tags with a Mean Streak to pass the time. Tolse and I had become prolific bombers by this time, but we focused mostly on the Valley where we both lived. The first time I realized that the San Fernando Valley was considered a cultural and geographic subdivision of greater Los Angeles was when I saw a tag by a well-known all-city writer. In thick black marker across the front of a bus-stop bench on the corner of Lanark and Van Nuys Boulevard, "Fuck the Valley!" was written right next to his name, 125.

I suddenly felt like a special "type" of writer despite all my efforts. I was, at least in 125's eyes, a "Valley writer." I had become a graffiti writer and was thriving in the margins of society, but now I was being marginalized within my own community. Unlike my class status, racial status, and even my mother's citizenship status, my status as a graffiti writer was in my control and could be increased by, as we say, "putting in work," or so I had thought. But now I was being confronted with 125's written statement and the realization that I was different. It made me mad because it made me sad. It became clear to me that I would never be recognized as an all-city writer as long as I was associated with this other territory. This other identity. Writers like 125, Chaka, Sleez, Triax, Wisk, and Oiler would always be considered better than me because they were not "Valley bombers" but "all-city bombers." Tolse and I both, I realized, had asterisks next to our names.

As my mother and I pulled away from my step-grandmother's house later that day, after dropping off the food stamps, I asked her to get on the freeway and head south. She was complaining about the "special cases" who didn't deserve welfare, and I was consumed with how I could shake being considered a special case in the graffiti world. I knew I needed to spend less time sitting at all-night diners with my mom.

Being homeless and having an envelope full of money was the greatest freedom I would ever experience, and I had to make the most of it. On the way out of the Valley, my mom hit up her connection and I bought a few cans of spray paint at the Builders Emporium. I planned to spend the rest of the afternoon at the park with our new dog, then hit the streets after my mom fell asleep.

We had had that dog for about four months, and in that time, before we became homeless, he ate my pet bird, chewed up all our shoes, and bit my little brother badly enough that he needed stitches. But sleeping in the back of a truck with a dog was comforting. Although I woke up every morning next to puddles of piss and with mounds of crap deposited around me, I liked having his body heat and his protection. I would cuddle him every night, in part because I loved him but also to keep him from barking, which would alert people in their homes that someone was in the pickup truck parked on their street, which would lead to a call to the police. I dreaded the spotlight from the police car shining in from the rear window, the crackle of radios as the officers walked up to the truck, and the insincere and authoritative "ma'am" and "sir" that police used when speaking with people they didn't respect.

After leaving the Valley, we got off the 101 Freeway fourteen miles later and went into Echo Park. Echo Park was one of the deepest gang hoods in the city, but it was located right between our old neighborhoods of Los Feliz, Frogtown, Silverlake, and Downtown's 24-hour diners. We pulled up to the neighborhood's namesake park, and our dog jumped out of the truck and just ran away. He never stopped or looked back—he just ran. I stood there watching, thinking he would come back, but he never did. I didn't want to leave the park without him, so I walked my mom over to the paddle boats in the lake at the center of the park. I rented a boat for a few dollars an hour and peddled the small fiberglass craft around, watching and waiting for our dog to reappear. Every now and then I would yell his name into the air; we called him Piper, after the wrestler Rowdy Roddy Piper. My mom nodded off, and I ended up paddling in circles most of the day.

I had planned to go bombing from Echo Park to Downtown that night, but by the time the boathouse closed and we were back at the truck, my legs felt like rubber. I slept without my dog, but I lined up the four new cans of Krylon along the wall of the truck bed and put the envelope still full of cash from the welfare office, minus the price of the boat rental and what my mom spent on her "stuff," in my pock-

et. Before falling asleep, I plotted my bombing routes and how I would show 125 what was up. I had never been so mad at anyone in my life.

My mom called me "Old Faithful." She was right: I was always there for her and dependable, especially when she needed someone to call the electric company to ask for an extension or to answer the door when the landlord came knocking. I hated our living situation, but I was never mad at her or at anyone in particular. Being homeless provided a break from the constant drama of maintaining some semblance of normalcy, the constant struggle and never-ending burden of helping to keep us housed. Homelessness was a break from the nightmare of barely hanging on.

My mom was also the most fun to be around when we were homeless, and I knew that despite the continuous self-inflicted defeats, she was selfless. I never saw her buy herself an article of clothing or treat herself to a night out. Rather, her brand of selfishness, which was common in our circles, was a result of her own undiagnosed mental illness, depression, addiction, pain, and inability to cope with a society that revolved around payments, paperwork, and paternalism. I feared her sadness, her anger, and her desperation, and I would do anything to prevent her from crying—but I didn't resent her.

Nowadays, when I see a mother smoking with her kids in the car or nodding off at a bus stop with her hands on the push bar of a stroller, I feel the rage that I spared my own mom rise to the surface. I am sickened by the selfishness exhibited by mothers who remind me of my own. Drug-addicted mothers for whom claims about having "a disease" supposedly exempt them from feeding their children. It is a rage I rarely have the opportunity to extend to fathers because their selfishness manifests as absence. Deadbeat and addicted fathers have the privilege of anonymity.

TACHO'S SRO

After weeks on the streets, we usually found a place to rent or someone willing to put us up. More than once that person was Tacho, a guy my mom had met through one of her connections.[3] I never knew

his real name. He was a Chicano in his late sixties, and he still wore his black hair slicked back, kept his baggy pants pulled up high on his stomach, and even sported a slim gold chain hooked to his belt loop like a zoot-suiter from back in the day. He lived in an SRO (single room occupancy) building on the edge of Downtown in the Pico Union/Westlake district. Aside from long prison stints, he had lived in the area his entire life, since "back when white people actually lived here," as he liked to say. The area was now a confluence of several gang territories, but because he was *veterano*, everyone gave him a pass. It didn't matter where you were from if you had lasted that long.

I first met him when my mother buzzed his room from the front of the 1930s-era tenement he had lived in for several years. He came to the door, squared up to me, and gave me the *cholo* handshake of respect. After leading us through a haze of cigarette smoke in the vestibule and down a narrow hallway covered in mildewed carpeting, he opened his door and offered us a seat on his perfectly made bed, which took up almost all the floor space in his immaculate room.

Like my stepfather, who also spent most of his life locked up, Tacho had recreated his prison cell on the outside. He kept cups of instant soup in neat rows above his microwave, his clothes folded with military precision on a shelf in his tiny closet, and a small box under his bed full of his personal effects, including a small collection of doo-wop and lowrider oldies on 45s and some pictures of his homeboys, posed shirtless, pants pulled up high, and sporting prison tattoos. But unlike my stepfather, he was gentle and spoke with an almost affected politeness. He was also socially awkward. Having spent so much time in prison, he had an old-timey way about him, which made him seem out of touch and out of sync with everyone and everything around him. He put on "I'm Your Puppet" by James and Bobby Purify and started to dance in the small floor space at the foot of the bed, knuckles pressed together, elbows out, feet shuffling as he swayed back and forth with his eyes closed.

He made a place for me to sleep on the floor, between his bed and the makeshift kitchenette, and started to pull back the bedcovers with bizarre, grand, chivalrous gestures. When my mother came out of the

bathroom, he was dusting the bed with talcum powder. She started screaming at him that he was a creep. For him, it was probably just a nice touch to make the bed more comfortable, but she told me, "Get your shit," because we were leaving. Tacho started to apologize and call her his "queen," whom he would never disrespect. I believed him and felt bad for him, but like my mom I thought the whole chivalrous act was pretty over the top.

We ended up staying because he started to cry. It was more of a pitiful moan, but my mom responded to it. She hugged him, sat him on the edge of the bed, and gave him a soothing sounding lecture about how she would never touch his "disgusting, decrepit-ass body" or let him put his "shriveled-up dick" anywhere near her. She whispered this to him as if I couldn't hear her from five feet away on the floor. That night, she slept in a fetal position on the edge of his bed, facing me, while he slept motionless on his back, fully clothed, arms folded over his chest, and without a hair out of place, like Dracula. He was up and making instant coffee by 6:00 a.m., playing "In the Still of the Night" by the Five Satins on his record player. My mom stormed out of the room and I followed her, and we drove a few blocks to the Original Pantry for breakfast.

We didn't stay with Tacho again for a couple weeks, but then we became desperate. The second time we showed up, he cracked open the front door of the building after she buzzed his room, and he told her he wasn't going to let us in. She grabbed him by the shirt, pulled him through the doorway, and swung him around behind her, where he fell and cut his head wide open. Seeing the thick blood pour from his head and pool on the concrete put my mother into immediate crisis-and-care mode. She helped him up and walked him into his unit, where she cleaned the wound with hydrogen peroxide, held him in her arms, and calmly berated him for "threatening to put us out on the street." She looked at me and gave me a sort of guilty "Oh, well" look. I wanted her to be nice to him. He was the nicest and most normal adult to enter my life since I could remember.

Earlier in the night, we had driven into Hollywood via the Cahuenga Pass, where I saw written in bold, legible letters, "Cisco, where are you? 818-846-3919. Lyric." I had been on the streets for so long that my crewmates had lost track of me, but they knew I was out there catching tags and that I would see their message. We got off the freeway at Hollywood Boulevard, and I called the number from a pay phone while my mother got gas. The number was for a pager, but I didn't have a return number to enter—the little slot where the pay phone's number should have been was melted off. At the beep I entered 8845, 8845, 8845, over and over again. The numbers correspond to "T-U-G-K" on the key pad, and I hoped the numeric message would let Lyric know I was alive and had seen his spot. What people may refer to as "aimless scribbling" on freeway walls meant everything to me. That cryptic writing was how I communicated with my friends and kept tabs on my rivals.

After Tacho's head wound had been cleaned and bandaged up, he put Pete Wingfield's "Eighteen with a Bullet" on the turntable, setting it to automatic repeat. The music helped my mother and me sleep through the noise of fighting inside the building and the sound of arguing and sporadic gunshots outside. Every time the song ended, I would hear the tone arm of the phonograph retract and land again on the edge of the record, followed by a few seconds of crackling and

static, and then the deep "doo, doo, doo, doo" followed by Wingfield's falsetto. I lay there listening on the clean but still cockroach-infested floor, thinking about my crewmates and that 125 tag, and I silently cried myself to sleep.

11 ALL CITY

RECONNAISSANCE AND REVOLUTION

In my quest to go all city, spot selection took up most of my day. Knowing that weekend crowds would gather in Hollywood or that suburban commuters would make their way en masse to Venice Beach, I pored over maps looking for all routes to and from such places, then noted the freeway on-ramps, interchanges, passes through the canyons, and off-ramps to nighttime destinations. I would follow popular routes, catching tags that I knew would be seen.

When I identified a whole area that was ripe for hitting, I would visit the neighborhood by day to scout out entry points onto the freeways, billboard access ladders, and hiding places between bus routes and side streets. I also looked for potential hazards such as 24-hour doughnut shops, newspaper stands, gas stations, local bars that would attract an all-night clientele, and evidence of a gang hood that would be risky by nightfall. In industrial districts, I had to be aware of the graveyard shifts at bakeries, shipping facilities, tow yards, and warehouses.

When I had found access via an alley, through thick brush, or along a culvert to a high-profile wall or a rooftop abutting a freeway, I would return home to assemble my paint and get a couple hours of sleep. Writers often talk about the time spent between selecting a spot and returning to hit that spot as the most nerve-wracking part of bombing. But you could keep your nerves in check by spending that time obsessing over the right backpack for scaling a roof; selecting the proper clothing (dark and neither too loose nor too tight); coordinating the right colors of paint for the fill-in, inner border, drop

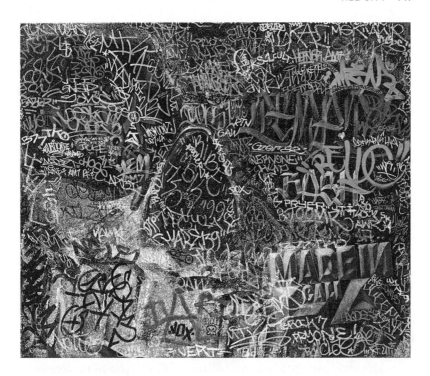

shadow, and outline; and finding the right tips (fat caps for outlines and fan tips for fill-ins). These seemingly mundane tasks are part of the ritual.

Sometimes I had to prep a spot before hitting it: removing old tires, shoving one dumpster from in front of another, pushing shopping carts out of the way, dragging homeless people's tents away from a wall. Sometimes after hitting a spot I would maintain the area to ensure visibility: pulling ivy down if it crept up the wall, ripping a "for lease" or "grand opening" banner from in front of my name. When the weeds grew high in front of a huge spot I had on Venice Boulevard, I borrowed a manual lawn mower from a house nearby, jumped the fence of the empty lot, and cut the weeds down. Once I even cut down a city tree with a hand saw after hitting a rooftop when I realized the tree's canopy obscured the last two letters of my name. I became crazed in pursuit of infamy.

Returning to a spot I had selected in daylight always necessitated

a moment of reorientation once I was out on the streets at night. Neighborhoods have dual lives. By day, an area might be bustling with homeless men on traffic islands seeking spare change, men in pickup trucks stacked high with old mattresses and scrap metal, *señoras* with plastic bags rushing to and from bus stops, and women selling *pupusas* from food carts. But by night, the same area would be transformed, occupied by only the most desperate, vulnerable, marginalized, derelict, and—in my case—determined members of society.

Once there, I would get out of view by scaling a fence or climbing a ladder. I never escaped injury accessing these spots: I've cut knees rolling over razor wire, skinned elbows dropping between cinderblock walls, and gouged the top of my head climbing under overhanging corrugated roofing. The pain, like my nerves, subsided as soon as I started to outline the first letter of my name.

I became known for revolutionizing the sheer scale and legibility of letters painted illegally on freeways and other difficult-to-access spots. Until I started painting my seven-by-seven-foot topless letters filled in with silver and outlined with ultra-flat black, graffiti on freeways had been more intricate, colorful, far smaller, and all too illegible. LA's early-form letters and bombing styles had been imported from New York City in the 1980s. In New York, transit riders on platforms came face to face with throw-ups and pieces painted on subway cars. But making a visual impact on the freeways of LA required going big, especially since my letters had to attract attention away from billboards, illuminated signs, and other graffiti that had been daringly and expertly painted along overpasses and on the backs of freeway signs. I deviated from the East Coast wildstyle and emulated the gangster *placas* that were impossible to miss. Gang graffiti—*Varrio Big Hazard* spelled out along Interstate 10's giant sound walls through the east side of LA and the beautifully crafted Rockwood Locos and White Fence 13 letters on the Interstate 5 and 101 Freeway overpasses—had a greater influence on my style than any "graffiti art" that looked so pretty to most people but meant so little to me. I was attracted to graffiti that was meant to mark territory, not beautify walls.

To craft such large letters, I used my body as a drafting compass.

With my left foot as the pivot point and my hips as the hinge, my right arm and spray can became a pencil with which I could outline symmetrical and evenly placed letters across brick, concrete, and metal surfaces. Outlining such large letters without a guide or grid required a fluid motion that could not be interrupted, so I had to wait for a lull in the traffic before I started each letter. Filling in these huge letters was labor intensive and time consuming. With each passing car or helicopter, as well as the occasional suspicious noise, I would crouch or lie down at the foot of the wall and hope to remain unseen. Sometimes I would leave the area temporarily if I thought I had been spotted from afar. Paranoia was as detrimental as actual threats were to my completing letters quickly.

Painting these burners took from twenty minutes to four hours, depending on how many times I had to stop and wait or run and hide. I was sure that the glowing silver paint applied to otherwise drab or already graffitied surfaces would attract attention, as would the overspray from my can that billowed and sparkled under street lamps. Re-outlining my bold letters in black made them much more legible and visible, finally rendering the scale of my work apparent. The excitement I felt when completing the final letter tempered my paranoia, just as accessing the space calmed my fear. Before I left, covered in paint, sometimes blood, and always sweat, I would stand in silence, marveling at the wall that I had just transformed.

GONE BY DAYBREAK

CBS (Can't Be Stopped or City Bomb Squad) was one of the first crews in LA. It formed during the mid-1980s as Los Angeles started to develop its own graffiti community and aesthetic. CBS had always been a "graffiti art" crew, but one of its founders and its longtime head, Skate One, also pushed bombing with legible letters as integral to the crew's identity. While most members of the crew painted colorful and complex burners in yards around the city, Skate would catch bold, simple, monochromatic tags and throw-ups, the bread and butter of graffiti. His all-city status gave the crew its street cred.

But the crew's aggressive enthusiasm for going all city ended when Skate was killed in 1993. He was out painting boxcars parked near the Budweiser Beer plant in the Valley when he was struck by a fast-moving train. All three hundred or so pounds of his body were spread around the yard upon impact. Friends of his went to the yard the next day and collected scraps of his skull with strands of his long blond hair still attached. Crew members still keep those bits of his remains in their wallets and hung in frames at their houses. The crew was small at the time, made up of about fifteen members, but they all chipped in money to have a memorial plaque permanently installed, with the city's permission, at Wattles Park in Hollywood, where CBS holds many of its meetings and hosts raucous barbecues.[1]

Skate was a Hollywood street kid who took outcasts under his wing. Just before the Hollywood district was redeveloped during the 1990s, Hollywood Boulevard and the neighborhoods around it, including the Melrose District, were populated with a community of traumatized, scared, violent, and deviant young people on the run from other places. White male runaways, black transgender prostitutes, female drug addicts from wealthy families, mixed-race queer kids from conservative enclaves, nonracist skinheads, and Latino gangbangers were all welcomed into Skate's squat.[2] Those who were more inclined to fight got down with LADS (Los Angeles Death Squad), whereas those more interested in writing on walls got down with CBS. The result was one of the most diverse crews and collections of people you could ever find. On any given night Skate and his crewmates walked the block past members of the 18th Street gang, racist skinheads, members of the Jewish Defense League, Scientology's private security guards, and even contingents of the vigilant and red beret–wearing Guardian Angels with no consequence.

In part because of Skate's death, and in part due to the mass evictions and clean sweeps that overtook Hollywood by the late 1990s, the street kid community scattered and CBS almost broke up. Tolse and I were actively bombing through all of this. We learned about Skate's death during the final judging of the KRS/STP battle. CBS was

a legendary crew that had lost its larger-than-life leader. So when I met Exist, one of the members of CBS, in 1996, and he asked me to come to a meeting that night, I was as excited to tell Tolse as I was to meet some of the CBS members who were like mythic figures to me.

At the meeting, I introduced myself by saying, "I am here to get up and go all city. I don't have a job, I don't go to school, I don't have a girlfriend, and I don't do drugs or drink. All I do is bomb." The group of fifteen members laughed and I was voted in on the spot, with the crew's new head, Anger, welcoming me in with a bear hug. That night I went bombing and almost got killed by a falling five-gallon bucket of black paint.

I was in CBS to play the same role I had played for KRS—a younger influence who could bring new energy to a crew whose members mostly partied and painted on canvas. So going out that first night was part of proving myself. Mear, my new writing partner, was legend for his innovative letter styles and longevity. He had painted the alleys of Melrose just about every weekend since he was a kid. He was a legend to me because he had designed the Guns N' Roses logo that adorned the band's kick drum the night they performed at Freddie Mercury's memorial concert. Going out with him meant I had arrived. I was now an all-city writer as much for being associated with him as for the years of work I had put in. It was 1996 and I was in CBS, suiting up for another bombing mission.

Mear drove to a place he had staked out earlier, and when we pulled up to an abandoned warehouse, I knew the spot would last for some time. Even from the freeway, I could see that a cast-iron pipe ran up the side of the structure to the third floor. From there, I could drop back down to the second-floor platform and paint my name across the abutting wall. You could see the gleaming white wall from a quarter mile down the freeway in each direction. And although we would be exposed once we got up there, it would be difficult to see our bodies in motion, covered in dark clothing against a night sky. But our combined twelve letters—his name, my name, plus the crew's initials, each of which would be eight feet wide by twelve feet high—were going to be larger than us, filled in with bright colors and

outlined in black with a paint roller on an extension pole. Something like that would be hard to miss.

Earlier that day, we had gone out to collect our supplies: a pack of quarter-inch-nap rollers, two heavy-duty roller frames, two eight-foot extension poles, and a five-gallon bucket of black paint. The black paint took some time, since that color is not commonly kept on the shelf. Mear ordered up five gallons of some off color like mauve or burnt sienna from the employee in the paint department, then turned it down once it was finished mixing. Later that day I went in alone to buy it from the cast-offs shelf at a discounted price. I asked one of the clerks to just add more pigment to the mix to turn it black. Rather than paying over a hundred dollars for the paint, we got it for fifty dollars and two trips to the store.

When we went to hit the spot with our new supplies, we realized getting everything up on the roof was going to be harder than just scaling a pipe with a backpack full of spray cans. Mear decided to climb to the second floor, where there was a recess in the face of the building. There, he could lie down, hook his feet on some piping, and reach his arms toward the ground to grab the bottom of the extension pole. I screwed on the roller frame and hooked it around the handle of the paint bucket.

I guided the pole as he pulled it up, hand over hand, straight above my head. We didn't realize that five gallons of paint were going to be so heavy. The fifty-pound bucket was a foot from his hands when the roller frame bent open and the bucket came falling straight down toward my face, fifteen feet below. Delivering over four hundred pounds of force by the time it reached me, it skinned the side of my face and shoulder and smashed onto the ground, slopping a giant circle of black paint onto the sidewalk and up onto my clothes.

Mear scurried down, and we started to scoop the paint back into the bucket with pieces of cardboard that were lying next to a trash bin. We salvaged about two gallons of the paint before making our way onto the roof and completing our slightly smaller letters. After all that effort, our spot lasted for only a little over a week before getting painted over.

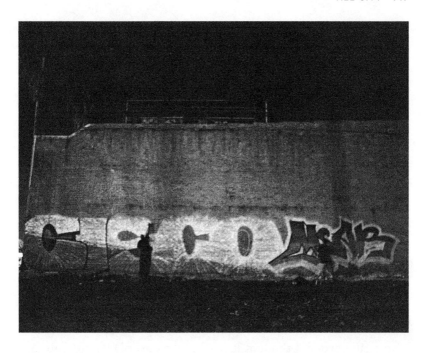

I had letters that lasted over a decade, and letters I spent all night crafting that were gone by daybreak, painted over by guys doing court-ordered community service. I had letters that wrapped around the exterior fence of a building on the 110 freeway in downtown LA for years before they were painted over, and at other times a small tag I was sure would become a landmark would be gone before I had the chance to return in daylight to take a picture. In the days before cellphone cameras, returning to the scene of the crime to snap a picture of your night's efforts was part of the ritual of going all city. There were periods in my life when the city became so large that I didn't have time to sleep.

I tried to amass a photo collection of my work, but so much dispossession from repeated evictions made that impossible. All the photos I now have of my work are ones that people have given me in recent years or that turned up online when the internet became the go-to database for global graffiti. In fact, one of the first public domains in the early years of the World Wide Web was a graffiti

website, artcrimes.com, which is still in operation today under the domain name graffiti.org. It was launched in 1994, the same year Microsoft, Yahoo, whitehouse.gov, Encyclopedia Britannica, Amnesty International, and sex.com made their web appearances. Graffiti is everywhere, especially if you are paying attention.

SEALED IN

In an effort to go all city, writers spend great amounts of energy to hit even the simplest spot—so much preparation, calculation, and cunning goes into every bombing mission and night out. While the visual payoff may be fleeting, the memories of being out on the street are enduring. Many of my memories of bombing are actually memories of experiencing an alternative city and the interactions that take place within it.

I witnessed one especially memorable interaction one night in North Hollywood. I thought it would take me only twenty minutes to put up giant letters at a particular spot that would surely never be buffed. While I was working on my letters, I heard the loud yelp of a siren. The blinking lights of a patrol car reflected off the wall I was painting and illuminated the empty lot around me. Instead of running, I fell to the ground amid the broken glass and huge cockroaches. By the time the police officer stepped out of his car, I realized he hadn't spotted me; he was making a traffic stop just a few feet away. Except for the occasional passing car, it was silent there at that hour, and I could hear every word being spoken, including the chatter on his radio, and the hum of his idling car engine.

I stayed motionless, splayed on the ground. If the officer had turned around, he would have seen me lying there in my hooded sweatshirt and baggy Dickies, holding a can of silver spray paint in my right hand. Assuming a traffic stop would take just a few minutes, I remained motionless. The officer immediately asked the driver to step out of the car and patted him down, telling the driver to keep his hands above his head, fingers interlaced. Then he used a blinding flashlight to look at the driver's face and eyes. He asked the driver

to sit on his hands, "palms facing down on the curb." He then asked a one-word question: "¿*Cerveza?*" The man replied in broken English that he had not been drinking. The cop laughed and walked over to the car's passenger-side door.

He methodically and aggressively searched every inch of the car. As he flung the man's personal items around, they thumped against the car's interior. After a few minutes, or what I am sure felt like hours for the man sitting on his hands, the officer walked back and asked the guy in a mockingly false Mexican accent sprinkled with *cholo* slang, "Is this a g-ride, *ese*? Where you from, *vato*?" The man just sat there with his head down, paint splattered on his clothes presumably from a long day of work.

Another squad car pulled up and the officers chatted for several minutes. The officer in the passenger seat of the car yelled, "*¡Adiós amigo!*" to the guy on the curb as his partner pulled away. Knowing commonly used police codes, as all writers do, I had known since the fifth minute of the stop that the man was not going to jail. The officer had issued a Code 4—no assistance needed. The stop had become a sadistic interaction for the cop's entertainment. It was something I saw frequently, but never before had I seen it from a few feet away while lying in the dirt. Cops were often sadistic when they weren't being outright brutal, but they usually said "ma'am" and "sir" while doing so. Cops were also sometimes nice, which would throw me off guard.

The officer finally got back in his patrol car and sped away. Seemingly exasperated and morally defeated, the man sat there with his head hung low between his knees for several more seconds. Then he stood up, got in his car, and drove off, a little tasseled white-and-blue Salvadoran flag waving from his rearview mirror. I went back to painting.

I have witnessed far worse things take place during traffic stops and police interactions, but something about the insidious torment of people in the communities I have lived in are the most memorable. Such treatment is more demoralizing and pervasive than headline-grabbing acts of objective brutality or sheer violence.

But it is not only police officers who inflict low-level torment on

people with less power. Landlords' and apartment managers' every-day acts of intimidation and threats of expulsion keep people in a constant state of anxiety long before the devastating evictions are actually initiated. I have seen frustrated landlords stop washing machines and dryers in midcycle, have cars towed without cause, lock pool areas on a Saturday morning, and refuse to fix security-gate callboxes, all as petty forms of extralegal retribution against their tenants.

At school, it is not the expulsions but the constant detentions and questioning by assistant principals and campus police about suspected gang membership and affiliations that make graduating much more difficult. On the streets, it is the constant name-calling by police, most of which is racialized, and the forceful frisks that create paranoia and anger. Store employees' vigilant stares and bus drivers' refusal to stop make people in the places where I come from feel more disrespected and dehumanized than instances of structural violence or sanctioned oppression do. It is the subtle, daily viciousness that often gets overlooked by outsiders but is impossible for insiders to ever forget. It is the willfully ignored or blithely unacknowledged shades of violence that hurt so bad and are so impossible to convey to those who have never endured such disrespect. It's social death by a thousand cuts.

I was right: the huge letters I painted on the wall that night never were painted over or removed. Rather, they were blocked by the area's first Starbucks, built in that empty lot where I had lain and watched the low-level torment of that man. To this day you can look between the buildings and just barely make out the overspray from the O in my name. Sometimes I drive by that Starbucks in the so-called NoHo Arts District and see cops sipping iced mochas and chatting with the neighborhood's new residents.

12 CAN'T BE STOPPED

CROSSING

Hitting freeway spots became increasingly stressful over the years. The sound of the whooshing cars at night is deafening, and getting onto and back off of a freeway leaves you vulnerable. It is impossible to casually walk up to a freeway shoulder and make it look as if you are just taking in the sights. Unlike street bombing, where you can look nonchalant between tags, on the freeway you are exposed and out of place whether you are in the act of painting or not. But hitting freeways is also crucial. Most people drive, and most people take the freeway, especially in a city like LA. A tag or throw-up on the freeway is sure to be seen by a captive and geographically diverse audience.

Before I was hit by the car in Pacoima, I approached running across the freeway to access the center divider in a calculated way. I would watch the traffic to get a sense of the flow, note the intervals of traffic clusters, and sometimes wait to see a passing highway patrol car so I knew another one would not be coming for a long time. Once I noted the rhythms of the freeway on a particular night, I would take off. Like a surfer breaking into a paddle to catch a wave after reading the ocean's swells, it was a frantic yet controlled pace toward a big payoff. Fear was canceled out by adrenaline.

But after getting hit, I was never able to find the rhythm again. I couldn't read the road as I had been able to before, and the car lights all formed long blurry trails of white and red. Even when I did find the rhythm of the road—cars arriving in clusters every twelve to fifteen seconds, with an occasional errant eighteen-wheeler arriving like a

rogue wave to crush the calm—my legs would go weak and I would have to sit down. I couldn't force myself to run.

Horrid, vivid images, bursts of light, and the sound of crunching bone and metal would fill my head. I wouldn't be able to lift my arms, let alone move my feet. I became overly analytical as I sat there. I tried to determine the traffic's rate of speed and how long it would take a speeding outlier traveling at a modest ninety miles per hour to close in on me as I moved across the first, second, third, and fourth lanes of traffic. Forty-eight feet of running, from inside shoulder to outside shoulder. I could run the forty-yard dash in about eleven seconds. I knew this. But being timed on the flat, grassy football field is different from running across a convex surface with its patina of motor oil, cracked concrete, and small pieces of debris punctuated by raised reflectors. How long would it take to get to the other side? Maybe five seconds to cross? In that amount of time, the speeding car could cover 660 feet of ground. Too much thinking was paralyzing.

Every time I attempted to cross the freeway, I was delayed by longer periods of such calculating and thoughtful waiting. As it took longer and longer to cross, I realized my days of running the lanes of traffic were over. But although I had lost the will to run, I had not

lost the will to paint. So I became more strategic in my spot selection. I would note high-profile walls as I drove the freeway by day, then return by night to scope out the front of the building whose back wall I would hit. Rather than approaching walls from the freeway side, I would access spots from the adjoining street or alley, sometimes climbing over barriers, running across storage areas, and even through abandoned buildings that stood between me and my destination. Bombing became more like breaking and entering, but even scaling a two-story building by shinnying up a drain pipe, climbing over a razor wire–topped fence, or kicking in a stairwell door to reach the roof of a building that had been gutted by fire felt far safer than playing Frogger on the freeway below.

THE RAID

I was happy not to have a personal archive of my work on New Year's Eve in 1996, when the Los Angeles Police Department raided the apartment I was living in with my mother and my two younger siblings. I wasn't at home when the two detectives and several officers entered the apartment and tore through my family's belongings as my eight-year-old sister and fifteen-year-old brother were forced to lie face down on the living room floor. My mother was taken outside in handcuffs to the steps leading up to our unit to be questioned by, as she described him, "some old man who looked like a math teacher or a pervert." He was a member of the Community Tagger Task Force who had accompanied the police on the raid. The Community Tagger Task Force is a "volunteer surveillance group" that documents graffiti and feeds law enforcement information about active taggers.[1] They photograph graffiti and even follow writers around to help prepare criminal cases. My habits during the months leading up to my eventual arrest must not have been what they were expecting from an all-city bomber.

I had started community college at Los Angeles Valley College earlier that year, and I had made new friends there. I was taking a full load of classes, had become president of the honor society, had joined

the swim team, had become a member of student government, and was earning $5.75 per hour to extract semen from the tops of male sea urchins with a Pasteur pipette. My friends at school talked incessantly about essays, exams, Communism, and financial aid. My closest friend, Maria, was a radical and self-described Maoist who sought out political rallies and was always ready to record police abuses on the small digital camera she kept in her backpack. She had heard that I was a graffiti writer, and at some point she said to me, "Grow up, you stupid idiot."

The search warrant listed a whole array of writing implements and weapons that the police expected to find. What they came away with was a shoebox full of my sister's colored pencils and washable markers and a school folder that had my brother's name written across the front in handwriting. This was enough to get a felony arrest warrant in which I was named as "the leader of two graffiti gangs" and was responsible for issuing "violent assaults and hits on rival taggers."

They raided my house on December 31 because after that day, aggregating misdemeanor vandalism charges to form a felony charge would no longer be permissible. As evidence, they had assembled a collection of pictures of my tags on freeway underpasses and light poles in the area. But none of my big freeway work from across LA was represented in the affidavit. They also didn't yet have me in custody. The morning of the raid, I was sleeping at a friend's house—or more precisely, in her closet, where she would let me crash. My brother dialed her number at 6:00 a.m. and told me what had just happened. A wave of panic hit me. I put on my shoes and jumped out of the window. I was now officially on the run.

Writers sometimes go to extreme lengths to conceal their activities while out writing, convinced they are being watched. They hang tarps along fences to obscure walls they are painting, wear all black so as not to be seen from passing cars, hide under air-conditioning units on rooftops to avoid being spotted by a passing helicopter, and even don disguises to get to and from spots. We are all perpetually paranoid, like Ray Liotta's character at the end of *Goodfellas*. A few times, I went out writing while wearing a cowboy hat like the ones

worn by the gay *rancheros* who danced at the night clubs on Santa Monica Boulevard, because I thought that would make me invisible to cops and gangsters. I have to assume it worked.

I didn't know where I was going after I hit the ground outside my friend's window, but I started running. I pictured squad cars pulling up on me as I walked down the sidewalk, so I ran from backyard to backyard, scaling walls and outrunning dogs. I was in the residential area just north of Universal Studios, and I could see the still-empty escalators in the hill above that led down to the *Back to the Future* ride. I was trying to get to the Cahuenga Pass, where I would catch a bus into Hollywood. At one point I hopped over a high wall that spanned the length of an entire city block. It was Bob Hope's backyard. In retrospect, trespassing onto other people's property was probably attracting more attention than simply walking down the street would have, but going to great lengths to accomplish very little was part of my DNA. I raced through life like a marble in a Rube Goldberg machine.

ON THE RUN

Most of the members of CBS lived in the Melrose District just south of Hollywood. Since the Community Tagger Task Force was housed in the Van Nuys police station, I felt like getting out of the Valley was like fleeing the country. I would be safe on the other side of the hill. I made it to my crewmate Axis's house hours later, drenched with sweat, legs aching from running, forearms thrashed from scaling walls.

Axis spent the entire day meticulously painting a canvas as I sat on his sofa listening for sounds of police cars pulling up and sur-rounding his apartment. He was a painter and a true graffiti "artist," so he couldn't relate to the situation. He asked me to leave that night, before his girlfriend got home. She was a veterinary tech who didn't like taggers. I felt more secure at night as I walked the two and a half miles to another crewmate's apartment off the corner of Wilshire and Fairfax, where the Notorious B.I.G., a CBS affiliate and well-known

rapper, would be shot and killed just two months later. When I got to Natoe's apartment, he was playing a video game and smoking weed out of a bong. He said I could stay with him for a day or two.

This was an era of moral panics that fueled the surveillance and rampant criminalization of graffiti writers.[2] Just that year, a prolific LA-based bomber, twenty-year-old Timothy Jody Badalucco, or "Gkae," was extradited from Seattle to face vandalism charges back in LA. He eventually served almost a year in jail and was ordered to pay a $100,000 fine. They were coming after me like they went after him. Unlike Gkae, I had no money for bail and certainly no one to pay for counsel. But, like him, I already had an arrest record for misdemeanor vandalism.

Years earlier I had jumped out of a friend's car to catch a tag on a corrugated metal fence in the middle of the night. Right then, an LAPD tow truck pulled up on us and turned on its flashing lights, so I ran. I assumed my friend in the car drove away or just told them he didn't know me. I walked home, several miles away. The next day my friend, who wasn't even a writer, told me I had left my wallet in the car when I jumped out, and that the police found it and took it. They let him go after giving him a lecture about "hanging out with taggers." About a month later, I got a notice in the mail saying an arrest warrant had been issued in my name, and the letter included a copy of my California ID.

A police report was included in the envelope. It was then I found out I had written on the LAPD impounded vehicle yard on Lankershim. It was the first time I ever turned myself in. I showed up for an arraignment, pled "no contest" to misdemeanor vandalism, and left with a thousand-dollar fine, which I never paid, and twenty days of community service, which I never performed. I knew this prior and my failure to complete the sentence would come back to haunt me if they ever caught me on these new and far more serious charges. I finally passed out on the couch as Natoe took bong hits and yelled at his avatar on the screen.

One night at Natoe's turned into a week. I didn't know him that well, but we were in the same crew and I had seen his tags over the

years. Like me, he had a straightforward lettering style and used black paint and a fat cap—nozzles that emit a high volume of paint so that the letters appear bold and thick. He spent most of his time playing video games, drinking beer, smoking weed, and eating pizza. I wasn't used to such a sedentary and depressing lifestyle. I kept thinking to myself that I might as well be in jail if I am going to be locked up in his apartment. But I was afraid to leave, and I appreciated his hospitality.

I soon had to adapt to his schedule. I stayed up all night and slept until noon. He wouldn't let me stay in the apartment alone for some reason, so when he did leave, I had to accompany him as he ate breakfast at fast-food places and drove across town to commit small acts of commercial burglary, which was his only source of income. He would steal Thomas Guides, small airbrush compressors, and cordless telephones. These were items that would sell fast.

In addition to Natoe, there was a whole network of new crew-mates and acquaintances who were willing to take me in, but I had been avoiding them. The CBS crew consisted of members who came from more privileged backgrounds than the guys from TUGK. They evidently had more time and resources to be able to drink more, do more drugs, and fight more often. As soon as I joined the crew, I felt I was being exposed to situations I had always avoided. Aside from going out bombing, intentionally taking chances was anathema to me. I had experienced too much trauma at the hands of others in my life who were engaged in this kind of behavior to willfully seek out such a lifestyle as an adult. I was, and I still am, repulsed by drama, dissolution, and depravity—repulsed to the point that avoidance of confrontation has become almost an obsession.

"WHEN YOU RUIN MY WALLS, WE RUIN YOUR LIFE!"

After staying on the run for a while, I turned myself in for the second time in my life. I figured that the stress from hiding out had to be worse than the stress from a court trial and possible imprisonment. I got $1,200 by selling my first car, a 1967 Ford Mustang with a bent frame and ripped ragtop, which I had bought for $500 off a guy I

had played football with in high school.[3] I then walked into a law office and asked to sit down with an attorney. While I was telling the attorney about my predicament in order to elicit some free advice, and before he even mentioned retention, he picked up the phone on his desk and called the Van Nuys Police Department with the touch of a single button.

Before I even realized what he was doing, he interrupted me to ask the person on the other end of the phone to talk to "the detective who unlawfully raided my client's home." I almost fell off the large leather chair when he continued, "Jerry, this is Dan at Bruce Margolin. I have Stefano here [mispronouncing my name by putting the emphasis on the *a* instead of the *e*]. What nonsense do you have on him and when would you like us to come on in?" I watched as he jotted down my tag name on a pad of paper, right next to "felony," "gangbanger," and "NO evidence!" and then turned the pad around for me to read the word written in all caps, "BULLSHIT!" He then hung up the phone and said, "This is how this is going to proceed." I still hadn't asked about his price, but evidently I had just hired him.

A week later I was standing in front of the Van Nuys court house at 8:30 a.m., waiting to meet him and go inside for what he had described as a "simple arraignment." "We will ask for all charges to be dropped," he had said in his office. "Bam, you're in, and bam, you're out. You won't say a fucking word to anybody."

A few minutes before 9:00 a.m., a person I had never seen before walked up to me and introduced himself as my attorney "from Bruce's office." I was wearing a bulky suit I had borrowed from a friend's father, and I was shaking so hard I could barely walk. When we entered the courtroom, Jerry Beck, the antigraffiti detective who had led the raid on my mother's apartment, was standing there in a suit as ill-fitting as mine. My attorney for the day, whose suit seemed to be made of hemp, or maybe burlap, wore a ponytail and smelled of marijuana. He positioned my body next to his and began speaking to the judge, asking for a dismissal on grounds that I didn't understand. The judge, without looking up, denied his motion, asked for my plea, and set my bail at $10,000. The entire exchange lasted about ninety seconds.

Before the judge was even done speaking, Detective Beck walked from the gallery and through the low swinging doors, pulled my hands behind me, and started to cuff my wrists together. The judge stood up and said, "Don't pull that crap in my court room! This young man will walk out of here on his own, and you can do whatever you want in the hallway, but not in here, Jerry!" I was amazed at how all these people who had entered my life in the past few days were on a first-name basis with each other.

Once in the hallway, Detective Beck went ahead and cuffed me as my attorney asked me if I had a thousand dollars for the bond. The detective then walked me over to the police station on the other side of the courthouse campus. Once we were inside the heavy door that leads to the processing room and holding cell, I was met by other detectives and officers coming out of their offices and cubicles. They all wanted to meet me, and they gathered around me as though I were a celebrity. Detective Beck uncuffed me, and the first plainclothes officer shook my hand and told me he had always wanted to meet me. Another cop said, "We finally got you, Cisco! I hope you learn your lesson and you start going to art school."

One of the officers who was wearing a suit asked me for my "autograph." He turned out to be Detective Craig Rhudy, head of the Valley Tagger Task Force. Like members of the infamous Vandals Squad in New York City, Rhudy was as knowledgeable about graffiti writers as graffiti writers were about each other, and he was serious about wanting my autograph. He kept "autographs" of writers he had captured and pictures of his favorite graffiti in six-inch binders on his desk. He seemed to have the same sick obsession with graffiti that I saw in my friends and even in myself.[4]

There I was, more scared than I had ever been in my life, not saying a word but also not trying to look hard. I just kept a neutral look on my face and only answered direct questions that I was compelled to answer. I was surrounded by feigned adoration and some seemingly sincere fawning. One of the few Latino officers offered to process me, and the others all walked back to their desks as the commotion of my presence died down.

As he stood behind me, crushing my fingers onto the ink pad and then onto the fingerprint card, he started whispering in my ear with hot coffee breath.

"You fucking *puto*! You run around with Hispanic Pride Raza and KRS. Yeah, I know who you are. Tell your homies this is real 'Brown Pride' and when you ruin my walls, we ruin your life, you fuckin' *maricón*!" Gang members had said virtually the same thing to me many times before.

I remained in lockup until the next day when, I suppose, my attorney made arrangements with a bail bondsman. The jailer called my name and told me to get my "shit." He walked me to the side door, buzzed it open, and out I walked. I headed straight over the hill and back to my attorney's office in West Hollywood. When I arrived, I finally met Bruce, the law office's namesake, who told me to "hang tight," and if I found out anything, to let him know. I had no idea what he meant by this. He then said to me, "The best person you have in your corner during a criminal case is yourself, so if you discover anything about your charges that you can prove is not true, give me a call."

I finally found out how much I was being charged for the legal representation as I stood back in front of the same judge during my pretrial hearing about a month later. On that day, the local councilperson had shown up to court to watch my hearing, and before walking into the courtroom I heard him in the hallway telling a reporter that tagging was a prelude to drive-by shootings and other gang violence and that I was "one of the worst of the worst." When I heard him say that, I knew I was headed to prison. But right before pleading again, the prosecutor from the district attorney's office offered to lower the charge from a felony to multiple misdemeanor counts of vandalism, and rather than three years of prison time, they would recommend three years of summary probation, ninety-nine days of community service, and a $25,000 fine in exchange for a guilty plea.

I was indignant. Not only did they have no evidence aside from the shoebox full of colored pencils and a school folder with my brother's name written across it, but most of the pictures they had in ev-

idence were of other people's tags. While I knew I was guilty, I knew they couldn't prove I was guilty. But I was terrified of going to prison. I wondered if I would be considered white in prison and have to hang out with a bunch of tweekers and racists, or if I would be considered a *Sureño* and have to kick it with gangsters whom I hated just as much. Either way, I was not prepared to have to fight for causes and identities that I had run away from my whole life.

As I stood up to face the judge, ready to plead "not guilty" for a second time and fight the case believing I would win, my attorney whispered into my ear, "There is no way you are going to trial because you will lose. People hate that tagging shit. But I will go to the next phase for another $5,000 if you want. You already owe me $5,000 though, so it's up to you, Cisco," emphasizing my nickname with an exaggerated sing-song.

So, like 98 percent of defendants facing criminal prosecution in the US, many of whom may actually be innocent of the charges but do not have the luxury of private counsel, I pled "no contest" and was sentenced. I walked out of the courtroom that day and took the bus straight to school. I had an 11:00 a.m. class.

EPILOGUE

GETTING OUT

I am still a graffiti writer. While I do not actively go out on all-night bombing missions, I still see the city as a writer does. I almost instinctively look for ways to access rooftops, calculate how many cans of paint it would take to cover a particular wall, and crane my neck in traffic to look at the backs of freeway signs. I survey fire hydrants, I scan the circumference of light poles, and I always keep one eye on passing cop cars. And although I am no longer active, I maintain my bomber status. Once a writer has been recognized as all city, they maintain that distinction well into retirement.[1]

I started college as an active bomber. I would attend classes by day and spend my nights on the streets as I had for the decade before I went to school. The only time I felt completely safe was when I was on a rooftop or in a classroom, so I was able to excel in both spaces.

I enrolled in college precisely for that feeling of safety and reprieve. The constant chaos of living in violent situations had the effect of driving me away from its sources. I was repulsed by the brutality of gang members and police officers, disgusted by my mother's drug use, and intolerant of the daily social drama that kept people like my brothers, sister, and friends trapped in despair, anger, and fear. I had an aversion to conflict and disorder. Just as writing graffiti provided me with structure and attainable goals, so eventually did being a student.

The first time I considered college to be anything more than a place rich kids go to become doctors, lawyers, and football players, I was walking down the street, past a community college campus, with

my writing partner and best friend Lyric. He wanted to cut through the quad to get to the train tracks on Woodman Street at Oxnard Avenue, where we would spend the day painting. When we emerged from between the classroom bungalows abutting the parking lot on Burbank Boulevard, what I saw was unreal. People were sitting in groups on a great lawn; some were playing Frisbee, and some were even sleeping, undisturbed, with books laid open over their eyes. The scene reminded me of one of those brightly colored Jehovah's Witness brochures, depicting children of every race sharing tropical fruits in a meadow where lions and deer frolic together. Lyric and I felt out of place but not unwelcome.

I felt safe on that campus, with the ball of the Uni paint marker rattling in my pocket and a can of spray paint tucked in the waistband of my cut-off Dickies pants. It would be a few years before I would return to this place and enroll as a student, but knowing it was there shifted my orientation. I started looking at college campuses differently. While walking through LA on bombing missions, I made a point of walking onto college campuses: USC, UCLA, Cal State LA and Northridge, and any one of the ten community colleges that dotted the city. That the world inside the campus perimeter differed so greatly from the world outside its walls attuned me to the fact that different spaces, no matter how proximate, can contain vastly different realities and opportunities.

I had never regularly attended school as a kid. I would go for a day here and there, but then my mother's overdoses, our evictions, or simply failure to wake up in the morning kept me home as I pleased. I also made my way in and out of a dozen elementary schools, two junior highs, and two high schools, all within a ten-mile radius of North Hollywood and the countless apartment buildings, houses, hotels, and vehicles I called home.

I left high school when I was seventeen. I was accused of writing on the bathroom wall, which I really had not done, and the assistant principal told me not to come back until my parents scheduled a conference with him. My stepfather was doing another stint in prison and my mother was perpetually passed out on the couch from taking

too many pills. The conference was an insurmountable burden, so I never went back. Not being in school freed me up to add to my all-city status, which included regularly hitting every light pole, curb, and electrical box within a mile radius of my high school, just to let everyone on the inside know I was still there.

I started community college soon after I got into CBS, and at the very campus I had walked across with Lyric. Being over eighteen, I didn't need a GED, equivalency certificate, or diploma to enroll—just a legal birth certificate. It took about a week to obtain the birth certificate from the county recorder's office. That was when I discovered that the last name I had been using since childhood was not my legal last name. I had used my stepfather's last name, "Sykes," for almost two decades. He always told me that he had adopted me, but clearly he never had. The certificate read "Bloch," a name I still sometimes misspell as "Block."

KEEPING IT REAL

After two years at Los Angeles Valley College, I transferred to the University of California, Santa Cruz. Once again, I selected a school to attend based on its campus. Berkeley and UCLA had also offered me admission with full financial rides, but Santa Cruz had trees. The forested campus environment was vastly different from the concrete jungle where I had lived my whole life, and I knew this would help me focus on my studies, because I would not be tempted to go bombing. I wanted to be tucked away on the "city on the hill" overlooking the Pacific Ocean, free from the people I loved and feared, and free as well from what I thought was my former self.

I put my identity as a writer on hold, and I embraced being a student and all I thought that entailed: a new backpack, a laptop computer, and for the first time in my life, a bed of my own in a room of my own. I moved into the dorms at the Stevenson Residential College and got to work cultivating my new identity.

I worked hard, and I struggled. I was too appreciative of the opportunity to leave, but I often had no idea what was going on. The

people I was around had experiences and vocabularies that I found alien and, frankly, annoying. Part of my struggle was the result of my rage. My class and racial identity had never been put into such stark contrast with those of my neighbors and peers. On the night I got the call that Tolse had been killed, my dormmates had a floor-wide pillow fight while trippin' on mushrooms, followed the next day by a mandatory meeting about "safe spaces." My best friend was dead.

During my junior year, I took a literature course focused on spatial theory with Professor Christopher Connery. We were reading David Harvey's *Spaces of Hope*, Henri Lefebvre's *The Production of Space*, Franz Kafka's *The Castle*, and bell hooks's *Teaching to Transgress*. I sat through lectures as if I were listening to a foreign language. I didn't speak the jargon, and I had no training in how to read a difficult text. I did all the readings and attended all the lectures, but the content just hung in the air. I was not gleaning any meaning from the class or the material, but I went through the motions and played the part of a good student. I was passing in more than one sense of the word.

I had thought no one on campus knew about my former identity, but a classmate came up to me one day after lecture and said, "You must love this class. It's like these books are talking about graffiti writers. I keep looking over at you in class because sometimes it seems like they are talking about you personally."

Unbeknownst to me, my classmate was from LA and had followed my writing career—and he had just given me the lens through which to view the material.[2] I was now translating otherwise convoluted spatial concepts and impenetrable critical theories into something personal and accessible. Rather than deny my identity as a graffiti writer to become a student, I embraced who I was to actually learn and apply the material. I went to Professor Connery's office hours and told him about my past. I had never revealed my street identity to an outsider before, let alone a white man in a position of power.

He told me to write about my experiences using the concepts of the class and themes of the assigned readings. Most importantly, he told me to "keep it real"—an expression I thought my community had

invented and used only on the streets. He entered my final project, a cognitive map of the city from the perspective of a graffiti writer, into a student competition for the Humanities Undergraduate Research Award. I won the award, and I was now surrounded by adults who were not only not judging me but encouraging me and wanting to learn from me.

When I returned to LA after graduation, I had a literature degree with honors, an award-winning research project, the $1,500 prize in my pocket, and nowhere stable to live. I started bombing again, resurfacing as one of the uppest writers in the city. But I was now competing with graffiti writers who had far more resources. The talent pool was deeper than I had ever known, and the competition was fiercely professional. The charm of walking down the street writing on stuff was supplanted by a need to go bigger and better than any of the dozens of bombers now sponsored by spray-paint companies, with bail money and lawyers waiting in reserve in case they got busted.

From the time I left for college in 1998, including the year I studied abroad in Budapest, to the time I returned to the streets of LA in 2001, graffiti had become rebranded as "street art" and, at least for me, had lost some of its allure. I no longer turned to it to help me survive. Instead, my identity as a budding scholar became my refuge.

After a year of hitting freeways and further solidifying my identity as a bomber, which was now over a decade in the making, I applied and was accepted to UCLA's Department of Urban Planning to work on my master's degree with the preeminent spatial theorist Edward W. Soja. I emailed him from a pay-by-the-minute internet kiosk at a café called Espresso Mi Cultura in East Hollywood. He emailed back instantly, inviting me to campus to meet.

For the next several years, through earning my PhD in geography at the University of Minnesota and holding postdoctoral positions at Brown University, I was once again in safe spaces that afforded me the privilege of writing about my transgressive acts and personal experiences. With that writing and reflection came the rigorous study of the academic literature and the refinement of research methods needed to produce scholarship worthy of being read.

GOING BACK

While I was at Brown and beginning to conceptualize this book, ideas about race started to make perfect sense. There were distinct racial categories and immutable racial characteristics that students and faculty willfully subscribed to. One's racial identity was an immediate proxy for their vulnerability or privilege and consequently prevented others from understanding their experiences or perspectives. Race was something that governed everything on campus and beyond, from social interactions to the formation of political and economic institutions. Both implicitly and explicitly, race mattered above all else. It became the lens through which we were invited as college students and faculty to view and hopefully empathize with each other. But where I came from, racial identity does not make so much sense, though it has been no less pervasive in my life. From a micro perspective, which is the scale at which humans exist in the world on a daily basis, race is complex, counterintuitive, celebratory, painful, and often secondary to the many other ways we identify ourselves and navigate the world.

Before I arrived at Brown, a place awash in opportunity, advantage, privilege, and prestige, I had never been told by so many people how to think about the race of others. Members of subcultures who lived in the communities where I came from were reduced to their racial status and negatively defined against that which they lacked. Subcultures were described by many students and colleagues as inherently protective, familial, and a product of privation. Gangs, for example, were said to form in the absence of coherent families, and graffiti writers were simply reacting to a lack of arts education in the schools. It seemed so simple for these people.

The well-meaning defense of these vulnerable communities that takes place within settings such as the academy became a form of romanticization that robs groups of their agency, complexity, and inherently human messiness and contradictions. Through scholarly analysis, people like my friends and I became little more than racial-

ized avatars navigating a gutted urban ghetto seemingly devoid of day-to-day incongruities.

In this book, I have tried to avoid the binaries that couch similar narratives about identity and the urban environment, favoring instead what the cultural anthropologist Clifford Geertz called "thick descriptions" of everyday life. I have also steered clear of a top-down analysis of culture that aims to speak for how people actually live at the bottom. Rather, I tell stories about how my friends, my family, and I lived. I place the people and situations I write about within what Geertz calls "the frame of their own banalities." Recalling these banalities, these stories of everyday struggle and survival, is hopefully what can make these experiences more accessible to you: the reader, the student, the teacher, the scholar.

■ ■ ■

My mother died in 2016, just before my family and I left Providence for Tucson, where I had taken a position as assistant professor in the School of Geography and Development at the University of Arizona. She had moved into Section 8 housing right off the corner of Sunset and Vine in Hollywood while I was away. It was the nicest and most secure place she had ever lived. She was paying $230 per month in rent and living next door to people paying $2,300. She was also part of the first group of people to be cured of Hepatitis C. She told me she was receiving an $80,000 treatment for free but didn't have a ride to the doctor's office.

She was, as always, funny, witty, angry, and desperate, blending a sense of entitlement with sincere appreciation. And as always, she was as complex as the world around her.

The last time I talked to her, she asked me if I was still in CBS. She had met a graffiti writer while shopping at the drugstore near her apartment. He was about nineteen and worked at the store. She told everyone I was a graffiti writer. He told her I was one of his idols, so she wanted me to come meet him. I laughed and told her I had to get off the phone. A week later I got a call from someone at St. Joseph's Medical Center in Burbank. Evidently my mother did understand

where I was working, because the nurse told me they Googled me based on the information they could glean from my mother, who was dying.

Although she was clear of Hepatitis C, cirrhosis had already taken over her liver. The nurse put me on the phone with the doctor, who told me my mom was jaundiced and experiencing almost complete liver failure. But what puzzled him, he said, was the fact that they had to revive her twice since she had arrived by ambulance a week earlier.

"Is your mother an alcoholic?" he asked.

I was surprised by the question. She had never had a sip of alcohol in her life. He said she was showing signs of withdrawal.

After a few seconds of silence, I said, "You know she is a drug addict, right? She has been on doctor-prescribed and street opioids for over fifty years."

"Oh, that makes perfect sense." He sounded relieved. "We will start her on a treatment to ease the withdrawal so we can focus on the liver. Regardless, she only has a few months to live."

He then abruptly said goodbye and handed the phone to the nurse.

"Goodbye," she echoed, and hung up.

I was shocked that they didn't know or couldn't tell she was an opioid addict. But I was mad at her. Once again, she had probably lied, or simply withheld information, even when it was costing her her life.

A few days later, she was dead and I felt relieved.

AUTHOR'S NOTE

As an autoethnographer, I am both the author and the focus of the story, the one who tells and the one who experiences, the observer and the observed. I am the person at the intersection of the personal and the cultural, thinking and observing as an ethnographer and writing and describing as a storyteller.

CAROLYN ELLIS

Autoethnography is a form of self-narrative that places the self within a social context [and] entails the incorporation of elements of one's own life experience when writing about others.

DEBORAH E. REED-DANAHAY

AUTOETHNOGRAPHY

My research method and the presentation form of my work in this book follows an approach known as autoethnography. The qualifying prefix *auto-* acknowledges the reflexive assertion and insertion of the self into the ethnographic accounting of and writing about others. Autoethnographers such as Carolyn Ellis and Deborah E. Reed-Danahay are part of an ethnographic tradition in which exploration and embodiment of culture is informed by and filtered through the researcher.[1] More specific for my own work, and as geographer David Butz puts it, the autoethnographic sensibility evokes a "knowledgeable perspective on the metropolis from the margins" and provides an example of research and writing that is "emotionally invested,

experiential [and] grounded in place, saturated with local specificity, the ebb and flow of daily life and what is going on behind the scenes."[2]

While the ethnographer's personal experience and individual perspective have always played a role in the research process,[3] any formal acknowledgment of this has traditionally been relegated to footnotes or given only brief mention in subsections on method. Autoethnography, which brought personal experience out of the margin notes, became a part of ethnographic research during the early stirrings of postcolonial and postpositivist approaches to research within anthropology,[4] but started to come of age as part of the poststructuralist, postmodern, feminist, and cultural turns taking place within sociology, cultural geography, performance studies, communication studies, and women's studies during the late 1980s and early 1990s.[5]

Over the past two decades, scholars have increasingly promoted the explicit inclusion of the self in social scientific analysis and cultural studies, and have been intent on humanizing our understanding of our collective and sometimes incongruent life worlds.[6] Coupled with the drive to legitimate autoethnographic research and writing is a critique of the institutional and disciplinary gatekeepers for whom the self is a source of confusion and unverifiable data. I and others argue that, on the contrary, making scholarly work personal makes it approachable and therefore effective in bringing about a greater understanding of complex structures and, ultimately, empathy for others. Still, there are ongoing debates about autoethnography as an "evocative," "analytic," and "moderate" method of social commentary, reflection, and writing.[7] More than just a methodological strategy designed in advance and employed later in the field, and more than a method that relies on a preemptive "commitment" to a particular research strategy,[8] autoethnography in its purest form, I believe, relies on looking back and mining memory to connect real-world experiences with scholarly insight. Cutting more to the point, as cultural criminologist Jeff Ferrell puts it, like ethnography, autoethnography "really isn't a 'method' at all. . . . It's more a way of living in and knowing the world."[9]

MEMORY AND ETHICS

In autoethnography, data generated through real-life experience may still be rigorously analyzed, but the initial collection of that data is often done organically, without dissertation advisors, institutional review boards, journal reviewers, or tenure committees in mind. I was not concerned, for example, with how my mom's overdoses or my best friends' being shot were generating insights that would appease a hiring committee of disciplinary sentinels.

In one interview while I was on the job market, an assistant professor of sociology argued that autoethnography was merely a "writing style." "Real" academics created theory, he said. He was likely evoking Leon Anderson's claim that "autoethnography loses its sociological promise when it devolves into self-absorption."[10] I sat there listening to him disparage this particular method with Carolyn Ellis and Arthur Bochner's counterargument in mind: autoethnography "shows struggle, passion, embodied life, and the collaborative creation of sense-making in situations in which people have to cope with dire circumstances and loss of meaning."[11] I also couldn't help but think that "theory" may have been his only reliable data. I offer Sarah Stahlke Wall's discussion of a "moderate ethnography" as a way to navigate the polemical discussion about authoethnography's worth.[12]

Mining memory is not free from the necessity of fact checking, inasmuch as facts are available to be checked. Further, the process of mining one's memory and "cleaning the data," so to speak, is no less subject to ethical standards, scholarly vetting, and academic integrity than are more traditional approaches. For example, while writing this book, I returned to the spaces I discuss to ensure accuracy in my accounts. Being in these spaces elicited more memories, and my fact-checking missions often became writing sessions on the front steps of places I used to live, on the bus-stop benches where I used to sit, and even while leaning against walls I used to bomb. I also returned to the sites where I lost friends and watched unspeakable violence enacted by gang members, cops, and people I had trusted and loved.

While in the field, I paid close attention to the composition of

neighborhoods and street corners, reexamined legal interactions, and retraced the chronology of events, fact checking claims against my own recollection. Even the mundane details about, for example, how far I had been chased by gang members on a particular night, the length of time I had to wait in a welfare office, or the wording on an eviction notice or death certificate have been vetted. As part of more broadly engaging qualitative research methods, I conducted archival research in the *Los Angeles Times* and sifted through court records to ensure that my mentions of dates, criminal charges, and causes of death were accurate. I looked at the demographic composition of places where I lived, went to old telephone directories to ensure that I accurately remembered the names of places that are no longer there, and obtained secondary information from reliable scholarly sources about changing policies, shifts in community composition, and facts about historical events when primary information was unavailable. I even ensured the make and model of a gun or a car I refer to are accurate. But most importantly, I described people as I remember them, only changing or excluding their legal names to protect their privacy. I did this painstaking memory work in the interest of accuracy and because I respect the people and places I talk about too much to let hyperbole color them any differently than they were in real life, or at least how I remember them. While writing a contextualized story, I do rely upon artful rendering, but not artistic license.

Many of the places I returned to have changed so drastically that I found it difficult to locate the exact spot where a particular interaction took place. For example, I tried to retrace the steps I took when coming off the freeway the night I was hit by a car while running from the police, and from there I wanted to walk the few blocks to where Tolse was murdered years later. I was disoriented when I arrived, because the entire off-ramp had been rerouted, and the small strip mall where Arest used the payphone to call the paramedics was now an empty lot.

I also talked to old friends and relatives, at least those who are left. I wanted to hear their versions of events. In doing this, I followed Collins and Gallinat, who caution against implicating friends and

family in our autoethnographies, while also engaging in what Adams, Holman-Jones, and Ellis call "process consent," which inspired me— as painful as it was and as insecure as it made me feel—to discuss some of the details of my work-in-progress and the stories I was re-counting with people close to me.[13]

However, given the nature of my subject matter and setting, many of the people who have meant the most to me and played roles in the construction of this work are gone—either dead, displaced, or despondent. There is no intact childhood neighborhood to return to. Given the types of neighborhoods I have lived in, stability is hard to come by, leaving memory as the only viable lens through which to an-alyze our lives. It is only through analytical recall, or what Shrivastava calls "a memory ethnography," that I have been able to access those spaces and times that are physically deteriorated but that continue to shape how I see and understand complex social settings.[14] Rigor-ous memory work opens up old wounds, but without the immediate exposure to danger there to facilitate your escape.

When writing this book, there were times when I had to suppress gut-wrenching sobs as colleagues and students sat around me in the library, utterly unaware. The perfectly kept, tranquil space of the Ivy League campus where I began this book belied the sadness and hor-ror as well as the exuberance and thrill that circulated in my mind as I wrote.

Relying on personal reflection has also allowed me to move be-yond rehearsed narratives about what it means to be a graffiti writer and, instead, "keep it real" when telling my story.[15] Unlike so many scholarly texts, I don't provide grand narratives or strategic justifi-cation about why graffiti writers write; rather, I simply provide an insider's view of everyday events and circumstances as I remember them. I leave the rest up to you.

STATUS AND ACCESS

In addition to a concern for and focus on research ethics and the role that memory plays in the construction of research data, autoeth-

nographers, like ethnographers in general, are also interested in status and access, both of which are crucial elements to consider when researching and writing about vulnerable and transgressive groups such as graffiti writers and gang members. Rather than looking in as an objective outsider or even an enthusiastic participant-observer, autoethnographers often rely on their own role and recognized status within the group, culture, and space they are studying. Typically, ethnographers are outsiders looking for access to other people's experiences and practices, whereas autoethnographers are insiders or former insiders looking to tell their stories to the outside world.

Gaining access can be particularly difficult when doing research on members of illicit, deviant, transgressive, and risky subcultures that are necessarily guarded as part of their survival. When outsider researchers show up and start asking questions, these necessarily "reluctant respondents" may convey silent skepticism if not outright hostility.[16]

While being an insider provides access points, it is not without its own problems. As a "complete-member researcher," or insider-researcher, potential respondents may take the researcher for granted due to familiarity, thereby failing to describe what they perceive to be mutually experienced, common, or everyday interactions and occurrences. For an insider-researcher, hearing "You know what I mean" becomes a deathblow to the research process. In my own work, I have proposed conducting interviews in situ or, as I put it, "at the scene of the crime" in order to elicit interview data and reflection that is not hindered by rehearsed narratives and assumptions about what may already be known by the recognized researcher. In arguing for what I call "place-based elicitation," I also point out the important task the insider-researcher has in interpreting and translating extradiscursive responses that, while not "articulate utterances," are no less insightful and revelatory. [17]

A researcher's status, then, may very well provide access, but there is still work to be done. That work may be the painstaking process of memory work or finding a way in the writing process to prevent one's scholarly training from overshadowing and obscuring real-world ob-

servations that may, at least initially, defy scholarly explication and theorization.

Finally, attention to writing as the method of delivery and medium of representation for autoethnography is crucial. Honing those writing skills relies, first and foremost, on reading. As Ferrell argues, developing your autoethnographic writing skills entails reading novels, stories, nonfiction reportage, and classic ethnographies, and avoiding, even if just temporarily, more traditional social scientific reporting that is otherwise crucial for developing your intellectual framework.[18]

The books that directly inspired my own writing, or that helped me get over writer's block or, simply, emotional and intellectual exhaustion, were those that did not necessarily have anything to do with my subject matter and even included books whose characters and authors I have nothing in common with. Just a few of the less-than-academic books I turned to when I couldn't bear to write another word of my own were Matthew Desmond's *Evicted*, William Finnegan's *Barbarian Days*, Danielle Allen's *Cuz*, Jill Leovy's *Ghettoside*, Alice Goffman's *On the Run*, Ta-Nehisi Coates's *Between the World and Me*, Nico Walker's *Cherry*, Rashad Shabazz's *Spatializing Blackness*, Victor Rios's *Punished*, and J. D. Vance's *Hillbilly Elegy*.

GRAFFITI STUDIES

Several excellent long-form studies of graffiti have been produced by outsider researchers. Susan A. Phillips's *Wallbangin'* stands out as a model for its rigorous adherence to the tenets of research ethics in addition to its enthusiasm for the subject and empathetic exploration of the gang and graffiti communities in 1990s Los Angeles. Her work follows the tradition of ethnographers such as Dwight Conquergood, for whom understanding and accurately portraying culture, particularly the graffiti subculture, was more important than theorizing and categorizing culture for the sake of scholarly consumption.[19]

The origins of studying graffiti as a place-based practice and of graffiti writers as self-proclaimed bombers goes back to the work

of geographers David Ley and Roman Cybriwsky and their "Urban Graffiti as Territorial Markers," the first scholarly article to note how graffiti "loners" methodically move across and mark urban space in the interest of "going" what we came to call "all city."

It was almost a decade before publication of the first major book on graffiti, Craig Castleman's *Getting Up*, that sought to identify the practitioners' motivations and discuss their bombing efforts. This work was followed more than a decade later by insightful book-length studies of graffiti and graffiti writers from more critical standpoints. These include Ferrell's *Crimes of Style*, which provides readers with an understanding of how graffiti is an inherently political act of transgression, and Tim Cresswell's *In Place/Out of Place*, which theorizes graffiti as a challenge to the hegemony of "moral geographies."

Following these two seminal works were Joe Austin's *Taking the Train* and Nancy MacDonald's *The Graffiti Subculture*. An active decade and a half of graffiti scholarship published in geography, sociology, anthropology, criminology, and ethnography journals followed.

As graffiti enters its third generation of practitioners, former writers have begun to make forays into the academy and have produced insider reflections on the field, some of which are included in two essay collections on graffiti: *Routledge Handbook of Graffiti and Street Art*, edited by Jeffrey Ian Ross, and *Graffiti and Street Art.*, edited by Konstantinos Avramidis and Myrto Tsilimpounidi. For reviews of the current state of the field, see Jeffrey Ian Ross, Peter Bengtsen, John F. Lennon, Susan Phillips, and Jacqueline Z. Wilson, "In Search of Academic Legitimacy," and also two special issues of the journal *City* (volume 14, nos. 1–2, 2010) edited by Kyle Iveson, which include excellent work by scholar-bombers Jeff Ferrell and Robert D. Weide.

ACKNOWLEDGMENTS

The process of publishing a book with the University of Chicago Press involves dozens of people, some known to me and many working behind the scenes. Each and every one has helped make this a better book as well as a wonderful experience. Thank you so much, Timothy Mennel and T. David Brent. Thank you, Jenni Fry, Dylan Joseph Montanari, and Kristen Raddatz. And thank you to my editor, Priya Nelson. How does anyone write a book without Priya Nelson?

Also, thank you to editor Kerry Higgins Wendt, as well as the anonymous outside reviewers, whose enthusiasm for and suggestions on the first drafts of the manuscript were so formative. Had it not been for Rashad Shabazz and Susan Phillips's ability to see what I was trying to say and do with the first draft of my manuscript, I am not sure it would ever have become a book. It was also Susan Phillips who inspired me to become a scholar of graffiti and gangs and has become a friend. I am still trying to become half the scholar she is.

While writing this book I was supported as a faculty member in the School of Geography and Development at the University of Arizona, after receiving support as Fellow in the Cogut Center for the Humanities at Brown University, and as an Andrew W. Mellon Presidential Fellow in the Urban Studies Program and from the Center for the Study of Race and Ethnicity in America at Brown. While beginning to conceptualize this book, I received support as a Fellow in the Geography Department at the University of Minnesota, and even before that as a recipient of the Humanities Undergraduate

Research Award at UC Santa Cruz and as a student at Los Angeles Valley College.

Thank you to all the people I have been permanently or temporarily related to over the years, including my brothers, Jayme and Daniel, and my sister, Mimi, and Cousin Angelo, and Aunt Michele (AMZ). Thank you to the Garcia family. And thank you, Coach Walt Cranston at North Hollywood High School.

Thank you to every member of the TUGK crew for also being my family. Lyric. Bet. Arest. Other. Mage. Smoke. Davis. Fose. Thorn. Spread. Seren. And to Efren "Tolse" Barbosa (1975–1999). The entire KRS crew. Oak Dee, Knot, Chrome, Tager, Chance. The entire CBS crew. Mear One, Exist, Axis, Anger. And thank you to all the LA writers, some of whom I have never met, but who inspired me to try to go all city.

Thank you to my friends, especially Christian Guzmán, who has always been there. Thank you to Metallica, Pantera, Ice-T, N.W.A., the Cranberries, Rage Against the Machine, and Radiohead. Elliott Smith helped, too.

The UCLA Department of Urban Planning is where I learned to become a scholar and an urbanist under the mentorship of Edward W. Soja, and it was at the University of Minnesota where I learned to be a geographer under Roger Miller (1951–2010), Abdi Samatar, Karen Till, and George L. Henderson. Thanks Sallie Marston and Derek Rushbrook.

Finally, and most importantly, thank you to my partner Maria and my kids—Black, Rainy, and Sunny—for being my life. And thank you again, Maria . . . and a million more times . . . and a million more.

GANGS, CREWS, AND GROUPS

GANGS

18th Street (*Dieciocho*): originally a location-based gang that began in the Pico Union District just west of downtown Los Angeles during the 1970s but has since spread via numerous cliques across North and Central America and Oceania.

Armenian Power 13: an ethnic identity gang started in East Hollywood in the early 1990s. After hostilities with local Chicano gangs, became aligned with *Sureños* while members of AP were locked up in the state prison system.

Asian Boyz (AB): an ethnic identity gang from the Mid-City district and the south bay of Los Angeles and northern Orange County. AB is aligned with the Crips.

Barrio Van Nuys: the district of Van Nuys's namesake gang, dating back to the 1970s.

Big Hazard: one of the oldest gangs in Los Angeles, originating from the Romona Gardens Housing Projects in Boyle Heights after WWII.

Black Guerilla Family: a black prison gang founded inside the walls of San Quentin Prison in 1966.

Black P. Stones: a predominately black, Blood-aligned gang from South LA that originated in Chicago.

Blythe Street Locos: founded in the 1980s on Blythe Street in the Van Nuys neighborhood of the San Fernando Valley, across from the now closed GM automotive plant. One of the first gangs to be named in a civil injunction.

Boys from the Hood: a small gang formed in the 1980s in the northeast San Fernando Valley, closely aligned with the larger 18th Street, Vineland Boyz, and Radford Street gangs.

Burbank Back Street: a small local gang from the northeast side of the City of Burbank.

Clanton 14: an early gang, with origins dating back to the 1920s by some accounts. Clanton's original hood is disputed, as is the use of the number 14, which predates and is unaffiliated with the *Norteño* use of the number. There are several C14 hoods spread around Los Angeles.

Columbus Street: a highly localized gang from the North Hills neighborhood in the San Fernando Valley.

East Side Punx: a small and short-lived "punk rocker" gang with origins in 1980s Burbank.

Echo Park (EXP): a predominantly Chicano/a gang originating in the 1940s in the Echo Park (formerly Edendale) district of Los Angeles. Echo Park had a gang injunction placed against it in 2014. Female members of the gang are accurately depicted in the 1993 film *Mi Vida Loca*, written and directed by Allison Anders.

Frogtown Rifa (FTR): a highly localized gang that lays claim to the part of the Elysian Valley neighborhood bounded by Riverside Drive and the Los Angeles River.

Gumbys 12: a short-lived black and white gang with origins in Mid-City, the Melrose District, and North Hollywood. G12 disbanded after the highly publicized killing of an LAPD detective's son in 1995.

Head Hunters: an enjoined gang whose hood included the Belmont Tunnel graffiti yard in the Westlake District of Los Angeles, just south of Echo Park.

Kaos 13: a short-lived, predominantly white gang with members in the Fairfax District and North Hollywood.

LADS (Los Angeles Death Squad): A nonterritorial gang whose members frequented the Fairfax, Hollywood, and Mid-City districts. LADS were one of the most diverse gangs in terms of race, style, and preoccupation.

Langdon Street: a San Fernando Valley–based gang and the target of a civil gang injunction.

Lennox 13 (LNX13): a gang originating from the west side of the small independent municipality of Lennox, located in Los Angeles County.

Logan Heights: one of the oldest gangs in California, with origins in the Barrio Logan neighborhood of San Diego, Logan Heights had a small clique in Los Angeles by the early 1990s.

Mara Salvatrucha (MS13, MSX3, La Mara): with origins in Los Angeles and among Salvadoran youth, MS was the first gang to be declared a transnational criminal organization active across the Americas by the US State Department.

Mickey Mouse Club (MMC): a predominately white gang from the west side of the San Fernando Valley.

North Hollywood Boyz (NHBZ, NH Boyz): one of the oldest and largest gangs in the San Fernando Valley, with cliques across North Hollywood and Van Nuys.

Pacas Trece (Pacoima 13): a Pacoima-based gang from the San Fernando Valley.

Pacoima Project Boys: a Pacoima-based gang and the target of a civil gang injunction.

Pinoy Real: an ethnic identity gang. The name translates from Tagalog as "Filipino Royalty."

Radford Street: a small gang from the east San Fernando Valley whose hood is at the corner of Radford Street and Vanowen Avenue.

Rockwood Street: a gang from the Pico Union district of Los Angeles and one of the oldest gangs in LA.

Runnymede Street Locas: an all-female gang from the northeast San Fernando Valley.

San Fernando (San Fer): the oldest gang in the San Fernando Valley, with origins in the incorporated City of San Fernando and with ties to both white and Chicano prison gangs.

Sureños (Sur 13): a loose affiliation of cliques aligned with the Mex-

ican Mafia within the state prison system and throughout the Southern California region more generally.

Temple Street: one of the gangs included in the Glendale Corridor, or "Echo Park," injunction.

Toonerville 13: one of LA's oldest gangs, with origins in the city of Glendale and the Atwater District, on the east bank of the LA River and across from Frogtown.

Vineland Boys (VBS13): based in North Hollywood and Sun Valley, a longtime rival of North Hollywood Boyz.

White Fence 13: one of the oldest organized street gangs in Los Angeles, dating from 1930s East LA.

PRISON GANGS

Aryan Brotherhood: white members only, started during the late 1960s in the California State Prison system.

Black Guerilla Family: black members only, started during the late 1960s in the California State Prison system.

Mexican Mafia (*La Eme*): the largest prison gang, predominately Chicano membership with origins in southeast Los Angeles, dating back to the 1950s. The number 13 that most Chicano/a gangs use references the thirteenth letter of the alphabet, *M*, for *Eme*.

Nuestra Familia (*Norteños*): originated during the late 1970s in response to *Sureño* control of the prison drug trade. *Norteños* began in Northern California and include recent immigrants from Mexico and US agricultural workers. They adopted the number 14 in reference to *N*, the fourteenth letter of the alphabet.

Sureños: a general category of "south sider" Chicano gang and Mexican Mafia affiliates.

GRAFFITI CREWS

Can't Be Stopped / City Bomb Squad (CBS): a crew started in 1988 in the Melrose/Fairfax District of Los Angeles.

Hispanic Pride Raza (HPR): a small, San Fernando–based crew started during the early 1990s.

Insane Criminal Rule (ICR): a small, San Fernando Valley–based crew that resulted from the merge of the IC and CR crews during the early 1990s.

Interstate Freeway Killers (IFK): one of LA's most prolific crews, whose members focused on freeway bombing starting in the mid-1980s.

Kids Rulin' Society; later, Kings Rulin' Society (KRS): a San Fernando–based crew started during the late 1980s.

Mexicans Causing Panic (MCP): a small, Van Nuys–based and ethno-exclusive crew.

Setting the Pace (STP): a large, San Fernando Valley–based crew started in 1988.

The Black Underground (TBU): a small and short-lived crew started for and by black graffiti writers.

The Under Ground Kings (TUGK): a small and prolific San Fernando Valley–based crew active during the early 1990s.

UnStoppable Criminals (USC): a crew originated by predominately white graffiti writers in the west San Fernando Valley in 1989.

Under the Influence (UTI): one of LA's largest and most active crews, started in the mid-1980s.

White Mother Fuckers (WMF): a short-lived, white-members-only crew, started in response to TBU, with whom they were cliqued.

LAW ENFORCEMENT GROUPS

Los Angeles Police Department: responsible for policing within the city limits of Los Angeles.

Los Angeles County Marshals: responsible for enforcing evictions during the 1990s.

Los Angeles County Sheriff's Department: provides policing services to incorporated and unincorporated parts of Los Angeles County, as well as to the men's and women's county jail system and the courts.

Community Resources Against Street Hoodlums (CRASH): a Los Angeles Police Department antigang task force in operation from 1979 until its controversial disbanding in 2000 as part of a federal consent decree.

Graffiti Habitual Offender Suppression Team (GHOST): an LAPD and community undercover antigraffiti task force active during the 1990s.

Community Tagger Task Force: a community-run and LAPD-affiliated antigraffiti investigative task force.

GLOSSARY

all city a status derived from having one's name written throughout a given city; as an adverb, to go out and prolifically write across the entirety of a city

barrio Spanish for neighborhood; also spelled *varrio*

beef hostility, rivalry between two parties

bomb to produce a large volume of graffiti

bruja Spanish for *witch*, refers to someone perceived as beguiling

capped shot with a gun or having new graffiti painted atop exisiting graffiti

cholo/chola a Chicano/a gang member

clique a subgroup of a gang whose primary neighborhood is often in a separate location from the larger gang's *barrio*

cliqued up aligned and allied

Code 3 law enforcement radio code indicating an emergency situation in which lights and sirens are deployed for rapid response

Code 4 law enforcement radio code indicating no further assistance needed

come up on to obtain something through illicit means

deep hood a neighborhood known to have many active gang members

diss short for disrespect, to cross out or put a line through a rival's name

drama hostilities and antagonisms between two parties

e-box short for electrical box, referring to a street-light junction box, often found at street intersections

ese Spanish form of familiar address for a man, used to refer to a gang member

Frogger a 1980s arcade game in which players help frogs navigate moving cars and obstructions to cross a busy street

g-ride a stolen car

get up to become prolific at writing one's name as graffiti

go all city to write one's name across the entirety of a given city; to be considered a prolific writer or "bomber"

hero someone who calls the police or actively takes the law into their own hands to stop a writer from doing graffiti; a vigilante

hit up for gang members, to ask someone aggressively what gang they belong to; for graffiti writers, to respectfully write someone else's name

hooking up meeting up with others socially; also used to describe engaging in an amorous relationship

jumped into beaten as part of a gang initiation

lame uncool and unknowledgeable

leva a Chicano/a slang word meaning "coward" or "lame"

long hair someone who listens to heavy metal music and often has long hair

mad-dog a dirty look directed at another person

maricón Spanish derogatory slang for a homosexual or someone "lame"

mayate a derogatory Spanish term for a black person; literally, a beetle or cockroach

Mean Streak a solidified-paint marker popular among graffiti writers, manufactured by the Sakura company

neighborhood; hood a particular gang territory

niches Cuban derogatory slang for dark-skinned Cubans or Afro-Cubans; in the US, the term is applied to black people more generally

noticias Spanish for "news"

orale pues Spanish for "all right then"

pee-wees the youngest members of a gang

pinche Spanish slang for "fuckin'"

placas traditional term for gang graffiti, particularly squared, legible letters

pupusas a Salvadoran street food consisting of a thick, fried corn tortilla-like patty filled with beans, cheese, and/or meat

puto Spanish for "asshole," the female variant is *puta*, meaning "whore"

racking the act of stealing from a store

Sakura a broad, felt-tipped marker made by the Sakura company

Sanborn Yard an area located on the corner of Sanborn Avenue and Sunset Boulevard in Los Angeles, where illegal graffiti writing was tacitly tolerated

sherm a cigarette dipped in PCP

signs intricate hand gestures used to indicate a gang name

slangin' dealing drugs or stolen goods

spic a derogatory term for referencing Chicano/as

Starter jacket a sports warmup jacket made by the Starter company

Street Fighter hand-to-hand combat and martial arts fighting arcade game, popular during the early 1990s

Sureño one who is identified as or self-identifies as originating from or laying claim to Southern California, especially as a classification for prison gang membership

throw signs to express intricate hand gestures used to indicate a gang name to another person

throw-up	letters quickly composed with spray paint, usually rounded and consisting of no more than two colors
***trece* gang**	traditionally, a gang that uses the number thirteen in name and writing to show its allegiance to the Mexican Mafia or to *Sureños* more generally, with *trece* indicating the thirteenth letter of the alphabet, *M*, as a reference to the Mexican Mafia or to marijuana
turf	a specific gang territory
tweekers	users of methamphetamine, also known as "speed"
uppest	the most prolific and recognized writer
vato	a Chicano gang member, or *cholo*
veterano	a longtime and old age member of a gang, often used as a term of respect
wildstyle	highly stylized and, for those who are not graffiti writers, difficult-to-decipher writing

NOTES

INTRODUCTION

1. Such threats are common in communities such as mine. As Goffman recognizes in her book *On the Run*, the "major three" threats police officers make when searching for a fugitive are "arrest, eviction, and loss of child custody" (63).

2. "Cisco" is a nickname some friends at school gave me after I told them I had downed an entire bottle of Cisco, a highly alcoholic fortified wine that some called "liquid crack." I was lying, but the name stuck.

3. Detractors of this type of methodology consider autoethnography—the writing about one's self as mediated through an analysis of culture—to be a form of "me-search" or scholarly navel-gazing that defies the objectivity and generalizable theories that are valued outcomes of social science research. Yet for others, including me, autoethnography allows those of us who have experienced the phenomena we research to write about it in a way that is reflexive and authoritative without being totalizing and emotionally removed.

CHAPTER ONE

1. For a discussion of how trauma, especially trauma that results from street violence in socio-economically isolated neighborhoods, affects mental health and wellbeing, see Ralph, *Renegade Dreams*. There is also a growing literature that looks at poor health outcomes for those who face racial bias, community disorder, negative police interaction, and other issues related to general neighborhood stigma, including Lowe, Stroud, and Nguyen, "Who Looks Suspicious?"; Williams, Neighbors, and Jackson, "Racial/Ethnic Discrimination and Health"; and Pain, "Chronic Urban Trauma."

2. For a story of "becoming white," see Conley, *Honky* and "Universal Freckle, or How I learned to Be White."

3. For a detailed discussion of how girls nevertheless become criminalized and caught up in "wraparound incarceration," see Flores, *Caught Up*, and Díaz-Cotto, *Chicana Lives and Criminal Justice*.

4. See O'Neill, "Latino Lawyers, Garcetti Meet over Tagger's Death"; Riccardi and Tamaki, "Praise and Insults for Man Who Killed Tagger"; and Riccardi, "Death of a Tagger a Typical Street Mystery for Police." For a moving description of the event, see the introduction to Phillips, *Wallbangin'*.

5. For a history of the development of the San Fernando Valley and a discussion of the racial politics that contributed to its construction, see Barraclough, *Making the San Fernando Valley*.

6. In these violent years, getting a busy signal when calling 911 was common, and waiting hours for police or fire response even in life-threatening situations was typical. But getting stopped daily and violently frisked by a succession of law en-

forcement officers while walking to the convenience store or home from school was routine. What Rios refers to in *Punished* as an "over-policing/under-policing paradox" was no more obvious, however, than in the zeal exhibited by the same cops who would brazenly reverse up a freeway off-ramp to apprehend suspected taggers, only to speed away as one of those taggers landed on the freeway's blacktop, presumably seriously injured or dead.

7. Pacifica Hospital, where I was taken that night, was sued for "patient dumping" among other malpractices and shut down a few years later. It is also where Rodney King was brought after being beaten by LAPD officers in Lakeview Terrace. The acquittal of those officers led to the eruption of the LA Riot in 1992.

8. Tolse's death was described in the next day's *Los Angeles Times*: "Around 10 p.m. Saturday, a 23-year-old Van Nuys man was fatally shot at a party in the 9800 block of Woodale Avenue in Arleta. Efren Barbosa, an alleged gang member, was shot multiple times in the upper torso after a fight broke out between rival gang members at the party, said homicide Det. Frank Bishop of the Foothill Division. 'There was a dispute, and then there was a gang fight,' Bishop said. 'Shots were fired.'" Miller and Ha, "1 Killed, 2 Hurt in Chain of Gang Shootings."

CHAPTER TWO

1. A search on YouTube brings up several "driving through the hood" videos. Far from cherry-picked depictions of street life in Chicago, Detroit, Jacksonville, and several other cities, amateur videographers like CharlieBo313 drive around while their dash-mounted cameras collect images of mundane street life, including signs of low-level disorder. People hang out in the street and walk the block, but chaotic scenes of violence are nonexistent. Violence does occur, to be sure, but as O'Brien and Sampson show in "Public and Private Spheres of Neighborhood Disorder," their study of "pathways to violence in Boston," violent crime is most likely to occur in private spaces among people who love and trust one another. This is especially true for violence committed against women.

Further, gun violence in Chicago, according to sociologist Andrew Papachristos in "Murder by Structure," follows a "social contagion" model by which violence spreads between people who are socially connected and is far less likely to "infect" average bystanders without warning. This should not imply that victims of violence "precipitate" violent encounters or "put themselves in harm's way," but it does illustrate how violence is a public health issue, making public street life far freer from violence than most outsiders think and most movies depict.

For a nuanced discussion of the "ghetto" as a conceptual and sociospatial concept, see Wacquant, "Three Pernicious Premises in the Study of the American Ghetto," and Small, "De-Exoticizing Ghetto Poverty." For discussion of the gang member's humdrum life, see Klein, *The American Street Gang*, and Vigil, *Barrio Gangs* and *A Rainbow of Gangs*.

2. Pols, "Suburban Wanna-Be Gang Gets Attention of Authorities."

3. The Gumby homicide case involved four white members of the gang who were tried and eventually found guilty in the killing of a police officer's son. Following the 1995 murder, a *Los Angeles Times* reporter wrote, "Gumbys, a suburban wanna-be gang, first caught the attention of police about two years ago. They believe the gang is a loose affiliation of teen-agers and some young men in their early twenties. The Gumbys, they believe, probably began in North Hollywood and have spread up the Ventura Freeway. Police have found the gang's graffiti as far north as Westlake High School, Ventura County Sheriff's Deputy Daniel Hawes said" (Pols, "Suburban Wanna-Be Gang Gets Attention of Authorities"). And in a second *Los Angeles Times* article (Pols, "Credibility of Gang Expert Is under Fire"), as well as in a recently published book on the Gumby case (Porinchak, *One Cut*), members of the gang are described as "graffiti vandals."

It was a portentous prediction, then, in 1995—the same year as the killings—when noted criminologist Malcolm W. Klein wrote that "the legislative machine is plugged in and warming up. . . . Maybe we'll see special sentence enhancements for murders committed by taggers!" But the refusal to call white social groups "gangs" insulated them from a whole host of new laws and sentencing enhancements passed as part of the 1988 California Street Terrorism Enforcement and Prevention Act, or STEP. In fact, there were times during the 1990s when police went after graffiti writers as if they were gangsters, while white gangsters were often treated as individuals to whom gang legislation did not apply.

4. The most prolific of all-city and daredevil bombers between 1986 and 1996, the first generation of LA-based graffiti writers, were Wisk, Sleez, Chaka, Oiler, and Gkae, with Rage, Snap, Kaze, and Jer focusing on the San Fernando Valley. Only one of these writers could be identified as anything other than white. White males as the subject of scholarly inquiry into street-based subcultures is hard to come by, with men of color typically being the demographic placed under the sociological microscope. Exceptions are Conley, *Honky*; Finnegan, *Cold New World*; and Wimsatt, *Bomb the Suburbs*.

CHAPTER THREE

1. Years later, one of my colleagues at Brown University likewise informed me that I was "really white" when they decided that I possessed far too little experience with race and far too much privilege to be able to speak to issues of racial identity. Whereas my stepfather's statement was tinged with desperation and delusion, theirs was delivered with authoritative derision and intellectual exclusion.

CHAPTER FOUR

1. A civil gang injunction is a court directive, like a restraining order, that forbids identified gang members from congregating within designated "safe zones." Acting in violation of an injunction, which includes "standing, sitting, walking, driving, riding, gathering, or appearing anywhere in public view or in any place accessible to the public," with any named codefendant is grounds for arrest even in the absence of observed or reported criminal activity. The first civil gang injunction in LA was issued in 1988. Recently, these injunctions have come under increased legal scrutiny for violating people's constitutional rights to due process.

There is a large literature that addresses gang injunctions from a constitutional law and civil rights perspective, with much of the literature coming from gang experts and those who study neighborhood conflict. For example, see Muñiz, *Police, Power, and the Production of Racial Boundaries*, a study of the origins of gang injunctions in the context of neighborhood change; Barajas, "An Invading Army," an analysis of draconian policing within a community safe zone; and Caldwell, 'Criminalizing Day-to-Day Life: A Socio-Legal Critique of Gang Injunctions', and Werdegar, 'Enjoining the Constitution" for analyses of injunctions' constitutionality.

2. Just about every neighborhood I have lived in over the years has been within or adjacent to a legally defined gang injunction "safety zone," including the injunctions against Barrio Van Nuys, Columbus Street, Langdon Street, Pacoima Project Boys, Blythe Street, 18th Street's Hollywood cliques, Temple Street, Toonerville, Frogtown, Echo Park Locos, Head Hunters, and more than few MS13 cliques. For "safety zone" maps that correspond to each legally enjoined neighborhood, go to https://www.lacityattorney.org/gang-injunction. For data on homicides in LA, including my figures for Echo Park, visit http://homicide.latimes.com/neighborhood/echo-park/year/2017.

In fact, gang injunctions were applied only in the types of neighborhoods that would rent to people like us. Even though many of these neighborhoods had real

problems with violence, injunctions were often not put into place until after the crime rates fell and newer, more educated, wealthier, and whiter residents moved in and demanded such "antigang" policing.

In 2014, the "Glendale Corridor Gang Injunction" included the Frogtown neighborhood, where I spent some of my childhood. Back then we had to know the secret honk to get let into the neighborhood and to keep from having our car destroyed. In 2018, with a gang injunction in place, an *LA Times* headline declared, "Frogtown: A Wonderfully Weird Creative Hub Blossoms along the L.A. River" (Nelson).

It seems gang injunctions have more to do with supporting displacement by gentrification than with fighting crime, just as police are often less engaged in "law enforcement" than they are in maintaining moral order at the behest of incoming residents. I discuss this issue at length with my coauthor and graduate student, Dugan Meyer, in our article published in *Environment and Planning D: Society and Space*.

The most accurate depiction of how Echo Park used to look is in the movie *Mi Vida Loca*. This movie shows the neighborhood from the perspective of a few *cholas* and before the streets were cleared of "gangsters."

3. After the disintegration of the Soviet Union, the 1990 US census counted over 60,000 Armenians in Los Angeles, 80.8 percent of whom were foreign-born new arrivals moving into what were becoming the most homogeneous communities in LA in terms of their concentration of incoming ethnic minorities. Allen and Turner, "Spatial Patterns of Immigrant Assimilation."

Racial antagonism between Armenians and Latinos erupted as Armenians moved into predominantly Latino communities and gang territories. Relatively soon after their arrival, the City of Los Angeles officially designated the east side of Hollywood "Little Armenia," given the concentration and burgeoning community strength of Armenians in the neighborhood. But when the first generation of Armenian-Americans began enrolling in highly segregated local high schools, race riots erupted. For a perspective on the school fights, see geographer Mary Thomas's "The Paradoxes of Personhood."

It was also during this period, and despite the conflict, that Armenian youth founded the Armenian Power gang, which was brought under the authority of the Mexican Mafia as a matter of protection and alliance within the state prison system. Armenian Power, therefore, became Armenian Power 13, the added number signifying *Sureño* gang affiliation and protection.

The gang expert and sociologist Martín Sánchez-Jankowski discusses more contemporary high school race-based violence in California in his book *Burning Dislike*.

4. Scholars including Victor M. Rios in his book *Punished* and journalist Jill Leovy in her book *Ghettoside* refer to this as the over-policing/under-policing paradox. The paradox may arise from the fact that law enforcement often engages in "hot spot" policing, which forces them to exert control over community members even when crimes are not being committed, but then those same departments don't have the resources or wherewithal to respond when the community actually needs them.

CHAPTER FIVE

1. Sometimes these quiet and well-kept fourplexes would be right next door to a giant apartment complex with overflowing trash dumpsters, loud music pumping out of every unit, and loose dogs. Matthew Desmond explains this "problem building" phenomena in *Evicted*. He writes that landlords' "screening practices that banned criminality and poverty in the same stroke drew poor families shoulder to shoulder with drug dealers, sex offenders, and other lawbreakers in places with lenient requirements. . . . The techniques landlords used to 'keep illegal and de-

structive activity out of rental property' kept poverty out as well. This also meant that violence, drug activity, deep poverty, and other social problems coalesced at a much smaller, more acute level than the neighborhood. They gathered at the same address" (89).

Rashad Shabazz discusses the carceral apartment complex in his *Spatializing Blackness*. He shows how prison complexes and apartment complexes often share a similar architecture, house the same people, and are built to serve the same purpose of control and containment.

2. In *Ghettoside*, which examines the investigation of a homicide in South LA, Jill Leovy discusses how low-level interpersonal drama over relationships and mild beefs between young men can erupt into violence. By labeling such violence as "gang related," the general public can distance themselves from what is actually domestic violence and a symptom of neighborhood trauma.

3. Desmond writes that "eviction is to women what incarceration is to men: a typical but severely consequential occurrence contributing to the reproduction of urban poverty" ("Eviction and the Reproduction of Urban Poverty," 88).

4. Gang member categorization is based on exceptionally vague and superficial criteria. For example, as the Los Angeles Police Department states on their website (http://www.lapdonline.org/get_informed/content_basic_view/23468), one way to identify a gang member is by determining if they wear jewelry that is "expensive or cheap" or even based on whether they wear "certain undergarments." Likewise, hairstyles that include shaved heads or braids should raise suspicion of gang affiliation. Criminality is never even mentioned in the list of descriptors, but tattoos and shoe laces or clothing of a "certain color" including white, red, blue, black, brown, purple and even plaid are. I am not sure any one of us would escape gang member categorization based on these criteria, regardless of our actions.

See Rios's *Human Targets* for a perspective on the use of the gang member label and Phillips's *Operation Fly Trap* for a discussion of how gang membership is defined in the context of police action.

5. My use of the word *neighborhood* refers to the claiming and naming of a turf or barrio by a local gang. Street gang territoriality is decidedly geographic, with cardinal points and directionality appearing in gang graffiti and the names of local cliques.

Far more than protecting the drug trade, identifying with and often violently protecting the boundaries of a particular neighborhood is the driving force behind intragang cohesion and identity formation. As Steven Levitt and Sudhir Venkatesh point out in "An Economic Analysis of a Drug-Selling Gang's Finances," the profit motivation from illicit sales is not the primary motivating factor behind joining or defending the integrity of a gang. In my own experience, few gang members could easily be defined as hardcore or even casual drug dealers.

6. Patricia A. Adler and Steven Adler's writings on research methods and their concept of the ethnographer's "insider and outsider status" have been important to my research, but it is their writing on self-injury in *The Tender Cut* that helps elucidate my experience here. As they argue, cutting, or in my case carving, acts as a coping mechanism and the conversion of unbearable emotional pain into manageable physical pain.

I am still surprised that I did such a thing. Looking back, I realize I coped with a lot by going out writing and turning my attention to something simultaneously productive and destructive. On this one occasion I was self-destructive.

CHAPTER SIX
1. Two of the motels we called home were part of a mid-90s debate over how to thwart prostitution in the area: see Schnaufer, "Van Nuys."

CHAPTER SEVEN

1. For coverage of the North Hollywood High School riots in the *LA Times* and on local broadcast news, see Bernstein and Meyer, "4 Arrested in Racial Melee at High School," and Cowan, "North Hollywood High School 'riot' coverage (1992)."

CHAPTER EIGHT

1. It is common to be from more than one graffiti crew at the same time. At one point Tolse was from STP, ICR, TUGK, MYL, USC, and IFK. This is another aspect of the subculture that distinguishes it from gangs.

2. There is much talk about taggers receiving long prison sentences, but in reality, and despite the massive amount of resources that do go into the criminalization and capture of graffiti writers, most writers who end up receiving long prison sentences have multiple priors and lists of offenses that include drug possession, weapons charges, domestic battery, assault, and theft. In 2011, the prolific bomber Trigz from the ICR crew was sentenced to prison time after being caught hitting a local freeway sound wall. While his arrest was for vandalism, his long list of priors is what led to his lengthy sentence.

I have spoken with many writers who regret their prior crimes and looked to graffiti as a nonviolent way out of larger criminal circles that nonetheless allowed them to maintain their notoriety and street credibility. But criminal records are always used against you, even if the third or fourth conviction is for no more than writing your name on a wall. The three strikes law, for example, does not weigh the severity of the third strike; rather, it applies the severity and sentencing stringency that pertained to the first and second strikes. The sentencing law was passed the year most of my crewmates started getting busted and sent away.

"Trigz," whose real name was Michael Christopher Pebley, was one of my friends as well as a gang member before he was a graffiti writer. He had turned to graffiti as a gateway crime out of the far more violent life he was leading as a member of Toonerville 13—a gang whose name he had tattooed across his face. He had also become a well-known tattoo artist before he was shot and killed on Laurel Canyon Boulevard in North Hollywood in 2014, just months after being released from state prison following a four-year bid for vandalism. For news coverage of the killing, see Serna, "Famed Tattoo Artist 'Trigz' Killed in North Hollywood Shooting."

3. The first graffiti website, artcrimes.com, was in fact among the very first websites of any kind, created at about the same time as whitehouse.gov and sex.com.

4. Goffman discusses the role that unpaid court fees and delinquent fines play in the process of mass incarceration in *On the Run*. Alexander also broaches the subject in *The New Jim Crow*. See also Harris, Evans, and Beckett, "Drawing Blood from Stones."

CHAPTER NINE

1. The sociologist Stanley Cohen coined the term *folk devil* in 1972 to describe those who are portrayed by the media and moral entrepreneurs as deviants, outsiders, and threats to the cohesion and purity of mainstream society.

2. During this era, it was common for gangs, far more than for graffiti crews—which are noteworthy for their broad diversity of race, ethnicity, and class—to express their ethnic and racial composition in their names, such as Armenian Power, Asian Boyz, Black P. Stones, *Pinoy Real* (which translates from Tagalog as "Filipino royalty"), and *Mara Salvatrucha* or MS13 (which translates from Spanish as "gang of Salvadorans"). Like these expressly ethno-exclusive gangs, most gangs who identify by street names are racially and ethnically homogeneous, but more as a reflection of the racially segregated neighborhoods and ethnic enclaves from which they hail than as a result of specific intention or exclusion.

Gang expert Diego Vigil discusses the ethnic and social composition of gangs in *A Rainbow of Gangs*. See also Alonso, "Territoriality among African American Street Gangs in Los Angeles"; Vigil, *Barrio Gangs*; and Freng and Esbensen's discussion of "multiple marginality" among gang adherents in "Race and Gang Affiliation."

3. If you, the reader, find the constant movement to new places and living situations confusing or disorienting, imagine how I felt. Stability, order, and coherence are luxuries many people don't have.

CHAPTER TEN

1. In *Street Kids*, Kristina E. Gibson discusses how homeless youth are at pains to blend in by looking like students or "normal people" as part of surviving on the streets and not attracting the attention of law enforcement.

2. My stepfather's most recent bank heists, which ultimately sent him back to prison for fourteen years, landed him on the local FBI's most-wanted list and led to him being dubbed "The Armed Old Man Bandit." He is described in a *Daily News* front page story as having "a reputation for being one of the crankiest of bank robbers—shouting at tellers with a string of profanity." See Bartholomew, "Robber Threatens Bombing at Bank."

3. Desmond discusses this common reliance on acquaintances in times of need and housing vulnerability in "Disposable Ties and the Urban Poor."

CHAPTER ELEVEN

1. For *Los Angeles Times* coverage of Skate's death and memorial, see Tamaki, "Train Kills 'Tagger' Taking Photos of Graffiti."

2. Susan M. Ruddick provides a glimpse of the youth homeless scene in this precise place and time in *Young and Homeless in Hollywood*.

CHAPTER TWELVE

1. For news coverage of the Community Tagger Task force, see Alger, "Van Nuys: Police to Honor Tagger Task Force."

2. The broken windows theory suggests that disorder is correlated with, if not causal of, increased occurrences of violent crime. The authors of that influential theory, James Q. Wilson and George L. Kelling, write that areas where disorder prevails will become "vulnerable to criminal invasion." However, several subsequent studies suggest that the source of residents' sense of panic when confronted with graffiti and other forms of disorder seems to be generated more by implicit bias associated with the presence of minorities, immigrants, and other "outsiders" than by experiences with actual predation. Kramer writes about reactions to graffiti in "Moral Panics and the Urban Growth Machine"; other studies look at the link between fear of crime, disorder, and racial bias, including Sampson and Raudenbush, "Seeing Disorder," Wickes, Hipp, Zahnow, and Mazerolle, "'Seeing' Minorities and Perceptions of Disorder," and Vitale, *City of Disorder*.

3. That guy, Alvaro Castillo, was actually our quarterback.

4. Antigraffiti cops and vigilantes are known for their obsession with graffiti; some of them become well-known enthusiasts. The self-proclaimed Graffiti Guerilla, Joe Connolly, has appeared in graffiti documentaries such as *Infamy* and *Bomb It*, in which he sounds like an admiring member and expert biographer of the graffiti community. In *Vigilante, Vigilante*, antigraffiti heroes are shown to adopt their own symbol and moniker as they go out at night to fight graffiti. And perhaps most illustrative of spillover obsession, Joseph Rivera, a member of the New York City Transit Police Department's so-called Vandal Squad even published a book of the same name that reads as a tribute to graffiti.

EPILOGUE

1. Most writers do not stop doing graffiti cold turkey. They move from all-out bombing to doing less and less graffiti to catching only the occasional tag. Laura Mac-Diarmid and Steven Downing call this a "rough aging out" of the graffiti scene.

2. Thanks, Jonah, wherever you are.

AUTHOR'S NOTE

1. For an example of this, see Contreras, *The Stickup Kids*. The quotes from Reed-Danahay and Ellis are from *Auto/Ethnography* and *Revision*, respectively.

2. Butz, "Autoethnography as Sensibility," 139.

3. Leon Anderson makes this point in *Analytic Autoethnography*.

4. See Hayano, "Auto-Ethnography."

5. See Adams, Holman-Jones, and Ellis, *Autoethnography*, for a chronological overview and extensive bibliography.

6. For examples, see Bochner, "Narrative's Virtues"; Ellis, *Revision*; Denzen, *Interpretive Autoethnography*, and Holt, "Representation, Legitimation, and Authoethnography."

7. Bochner and Ellis, *Evocative Autoethnography*; Anderson, *Analytic Autoethnography*, and Wall, *Toward a Moderate Autoethnography*. See the special issue of the *Journal of Contemporary Ethnography* 35, no. 4 (2006) for a call and response debate on this topic.

8. Anderson, "Analytic Autoethnography."

9. Ferrell, "Criminological Ethnography," 147.

10. Anderson, "Analytic Autoethnography," 385.

11. Ellis and Bochner, "Analyzing Analytic Autoethnography," 433.

12. Wall, "Toward a Moderate Ethnography."

13. Collins and Gallinat, *The Ethnographic Self as Resource*; Adams, Holman-Jones, and Ellis, *Autoethnography*.

14. Srivastava, "On Sanitation."

15. I explore the idea of "keeping it real" in "Place-Based Elicitation."

16. Adler and Adler, *Membership Roles*.

17. Bloch, "Place-Based Elicitation."

18. Ferrell, "Criminological Ethnography."

19. Conquergood, "Rethinking Ethnography."

BIBLIOGRAPHY

Adams, Karen L., and Anne Winter. "Gang Graffiti as a Discourse Genre." *Journal of Sociolinguistics* 1, no. 3 (1997): 337–60.

Adams, Tony E., Stacy Linn Holman-Jones, and Carolyn Ellis. *Autoethnography.* Understanding Qualitative Research. Oxford, Oxford University Press, 2015.

Adler, Patricia A., and Peter Adler. *Membership Roles in Field Research.* Thousand Oaks, CA: Sage, 1987.

Adler, Patricia A., and Peter Adler. *The Tender Cut: Inside the Hidden World of Self-Injury.* New York: NYU Press, 2011.

Alexander, Michelle. *The New Jim Crow: Mass Incarceration in the Age of Colorblindness.* New York: New Press, 2012.

Alger, Douglas. "Van Nuys: Police to Honor Tagger Task Force." *Los Angeles Times,* 29 Sept 1995.

Allen, James P., and Eugene Turner. "Spatial Patterns of Immigrant Assimilation." *Professional Geographer* 48, no. 2 (1996): 140–55.

Alonso, Alejandro A. "Territoriality among African-American Street Gangs in Los Angeles." master's thesis, University of Southern California, 1999.

Anderson, Leon. "Analytic Autoethnography." *Journal of Contemporary Ethnography* 35, no. 4 (2006): 373–395.

Austin, Joe. *Taking the Train: How Graffiti Art Became an Urban Crisis in New York City.* New York: Columbia University Press, 2001.

Avramidis, Konstantinos, and Myrto Tsilimpounidi, eds. *Graffiti and Street Art: Reading, Writing and Representing the City.* New York: Taylor and Francis, 2016.

Barraclough, Laura R. *Making the San Fernando Valley: Rural Landscapes, Urban Development, and White Privilege.* Athens: University of Georgia Press, 2011.

Barajas, Frank P. "An Invading Army: A Civil Gang Injunction in a Southern California Chicana/o Community." *Latino Studies* 5, no. 4 (2007): 393–417.

Bartholomew, Dana. "Robber Threatens Bombing at Bank." *Los Angeles Daily News,* 26 November 2005.

Bernstein, Sharon, and Josh Meyer. "4 Arrested in Racial Melee at High School." *Los Angeles Times,* 27 October 1992. http://articles.latimes.com/1992-10-27/local/me-745_1_north-hollywood-high-school.

Bloch, Stefano. "Place-Based Elicitation: Interviewing Graffiti Writers at the Scene of the Crime." *Journal of Contemporary Ethnography* 47, no. 2 (2018): 171–98.

Bloch, Stefano, and Dugan Meyer. "Implicit Revanchism: Gang Injunctions and the Security Politics of White Liberalism." *Environment and Planning D: Security and Space,* February 25, 2019. https:doi.org/10.1177/0263775819832315.

Bochner, Arthur P. "Narrative's Virtues." *Qualitative Inquiry* 7, no. 2 (2001): 131–57.

Bochner, Arthur P., and Carolyn Ellis. *Evocative Autoethnography: Writing Lives and Telling Stories.* New York: Routledge, 2016.

Butz, David. "Autoethnography as Sensibility." In D. DeLyser, S. Herbert, S. Aitken, M. Crang, and L. McDowell, eds., *The Sage Handbook of Qualitative Geography.* Thousand Oaks, CA: Sage, 2010.

Caldwell, Beth. "Criminalizing Day-to-Day Life: A Socio-Legal Critique of Gang Injunctions," *American Journal of Criminal Law* 37 (2009): 241–90.

Cowan, Donald. "North Hollywood High School 'riot' coverage (1992)." *YouTube,* 5 May 2007. www.youtube.com/watch?v=n-gamC24n3M.

Collins, Peter, and Anselma Gallinat, eds. *The Ethnographic Self as Resource: Writing Memory and Experience into Ethnography.* New York: Berghahn Books, 2010.

Conley, Dalton. *Honky.* Los Angeles: University of California Press, 2000.

Conley, Dalton. "Universal Freckle, or How I Learned to Be White." In *The Making and Unmaking of Whiteness,* ed. Birgit Brander Rasmussen, Eric Klinenberg, Irene J. Nexica, and Matt Wray, 25–42. Duke University Press, 2001.

Conquergood, Dwight. "Rethinking Ethnography: Towards a Critical Cultural Politics." *Communications Monographs* 58, no. 2 (1991): 179–94.

Contreras, Randol. *The Stickup Kids: Race, Drugs, Violence, and the American Dream.* Berkeley: University of California Press, 2013.

Cresswell, Tim. *In Place/Out of Place.* Minneapolis: University of Minnesota Press, 1996.

Denzin, Norman K. *Interpretive Autoethnography.* Thousand Oaks, CA: Sage Publications, 2013.

Desmond, Matthew. "Disposable Ties and the Urban Poor." *American Journal of Sociology* 117, no. 5 (2012): 1295–335.

Desmond, Matthew. *Evicted: Poverty and Profit in the American City.* New York: Crown Books, 2016.

Desmond, Matthew. "Eviction and the Reproduction of Urban Poverty." *American Journal of Sociology* 118, no. 1 (2012): 88–133.

Díaz-Cotto, Juanita. *Chicana Lives and Criminal Justice: Voices from el Barrio.* Austin: University of Texas Press, 2006.

Ellis, Carolyn. *Revision: Autoethnographic Reflections on Life and Work.* London: Routledge, 2016.

Ellis, Carolyn S., and Arthur P. Bochner. "Analyzing Analytic Autoethnography: An Autopsy." *Journal of Contemporary Ethnography* 35, no. 4 (2006): 429–49.

Ferrell, Jeff. *Crimes of Style: Urban Graffiti and the Politics of Criminality.* New York: Garland, 1996.

Ferrell, Jeff. "Criminological Ethnography: Living and knowing." In Rice, S.K. and Maltz, M.D. eds. *Doing Ethnography in Criminology.* New York: Springer.

Finnegan, William. Cold New World: Growing up in a Harder Country. Modern Library, 1999.

Flores, Jerry. *Caught Up: Girls, Surveillance, and Wraparound Incarceration.* Los Angeles: University of California Press, 2016.

Freng, Adrienne, and FinnAage Esbensen. "Race and Gang Affiliation: An Examination of Multiple Marginality." *Justice Quarterly* 24, no. 4 (2007): 600–628.

Goffman, Alice. *On the Run: Fugitive Life in an American City.* Chicago: University of Chicago Press, 2014.

Gibson, Kristina E. *Street Kids: Homeless Youth, Outreach, and Policing New York's Streets.* New York: NYU Press, 2011.

Harris, Alexes, Heather Evans, and Katherine Beckett. "Drawing Blood from Stones: Legal Debt and Social Inequality in the Contemporary United States." *American Journal of Sociology* 115, no. 6 (2010): 1753–99.

Hayano, David. "Auto-Ethnography: Paradigms, Problems, and Prospects." *Human Organization* 38, no. 1 (1979): 99–104.

Holt, Nicholas L. "Representation, Legitimation, and Autoethnography: An Autoethnographic Writing Story." *International Journal of Qualitative Methods* 2, no. 1 (2003): 18–28.

Klein, Malcolm W. *The American Street Gang: Its Nature, Prevalence, and Control.* Oxford: Oxford University Press, 1995.

Kramer, Ronald. "Moral Panics and Urban Growth Machines: Official Reactions to Graffiti in New York City, 1990–2005." *Qualitative Sociology* 33, no. 3 (2010): 297–311.

Leovy, Jill. *Ghettoside: A True Story of Murder in America.* New York: Spiegel & Grau, 2015.

Levitt, Steven D., and Sudhir Alladi Venkatesh. "An Economic Analysis of a Drug-Selling Gang's Finances." *Quarterly Journal of Economics* 115, no. 3 (2000): 755–89.

Ley, David, and Roman Cybriwsky. "Urban Graffiti as Territorial Markers." *Annals of the Association of American Geographers* 64, no. 4 (1974): 491–505.

Lowe, Maria R., Angela Stroud, and Alice Nguyen. "Who Looks Suspicious? Racialized Surveillance in a Predominantly White Neighborhood." *Social Currents* 4, no. 1 (2017): 34–50.

MacDiarmid, Laura, and Steven Downing. "A Rough Aging Out: Graffiti Writers and Subcultural Drift." *International Journal of Criminal Justice Sciences* 7, no. 2 (2012): 605.

Macdonald, Nancy. *The Graffiti Subculture: Youth, Masculinity and Identity in London and New York.* New York: Springer, 2001.

Miller, T. Christian, and Julie Ha, "1 Killed, 2 Hurt in Chain of Gang Shootings, Police Say; Suspect Arrested," *Los Angeles Times,* 25 January 1999.

Muñiz, Ana. *Police, Power, and the Production of Racial Boundaries.* New Brunswick, NJ: Rutgers University Press, 2015.

Nelson, Steffie. "Frogtown: A Wonderfully Weird Creative Hub Blossoms along the L.A. River," *Los Angeles Times,* 27 March 2018.

O'Brien, Daniel Tumminelli, and Robert J. Sampson. "Public and Private Spheres of Neighborhood Disorder: Assessing Pathways to Violence Using Large-Scale Digital Records." *Journal of Research in Crime and Delinquency* 52, no. 4 (2015): 486–510.

O'Neill, Ann W. "Latino Lawyers, Garcetti Meet over Tagger's Death," *Los Angeles Times,* 11 February 1995.

Papachristos, Andrew V. "Murder by Structure: Dominance Relations and the Social Structure of Gang Homicide." *American Journal of Sociology* 115, no. 1 (2009): 74–128.

Phillips, Susan A. *Operation Fly Trap: LA Gangs, Drugs, and the Law.* Chicago: University of Chicago Press, 2012.

Phillips, Susan A. *Wallbangin': Graffiti and Gangs in LA.* Chicago: University of Chicago Press, 1999.

Pols, Mary F. "Suburban Wanna-Be Gang Gets Attention of Authorities," *Los Angeles Times,* October 22, 1995. http://articles.latimes.com/1995-10-22/news/mn-59950_1_suburban-gang.

Pols, Mary F. "Credibility of Gang Expert Is under Fire," *Los Angeles Times,* March 20, 1996. https://www.latimes.com/archives/la-xKKKKpm-1996-03-20-me-48942-story.html.

Porinchak, Eve. *One Cut.* New York: Simon Pulse, 2017.

Ralph, Laurence. *Renegade Dreams: Living through Injury in Gangland Chicago.* Chicago: University of Chicago Press, 2014.

Reed-Danahay, Deborah, ed. *Auto/Ethnography.* New York: Berg, 1997.

Riccardi, Nicholas. "Death of a Tagger a Typical Street Mystery for Police," *Los Angeles Times,* 7 April 1995.

Riccardi, Nicholas, and Julie Tamaki, "Praise and Insults for Man Who Killed Tagger," *Los Angeles Times*, 4 February 1995.

Rios, Victor M. *Human Targets: Schools, Police, and the Criminalization of Latino Youth*. Chicago: University of Chicago Press, 2017.

Rios, Victor M. *Punished: Policing the Lives of Black and Latino Boys*. New York: NYU Press, 2011.

Rivera, Joseph. *Vandal Squad: Inside the New York City Transit Police Department, 1984–2004*. New York: Powerhouse Books, 2008.

Ross, Jeffrey Ian, ed. *Routledge Handbook of Graffiti and Street Art*. London: Routledge, 2016.

Ross, Jeffrey Ian, Peter Bengtsen, John F. Lennon, Susan Phillips, and Jacqueline Z. Wilson. "In Search of Academic Legitimacy: The Current State of Scholarship on Graffiti and Street Art." *Social Science Journal* 54, no. 4 (2017): 411–19.

Ruddick, Susan M. *Young and Homeless in Hollywood: Mapping the Social Imaginary*. New York: Routledge, 2014.

Sampson, Robert J., and Stephen W. Raudenbush. "Seeing Disorder: Neighborhood Stigma and the Social Construction of "Broken Windows." *Social Psychology Quarterly* 67, no. 4 (2004): 319–42.

Sánchez-Jankowski, Martín. *Burning Dislike: Ethnic Violence in High Schools*. University of California Press, 2016.

Schnaufer, Jeff. "Van Nuys: Motel Owners Split on Prostitution Issue." *Los Angeles Times*, 8 June 1994. http://articles.latimes.com/1994-06-08/local/me-1830_1_motel-owners.

Serna, Joseph. "Famed Tattoo Artist 'Trigz' Killed in North Hollywood Shooting." *Los Angeles Times*, 10 October, 2014. www.latimes.com/local/lanow/la-me-ln-trigz-shot-north-hollywood-20141010-story.html.

Shabazz, Rashad. *Spatializing Blackness: Architectures of Confinement and Black Masculinity in Chicago*. University of Illinois Press, 2015.

Small, Mario L. "DeExoticizing Ghetto Poverty: On the Ethics of Representation in Urban Ethnography." *City & Community* 14, no. 4 (2015): 352–58.

Srivastava, Vinay Kumar. "On Sanitation: A Memory Ethnography." *Social Change* 44, no. 2 (2014): 275–90.

Thomas, Mary E. "The Paradoxes of Personhood: Banal Multiculturalism and Racial-Ethnic Identification among Latina and Armenian Girls at a Los Angeles High School." *Environment and Planning* 40, no. 12 (2008): 2864–78.

Tamaki, Julie. "Train Kills 'Tagger' Taking Photos of Graffiti: Vandalism: Man was with group that had just painted railroad boxcar. Four others escape injury." *Los Angeles Times*, 25 June 1993.

Vigil, James Diego. *Barrio Gangs: Street Life and Identity in Southern California*. Austin: University of Texas Press, 2010.

Vigil, James Diego. *A Rainbow of Gangs: Street Cultures in the Mega-City*. Austin: University of Texas Press, 2010.

Vitae, Alex. *City of Disorder: How the Quality of Life Campaign Transformed New York Politics*. New York: New York University Press, 2008.

Wacquant, Loïc J. D. "Three Pernicious Premises in the Study of the American Ghetto." *International Journal of Urban and Regional Research* 21, no. 2 (1997): 341–53.

Wall, Sarah Stahlke. "Toward a Moderate Autoethnography." *International Journal of Qualitative Methods* 15, no. 1 (2016).

Werdegar, Matthew M. "Enjoining the Constitution: The Use of Public Nuisance Abatement Injunctions against Urban Street Gangs." *Stanford Law Review*. 51, no. 2 (1999): 409.

Wickes, Rebecca, John R. Hipp, Renee Zahnow, and Lorraine Mazerolle. "'Seeing' Minorities and Perceptions of Disorder: Explicating the Mediating and Moderating Mechanisms of Social Cohesion." *Criminology* 51, no. 3 (2013): 519–60.

Williams, David R., Harold W. Neighbors, and James S. Jackson. "Racial/Ethnic Discrimination and Health: Findings from Community Studies." *American Journal of Public Health* 93, no. 2 (2003): 200–208.

Wilson, James Q., and George L. Kelling. "Broken Windows." *Atlantic Monthly* 249, no. 3 (1982): 29–38.

Wimsatt, William. *Bomb the Suburbs.* Soft Skull Press, 1999.